THE ENCYCLOPEDIA OF
PHOTOGRAPHY

Michael Busselle

OCTOPUS BOOKS

Contents

First published in 1983 by Octopus Books Limited
59 Grosvenor Street, London W1
© 1983 Octopus Books Limited
Second impression 1984
Reprinted 1985
ISBN 0 7064 23739
Printed in Hong Kong

Introduction

I was first introduced to the magic of photography more than thirty years ago when, as a young lad, I was given a box camera. At that time the ability to create an image within a small black box, at the press of a button, really did seem like a mystical process. When I developed my first roll of black and white film, lifting out the gleaming wet spiral of celluloid with its newly formed images I felt an excitement which has happily never left me. I can still experience the same thrill today when experimenting with a new piece of equipment or making a print of a picture I am particularly pleased with.

Photography is, of course, now quite common place, in many ways it dominates our lives and much of our experience today is, in fact, lived vicariously through the medium of the camera. For this reason some of the essence of photography has been lost in familiarity and sophistication; it is however still there and those photographers who penetrate beyond the superficial aspects of this snapshot taking will still discover a fascinating and rewarding activity which can quite literally give them a lifetime's pleasure.

My special aim with this particular book is to inform and instruct while also introducing newcomers to photography to the experiences and interests of the medium that have given me so much pleasure.

There is much more to photography than just taking pictures. Therefore the scope of this book has widened beyond aspects of technique and equipment to include the beginnings of the medium where people, who were essentially scientists, made the first crude images.

The development of the craft of photography was perfected and raised to an aesthetic level comparative to the traditional visual arts by a constantly growing list of perceptive and innovative photographers. The selection of these photographic masters is, of necessity, restricted and very much a personal view. However, I hope that the highly individual vision of at least one of these will strike a chord, inspiring you to take a more personal and meaningful view of your photography. In addition I have included, in photoprojects, some ideas of how you might apply the skills that you acquire. Your photography should then also have motivation and direction.

Photography means many different things to different people: For some, it is simply a way of recording the important events and people in their life; For others it is an art form, a means of personal expression. Whatever it means to you I hope that this book will help make it what it has been for me – absorbing, rewarding, but above all – a great deal of fun.

Michael Busselle.

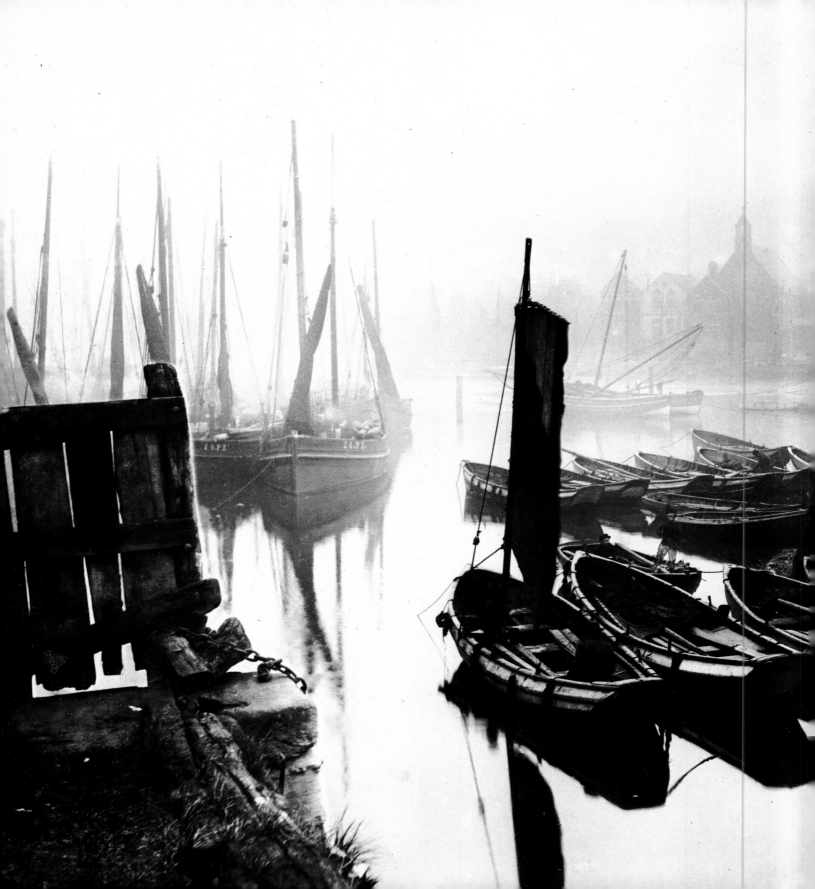

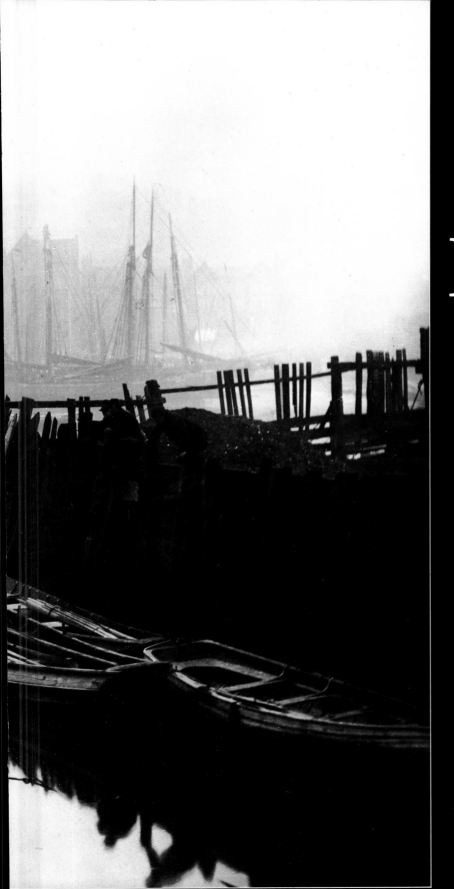

The Story of Photography

Discovery and development

The discovery of photography was not an overnight sensation, like penicillin on a Petri dish. Its evolution spans centuries and is the story of what happens when physics and chemistry are taken from the scientist and dropped into the lap of the artist.

Photography is essentially the combination of two separate factors: the ability to create an image of a subject which can be projected onto a screen; and the discovery of a suitable medium to record and fix that image.

Image projection came first. A narrow beam of bright light entering a dark room will project an image, albeit upside down and fuzzy, of the scene outside onto a piece of paper about 15cm from its entry point. This natural phenomenon was noted by Aristotle in the 4th century BC. Yet it was not until AD1490 that Leonardo da Vinci realised the potential of the *camera obscura* (Italian for dark room) as an aid to accurate draughting and perspective. Over the next century, it was refined and improved. Lenses were

incorporated to sharpen and invert the image. The room became a portable, though cumbersome, black tent. By the 17th century, neat, really portable and sophisticated box models were being produced all over Europe. Robert Boyle made one in England. Things could go no further. We had the camera, but not the film.

It was not until the beginning of the 19th century that the other half of the process began to evolve. In 1827 a wealthy French landowner, Joseph Nicéphore Niépce, whose scientific interests had led him to experiment in the field of lithography, showed the Royal Society in London 'the first picture copied from Nature', a view from the window of his house. About the same time an Englishman, William Henry Fox Talbot, was pursuing a similar line of experimentation. In fact he had already successfully produced a series of negative-positive images called *calotypes*, using sensitised paper inside a camera, when his hopes of being the first to

announce a new discovery were dashed. Louis Daguerre revealed his discovery of the copper plate process in 1829. Unlike Daguerre, however, Fox Talbot had produced a method by which any number of copies could be made from an original negative, the principle of modern photography. Daguerre's process produced a single metal plate with a reversed image.

Nevertheless, it was the daguerreotype which caught the public imagination, and the first photographic studios were opened offering perfect likenesses for all the family. This often involved having to sit still and hold a pose for many minutes, often with your head clamped in position. This goes some way to explain the stiff and glaze-eyed portraits of the period. Yet the days of the daguerreotype were numbered. Improvements in the calotype process resulted in its gradual demise.

In 1851, Frederick Scott Archer introduced the wet plate process, in which a

Right *A processing tent in which photographers who were working outside their studios had to both coat and process the glass plates before and after each exposure.*

Below *An early example,* circa 1870, *of a wet plate camera.*

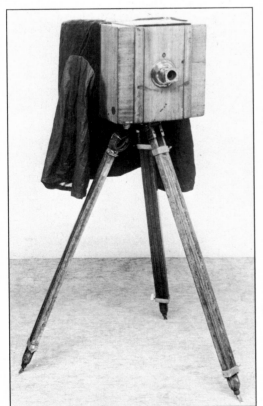

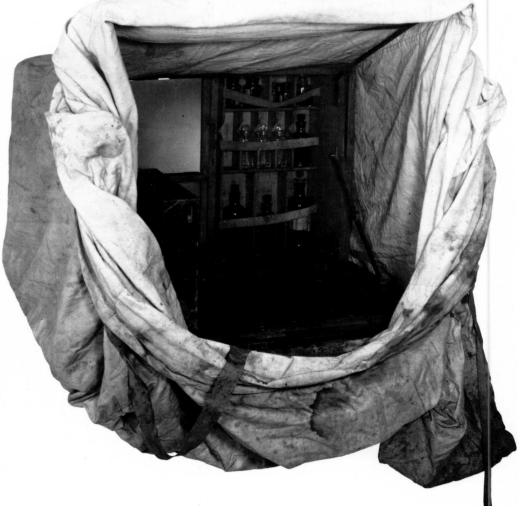

Above *A portrait of Queen Alexandra, which shows how it was necessary for the subject to be supported by clamps, to prevent movement, during the long exposure time required of the crude and insensitive film which was in use at this time.*

Above right *This illustration shows a typical Victorian portrait studio illuminated by daylight.*

Right *A photograph by Roger Fenton taking during the Crimean war. It demonstrates that in spite of the slow and cumbersome nature of photography at the time the skill was not confined to the studio.*

glass plate was coated with a layer of light-sensitive chemicals. This had to be exposed and processed whilst still wet, but it produced a negative of great image quality and was far more sensitive than previous methods.

The process of taking a picture was complicated by the fact that the plates had to be prepared for each exposure and developed immediately afterwards, so that photographers working outdoors had to set up a darkroom tent for each picture. This encumbrance was finally removed in the 1880s with the introduction of dry plates, which meant that ready-prepared plates and photographic papers could be bought in packets.

Photography was by now an accepted and familiar part of the Victorian scene, used not only for family portraits but also for documentary work and of course for art. Although the earlier exponents were mostly painters or scientists, interest in the medium soon resulted in the establishment of a new profession, that of photographer.

The magic box

The development and the improvement in sensitive materials was matched by a similar development in the camera itself. The very first instruments were indeed quite crude wooden boxes, but later refinements produced cameras beautifully crafted from the best teak and mahogany, with finely engineered brass fittings.

Although cameras were available to the general public from as early as 1839, and became increasingly more available as the process itself improved, it was not until the 1890s that photography really took off with the advent of the paper-backed roll-film and the simplified cameras that were designed to use it. Eastman's Kodak pocket camera was the first to be made by mass-production techniques and the initial daily output of 300 cameras soon had to be increased. Although these first roll-film cameras were quite inexpensive compared to the earlier plate cameras, George Eastman was anxious that photography should be available to all. In 1900, he introduced the now famous Box Brownie, which sold for one dollar in the USA and five shillings (25p) in England. It sold over 100,000 in the first year.

The development of the roll-film camera continued, with many improvements and refinements. Simple wooden structures were replaced by precision-engineered metal instruments with more accurate means of viewing and focusing the image, as well as more sophisticated shutters to control the exposure.

Once the improvement in the quality of the sensitive film had increased sufficiently, it became logical to consider even smaller formats. Since perforated 35mm film had already been manufactured for the motion picture industry, it was natural that the still camera makers should turn their attention to this. Although several manufacturers had already dabbled with the 35mm format, it was not until 1925 and the introduction of the Leica, made by Ernst Leitz in Germany, that 35mm photography started to become really popular. Along with improvements in the design and manufacture of the camera, the lenses it used had also undergone radical changes. The early plate cameras used lenses of quite simple construction, with very small maximum apertures in the order of f16. These were soon replaced with more

complex designs using different elements which overcame many of the inherent flaws, resulting in sharper, clearer images. One of the most significant improvements in the design of lenses has been the use of coated surfaces, to improve light transmission and contrast. This was developed in the 1940s, and has made possible the use of multiple element designs in modern lenses.

The two developments that have been most important in modern camera design are the application of electronic and microchip technology to the control of camera functions and the use of the reflex system of viewing and focusing. The latter has been around for a long time. As early as the 1860s a mirror was used to deflect the image onto a viewing screen in a camera designed by the English photographer Thomas Sutton. However, the first true single lens reflex as we know it was not available until the Ihagee Kine Exacta of 1935. Yet it was the introduction of the pentaprism, which enables the image to be seen at eye level and the correct way round, that really started the popularity of today's SLR. That didn't happen until the 1950s when the first popularly priced models appeared.

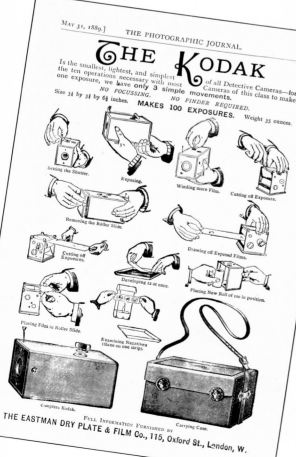

Left An illustration of an advertisement for the No. 1 Kodak box camera produced in 1889. This was a crucial landmark in the development of photography as it gave the general public access to the medium through a widely available, simple, camera.

Above The start of the 19th century heralded the beginning of newsworthy events recorded on portable cameras. This shot captures the arrest of Gavrilo Princip after the Sarajevo assassination of Austrian archduke Francis Ferdinand in 1914.

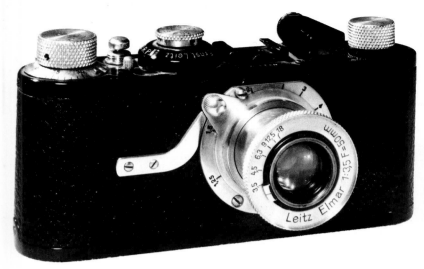

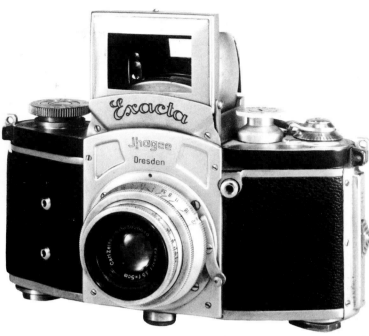

Above *The pictures show two of the most significant cameras in terms of modern photography. The Leica 1 introduced in 1925, and the Kine Exacta introduced in 1937 which can be considered to be the forerunner of sophisticated SLR cameras.*

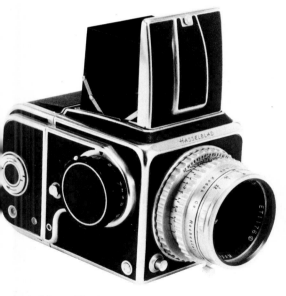

Above *First introduced in the 1950s the Hasselblad is still the most widely used professional 'work horse' camera offering as it does a wide range of specialist accessories.*

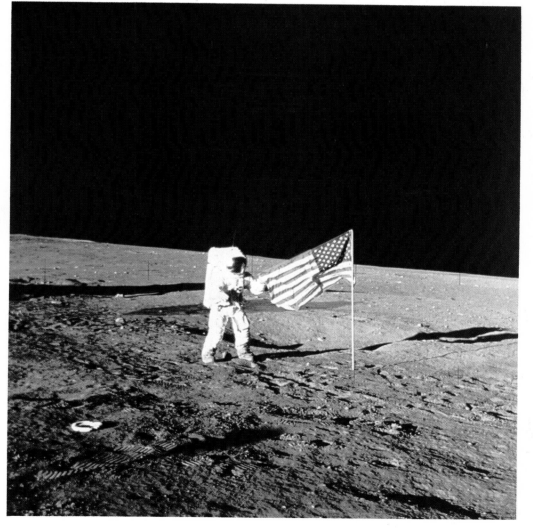

Right *The Hasselblad's place in the history of photography was firmly marked by its use to capture the famous Apollo moon-landing pictures.*

Julia Margaret Cameron

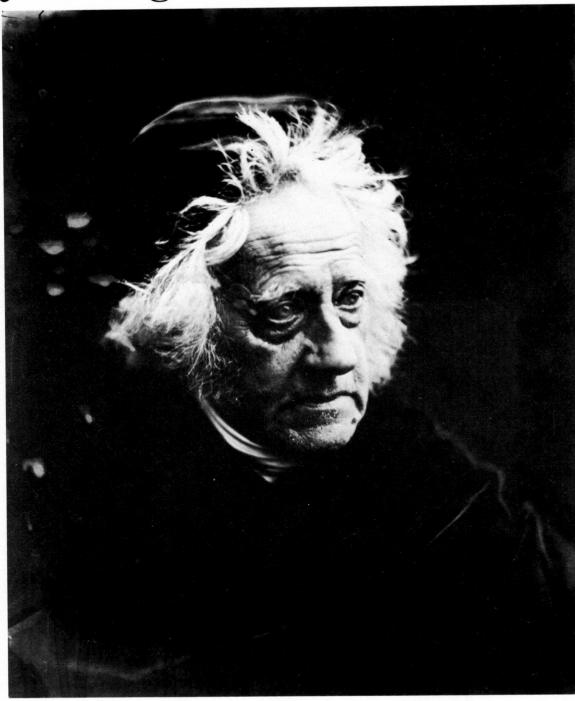

Julia Margaret Cameron was an Englishwoman who was born in Calcutta in 1815. Although educated in France and England she did not settle in her homeland until 1848. Her interest in photography did not emerge until she was 50, when her daughter gave her a large box camera as a present. It used the current materials of the time, the wet collodion process. In order to prepare and process the huge 15×10-inch plates, she converted the coal house of her cottage home into a darkroom and the nearby chicken house into a daylight studio. She did not even have the luxury of running water and had to fetch water from the well to wash her negatives.

In common with most of her contemporaries, Julia Cameron was a self-taught amateur who learned her craft by a combination of trial and error and determination. Unlike many of the professional portrait photographers of the time, her work possessed a free and almost simplistic quality. Her subjects ranged from the local people of her village on the Isle of Wight to the famous characters of the day, including Alfred, Lord Tennyson. She was a wealthy woman and was able to indulge her hobby, making many hundreds of large prints which she frequently gave to sitters and friends as well as submitting to many exhibitions. In 1875, she and her husband settled in Ceylon (Sri Lanka), where they lived in a house by the sea, and she continued her photography, mostly with the natives as subjects. Julia Cameron died in 1879 having made a memorable contribution to the new medium of photography.

Major collections of her work can be seen at the Royal Photographic Society and the Victoria and Albert Museum, London.

Frank Meadow Sutcliffe

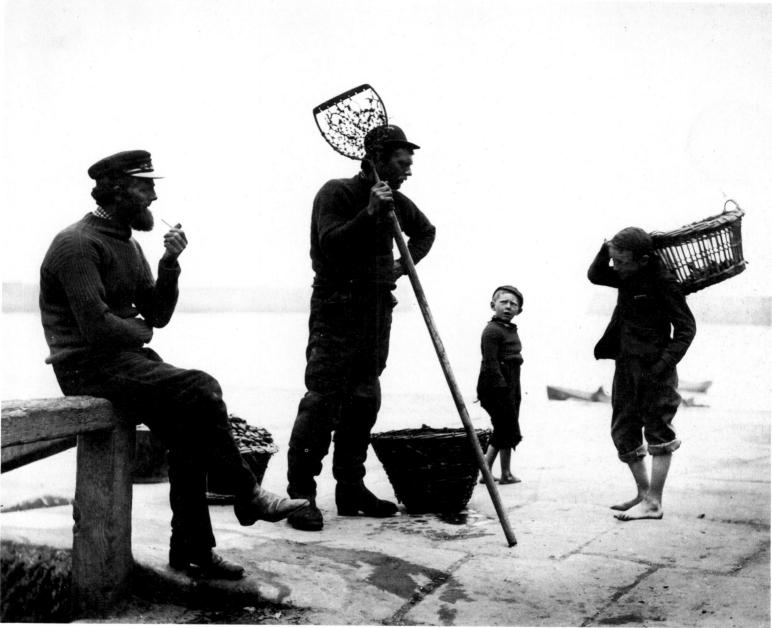

Frank Meadow Sutcliffe was born in Leeds, Yorkshire, in 1853. His father was a printer by trade but also a keen amateur photographer. In 1871, the family moved to Whitby and it was here that Frank took up photography. Unable to find a suitable studio in Whitby, he moved to Tunbridge Wells, Kent, with his wife, but found that he was unable to make a satisfactory living in the more competitive environment of the south and returned to Whitby in 1875.

Although portrait photography was his living and he was highly acclaimed in this field, winning numerous medals at international exhibitions, it was for his landscape and documentary work that he became best known. His early photographs of Whitby and its people taken without contrivance must have required tremendous skill and patience with the wet plates which were necessary at that time, and the resulting images have a fine luminous quality. One of his best-known pictures, a group of naked children playing in a boat, is a fine example of his natural, almost reportage approach. However, it landed him in considerable trouble, being cited by the Church as an example of depravity. They excommunicated him.

Fortunately he recovered from establishment disapproval and was eventually sponsored by Kodak to do experimental work with new cameras and materials. At the age of 70, he became the curator of the Whitby Gallery and Museum, a post he held until his death in 1941 at the age of 87.

Collections of his work are held at the Royal Photographic Society and the Whitby Literary and Philosophical Society.

Edward Weston

Edward Weston was born in Illinois, USA, in 1886 but made his home in California after a holiday there in 1906. His interest in photography began when his father gave him a camera and gradually blossomed into an absorbing passion. Weston taught himself the craft of photography in his spare time while working as a salesman and earned extra money by knocking on people's doors and offering to take portraits. His success in this venture was encouraging enough for him to open a portrait studio in Glendale in 1911.

His early work was heavily retouched and soft focus owing much to the romantic, painterly style prevalent at that time. However, after seeing exhibitions of more modern work and meeting photographers such as Alfred Stieglitz, he changed his approach to that for which he is now famous — pictures taken on a 10×8 camera which exhibit a masterly control over image quality. Weston was a true photographic perfectionist who was able to create memorable images from everyday objects and situations by exploiting the subtleties of tone and detail within a subject.

After a period in Mexico, he opened a studio in Carmel in 1928 from where he continued his notable career with many exhibitions and publications until he was tragically afflicted with Parkinson's Disease in 1948. With the help of one of his sons, Brett Weston, he published his 50th anniversary portfolio in 1955 and sets of prints from his best negatives in 1956. He died in 1958.

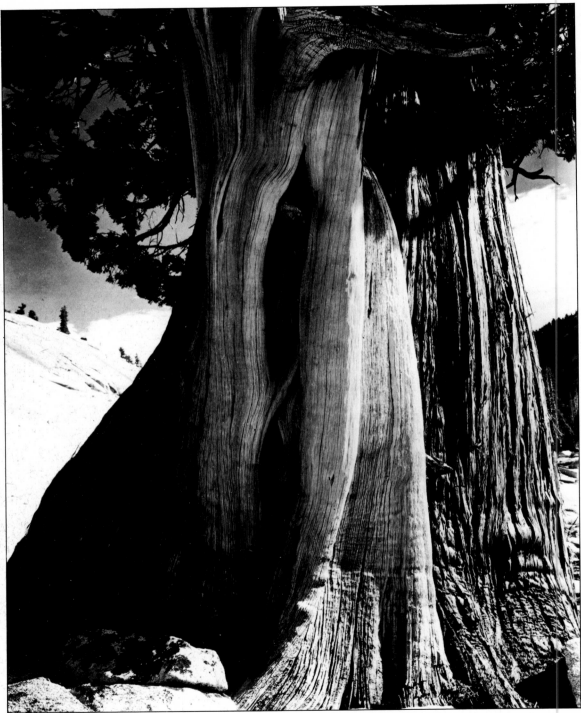

André Kertész

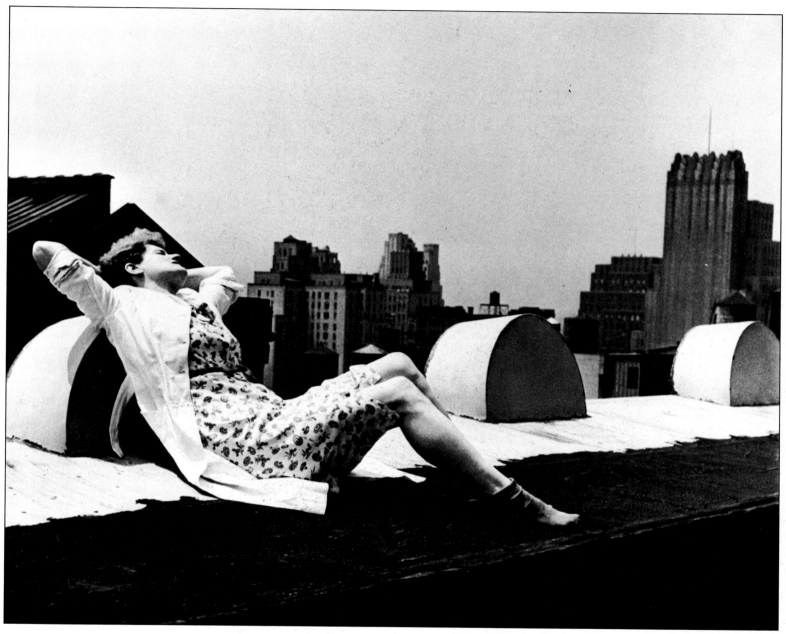

André Kertész was born in Budapest, Hungary, in 1894 at a time when photography was undergoing radical changes and becoming available and accessible to more people. Indeed he was known as the father of modern photography and Henri Cartier Bresson said of him 'we all owe something to Kertész'. He took his first photograph when he was 18 with a cheap box camera, but later progressed to a better camera, taking 9×12cm glass plates. He photographed the world and the people around him, even taking his camera with him to the front line when he was called up in 1915.

After the war he continued in his work as a clerk, but in 1925 he moved to Paris and became a freelance photographer, making his prints on a home-made enlarger. In addition to the street life of Paris, he also photographed many famous artists, including Chagall and Mondrian. He was one of the first people to buy a Leica when it became available in Paris and it was indeed a camera to match his approach to the medium. He began to work for the big illustrated news magazines which emerged in the major cities at that time. In 1936 he went to New York and, although unhappy there, the war and lack of money prevented him from returning to Europe. In 1949 he signed a contract to work for the glossy magazines of Condé Nast, an arrangement that turned out to be unsatisfactory. Eventually he returned to the self-employed status.

Although he works primarily in black and white, he no longer makes his own prints and has been experimenting with Polaroid SX70. One piece of advice that he gives young people looking for a means of self-expression is that photography is the easiest and the best medium to use.

J-H. Lartigue

Jacques-Henri Lartigue was born near Paris in 1896. When he was seven years old, he was given a camera which stimulated an interest in photography. However, he was destined for a formal art training and by the end of World War I was working as a full-time artist. Painting, in fact, is his profession. The pictures that he took as a child and a young man were very much personal records of family, friends and events — indeed snapshots

might seem a fair description. However, his painter's eye gave them a quality and insight that made them quite unique. Although much of their present appeal lies in their nostalgic and historic value, it is Lartigue's perception that has made them much more than mere snapshots.

Lartigue is obviously fascinated by movement and the camera's ability to freeze and record passing moments and his approach to photography is quite

different to that required by painting. He made little or no attempt to control or compose his pictures in an 'arty' way. While the preoccupation of many contemporary photographers was to make their photographs appear as much like paintings as possible, Lartigue's pleasure lay in the uniquely spontaneous qualities of the camera. In addition to the more commonplace black and white images of that period, he also

experimented with colour photography and produced some equally evocative images using the auto chrome process.

Ansel Adams

Ansel Adams was born in San Francisco, USA, in 1902. Although he showed an early interest in the subject, it was not until 1930 that he took up photography as a full-time occupation. In 1932, he opened the Ansel Adams Gallery in San Francisco, specialising in photography and other arts, and was instrumental in founding the Department of Photography at the Museum of Modern Art in New York.

Almost from the start of his career he has been an active lecturer and teacher in the field of creative photography and has done much to gain its acceptance as a medium of fine art. This particular aspect of photography is reflected in his personal approach, which, while in no way contrived or 'arty', does exhibit a tremendous sensitivity to the pure visual quality of the photographic image and to the sensual nature of the relationship between light and landscape.

Adams demands the highest technical quality from his pictures and to this end works mostly with large-format cameras, although much of his work has been done in the more remote and inaccessible places like the Sierra Nevada and Death Valley. To enable him to have a fine degree of control over the tonal quality of his black and white prints, he devised a system of exposure calculation known as the zone system, in which a subject could be analysed in terms of a series of densities that could be directly related to tones in the finished negative and print. His approach to photography displays a great love of the outdoors and of the wonder and spectacle of natural things.

Collections of his work are to be found in many of the major American museums as well as the Royal Photographic Society in London and the Bibliothèque Nationale in Paris.

Bill Brandt

Bill Brandt was born in London, England, in 1904, but much of his early life was spent in Germany. In 1929 he went to Paris, where he worked as an assistant to Man Ray. He returned to London in 1931, where he began to work for magazines such as *Picture Post* and *Lilliput,* specialising in documentary work. He had an interest in architecture and much of his early work was in this field. Later he turned to landscape, where his ability to create atmosphere was more readily realised. However, it is not the choice of subject which dictates his style and approach, since it has been quite diverse, ranging from photojournalism to nude and abstract pictures, it is primarily the distinctive quality which he creates both in terms of the photographic image and his way of seeing.

Unlike many successful photographers who work primarily in black and white, Bill Brandt is a great believer in doing his own darkroom work. He feels that it is essential for a photographer to make his own enlargements as only he knows the effect he wants. Indeed, his prints have a very personal quality, using strong contrasts and bold masses of tone to emphasise the structure and form of his pictures.

He uses a roll-film camera for most of his work, for many years a Rolleiflex but more recently a Hasselblad. However, his well-known series of nudes with exaggerated perspective were shot on an old mahogany and brass camera fitted with a very wide angle lens. Surprisingly for a photographer who started in the documentary field, he has no inhibitions about using contrived means of achieving results, both in his approach to the subject and in his control over the quality of the image.

Henri Cartier Bresson

Henri Cartier Bresson was born in Chanteloup, France, in 1908. He has been one of the most dominant figures in photography, not only because of the unique quality of his work but also because of his tremendous influence on the medium. He studied painting and then took up photography seriously in 1931.

Cartier Bresson's approach is that of a purist. He uses the most basic equipment and never resorts to the contrivance of unusual viewpoints or exaggerated perspectives. He insists that his pictures are not cropped and is at pains to preserve his anonymity. Yet in spite of, or may be because of, this his pictures are immediately identifiable as Cartier Bressons. Most of his pictures are taken on the 50mm lens of his Leica. The impact and visual quality of his photographs rest on his unerring ability to be able to select the precise moment at which the individual elements of an image fleetingly combine to create the most telling effect. Indeed, at times it almost appears that he is able to will things to happen 'fortuitously'.

Henri Cartier Bresson is the undoubted guru of those photographers who believe that the most valuable quality of the medium is its ability to isolate and encapsulate a brief moment of time. The phrase that he coined to explain his own approach, 'the decisive moment', has become a watchword for many thousands of photographers. There are essentially two types of photographer, one who previsualises a photograph and strives to create it, and one who prefers to discover pictures by chance. Henri Cartier Bresson is the master of the latter.

Arnold Newman

Arnold Newman was born in New York City, USA, in 1918. After studying art at the University of Miami he started his photographic career in 1938 in a commercial portrait studio and his reputation and contribution to photography so far has been in that field. His approach to portraiture is far from that of the commercial portrait, where the main aim is to produce a flattering, even idealised impression of the subject. Indeed, Arnold Newman's portraits often have what might well be an uncomfortable, hard-edged and revealing quality as far as the sitter is concerned. His famous portrait of arms manufacturer Alfred Krupp taken in 1963 was lit with a direction and quality of light which created a distinctly evil, even depraved image, making an unashamed personal statement about his subject, who was not at all pleased by it.

If there is one tangible quality which exists in many of Arnold Newman's portraits, beyond that of his own style, it is his ability to use a setting to complement and enhance the personality of his subject. Newman himself disclaims the idea of being an innovator in what is called environmental portraiture; he simply says that he found the studio a sterile place in which to work. Much of his work is done on large-format view cameras. He does, however, use 35mm SLR cameras, where the additional freedom is an advantage. He also prefers the quality of natural light, but where necessary will supplement it with additional lighting and reflectors in a way that retains a natural appearance. He prefers to describe his work as 'pictures of people' rather than portraits, and believes that as such they must first of all be good photographs.

Eugene Smith

W. Eugene Smith was born in Wichita, Kansas, in 1918 and became a news photographer at the age of 15. He won a photographic scholarship to Notre Dame University and left in 1937 to become a photographer for *Newsweek* magazine. During World War II he was a correspondent photographer and covered numerous invasions and air combat missions. He was badly wounded and spent two years recuperating. He rejoined *Life* magazine in 1947, but after a series of differences over the way his pictures were used, he resigned in 1955 to join the international photographic agency Magnum.

Eugene Smith personified the concerned photographer, one for whom the medium was more a means of expressing his own fears and misgivings about the world than of simply creating effective images. He was invariably extremely involved with his subject and often spent periods of a year or more working on a particular story. His final assignment, typical of his anguish and concern over man's inhumanity to man, was a series of pictures on the effects of industrial waste on the people of a small fishing community in Japan. His involvement led to him being badly beaten up by men from the chemical company, and after returning to America, he gave up photojournalism and devoted the rest of his life to lecturing and exhibiting.

Not only was he one of the great masters of the picture story, but his pictures individually combine the harsh imagery of the documentary approach with the rich, brooding quality that characterises his finely made prints.

Ernst Haas

Ernst Haas was born in Vienna in 1921. He studied medicine initially, but after World War II his interest in the arts led him to take up photography. His first one-man show was held in Vienna in 1947. Unlike many other great photographers who rely upon the black and white medium for their more personal and expressive work, Haas is very much a colour photographer and has imposed his own individual way of seeing upon the colour process. His interest is very much based on the wonder and beauty of natural things, but he has no inhibitions about using photographic techniques to manipulate the image. The picture on this page is in fact a double exposure, and he frequently makes use of slow shutter speeds and blur to create visual effects. His choice of camera is the 35mm and his transparencies are of impeccable technical quality. Haas's work is used widely in glossy magazines and he has produced picture stories for publications such as *Life, Holiday, Paris Match* and *Look.* He has also applied his skills to advertising assignments and film publicity.

Many of Haas's most compelling images were used in a collection of photographs entitled *The Creation*, published in 1971, in which the acute observation of often quite ordinary natural formations and objects transforms them into mystical images of vivid visual impact.

Stephen Dalton

Stephen Dalton was born in Surrey, England, in 1937. After a period working in a company manufacturing agricultural machinery, he took a full-time photography course at London's Regent Street Polytechnic. After leaving, his interest in natural history encouraged him to build up a library of wildlife subjects.

His particular interest was insect life, but he was not satisfied with the static pictures that the limitations of existing equipment dictated. With the help of a friend who was an electronics expert, he developed a system of lighting a flying insect that could be triggered to freeze its movement at a precise point in flight, making it possible for details of the flight actions of such creatures to be seen for the first time, and recorded with remarkable clarity. This alone was not enough. He also wanted to create the natural environment of the insect and not simply make a sterile record of the subject. This has resulted in his pictures having an aesthetic quality of far greater interest than scientific information alone.

Modern life encourages specialisation and photography is no exception. Very often, however, the specialist approach can lead to work of limited appeal, but the successful blend of the naturalist's curiosity and thirst for knowledge and the perceptive and sensitive eye of a photographer has raised Stephen Dalton's work to a level of universal appeal. These remarkable pictures can be seen in his books *Borne on the Wind* and *The Miracle of Flight*.

Donald McCullin

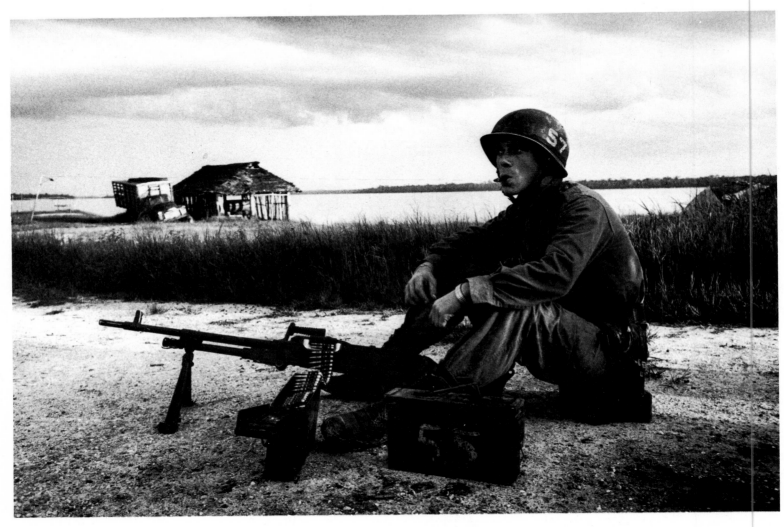

Donald McCullin was born in London in 1935 and after a secondary school education won a scholarship to Hammersmith School of Arts. During his National Service he became an assistant in the aerial reconnaissance department of the Royal Air Force and after leaving the service pursued his interest in photography and began to work as a photojournalist for national newspapers and magazines. Unlike many photojournalists, however, his career began to become specialised and he joined the small and very unique band of photographers who have taken it upon themselves to record the ravages and horror of human conflict.

In many areas of photojournalism the photographer is simply a witness on the sidelines, not involved with what is taking place in front of his camera, but not so with a war photographer, since he must inevitably be a part of the action taking the same risks and needing the same courage as the soldiers he photographs. Another famous war photographer Robert Capa once said 'if you're pictures arn't good enough you arn't close enough'. Don McCullin has always been close enough. Quite apart from the dramatic nature of his subject his pictures have all the visual qualities that define a fine photograph and indeed, he has, and still does, photograph subjects other than war, creating equally memorable images.

Inspite of the urgency of his chosen subject he is a fine craftsman, concerned with the subtleties of image quality, preferring the black and white medium to that of the colour photography. This, in many ways, suits his particular style and approach since his pictures, including peaceful subjects, invariably have a grey, grim and disturbing quality, there is little joy to be seen in his work and it is interesting to wonder whether this is the result of his preoccupation with war, or whether he chose his subject because of his own approach to photography. His books include *The Destruction of Business, 1971, The Homecoming, 1979* and *Hearts of Darkness, 1980.*

David Bailey

David Bailey was born in London, England, in 1938 and is a self-taught photographer. Apart from his highly personal approach to photography he is also notable as a representative of a significant change in the attitude to the glossier aspects of the art which took place in the 1960s. The fashion and advertising side of the business had been dominated by rather more aloof personalities than the slightly irreverent natures of David Bailey and some of his contemporaries. His approach to fashion photography was much less remote than much of the earlier work in the fashion magazines. His models were photographed more as girls and less as clothes horses.

Although his association with *Vogue* magazine categorised him as a fashion photographer, his interest extends far beyond that, and his more personally orientated work includes landscape, reportage and nudes. His approach to photography was strongly influenced by the cinema and this interest has continued to the point where he now directs television commercials and documentaries.

Contrary to the dependence on automation that some contemporary photographers in the trendier area of the medium have, David Bailey displays and respects technical skill and control and is as much at home with a large-format camera as with a 35mm. He is constantly experimenting with new equipment, materials and techniques.

Books of his photographs include *Trouble and Strife,* 1980, *Papua New Guinea,* 1975, and *Goodbye Baby and Amen,* 1969.

The Basic Principles

Camera types

If you were to compare one of the early plate cameras with one of the modern electronic SLRs it would be understandable to conclude that they had little in common. However, the essential functions have changed little and indeed today's standard professional studio camera, the view camera, has a great deal in common with the early machines in looks as well as function.

The **view camera** is really just a box with a film holder at one end with a removable screen for viewing, and a lens at the other end. These are connected by bellows with a rack-and-pinion focusing movement to alter the distance between the lens and film. The lens of a view camera is usually fitted with a between-the-lens leaf shutter to control the length of exposure and an adjustable aperture called an *iris diaphragm* to control the brightness of the image on the film. The main advantage of such a camera is that it is designed to take single sheets of film, up to 25×20cm. This allows individual treatment for each exposure as well as the avoidance of too much enlargement and subsequent loss of definition. In addition, the positions of the lens and film panels can be altered in relation to each other to give a considerable degree of control over both the perspective and the depth of field.

The disadvantage of the view camera is that the image is seen inverted and reversed. It is slow in operation since, after framing and focusing, the viewing screen must be replaced by the film slide and the shutter closed and the aperture set manually before the film protective sheath can be removed and an exposure made. This means that the camera must always be mounted on a tripod and can therefore only be used for relatively static subjects.

The **viewfinder camera** is designed to provide a supplementary means of viewing the image through a separate optical system. Most cameras of this type are made to use the smaller film formats from roll-film and instant picture film to the disc film and are much easier and faster to use than the view camera, as the film is always ready to be exposed. Instead of the bellows and focusing rail of the studio camera, the viewfinder camera usually has a lens mounted in a helical thread which is rotated to extend the lens further from the film to focus on closer subjects. With a very simple camera such as a cartridge-loading type, the lens is set at a fixed-focus position and in other types it is focused by simply estimating the distance and setting it on the lens mount. The more advanced cameras of this type can be focused with great accuracy, either by means of a coupled rangefinder or by an automatic focusing mechanism.

The main disadvantage of this type of camera is that the viewfinder does not give a totally accurate impression of the field of view seen by the taking lens. Additionally it shows the whole image as sharp, regardless of how it is focused.

The **twin lens reflex** is a camera that for many years was the standard roll-film tool of the professional photographer. Although it uses a separate lens for viewing, the image is projected onto a viewing screen so that the effect of focusing can be seen quite accurately. There are few cameras of this type available now, since the single lens reflex system offers greater advantages.

The most significant development in camera design during the last three decades has been the adoption of the **single lens reflex** (SLR) system for focusing and viewing. Its popularity is based on the fact that although it is as quick and convenient to use as a viewfinder camera, it offers a degree of accuracy on a par with the view camera, and the nature of its design enables it to be adapted for a wide variety of use.

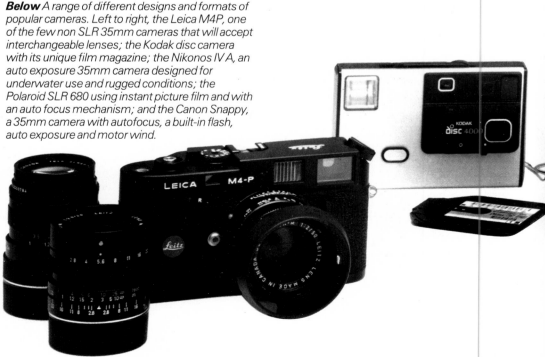

Right This is the modern equivalent of the early mahogany and brass field cameras. It is used in professional studios for subjects such as still-life, as it combines the advantage of a large format, for maximum image quality, with a wide degree of control over depth of field and perspective through movements built into the lens and film supports.

Below A range of different designs and formats of popular cameras. Left to right, the Leica M4P, one of the few non SLR 35mm cameras that will accept interchangeable lenses; the Kodak disc camera with its unique film magazine; the Nikonos IV A, an auto exposure 35mm camera designed for underwater use and rugged conditions; the Polaroid SLR 680 using instant picture film and with an auto focus mechanism; and the Canon Snappy, a 35mm camera with autofocus, a built-in flash, auto exposure and motor wind.

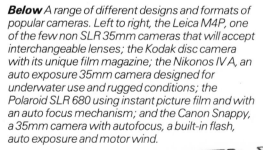

Below *This type of camera is essentially the same as a view camera but with more limited lens and film plane movements. It has a separate viewfinder, and rangefinder added so that it can be used without a tripod.*

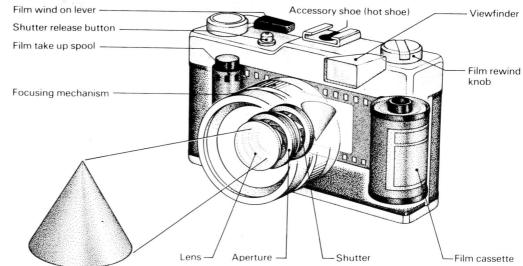

Film wind on lever

Shutter release button

Film take up spool

Focusing mechanism

Accessory shoe (hot shoe)

Viewfinder

Film rewind knob

Lens — Aperture — Shutter — Film cassette

Above *This illustration shows how a 35mm viewfinder camera still shares the same essential functions as the view camera but is designed to be more convenient in use in spite of its radically different appearance.*

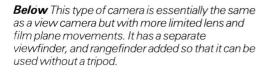

The SLR system

The design of the SLR is centred on the use of a mirror inside the camera body to deflect the image projected by the camera lens towards the film onto a viewing screen. This means that you see the image exactly as it will appear on the film, as you would in a view camera. However, the use of the mirror combined with a pentaprism (with which all but the roll-film SLRs are fitted) enables you to see the image the right way up and the right way round. You also see the image at eye level as opposed to looking down onto the screen. This mirror, together with the iris mechanism and the shutter, are automatically coupled to the shutter release button. When you press the button, the mirror flips up out of the way, the iris closes down to its preset aperture and the shutter opens and closes. With most SLRs, the iris then reopens and the mirror returns automatically, so that at normal shutter speeds all you experience is a slight blink when viewing the subject. Unlike the majority of viewfinder cameras most SLRs are fitted with a focal plane shutter inside the camera body, which means that individual lenses do not need to have their own shutters. This makes the use of interchangeable lenses both relatively simple and inexpensive.

The advantages of the SLR system are even more far-reaching, since it is possible to incorporate many more features within the optical system. Light readings, for instance, can be taken from the image itself and coupled to the iris and/or the shutter to offer automatic exposure, which will take into account any attachments or filters fitted to the lens. Because of the basic principle of the optical system, any lens or attachment fitted to the camera such as extreme wide angle, telephoto or close-up devices will still create an accurate image in the viewfinder. In this way, the SLR camera body is the basis for a complete system. Additional accessories can be fitted to cope with a wide range of different subjects and different conditions. It is possible, for instance, to buy cameras with interchangeable film magazines as well as lenses so that different types of film can be used and changed in mid-roll. This facility is more widely available in the roll-film formats, but the Rolleiflex SL2000F also offers it with 35mm film. This enables many professional-type SLRs to be fitted with an instant picture film back so that set-ups can be checked before the shots are made on normal film.

The advent of the SLR has meant that the keen amateur photographer can start with a camera body and, say, a standard lens and then gradually add to the basic unit as their interests and experience extend to handle a wider range of subjects.

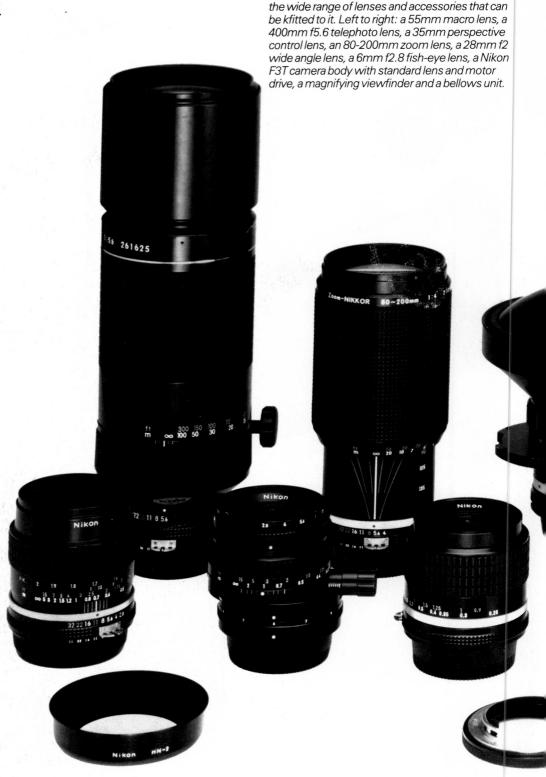

Below A typical 35mm SLR system with some of the wide range of lenses and accessories that can be kfitted to it. Left to right: a 55mm macro lens, a 400mm f5.6 telephoto lens, a 35mm perspective control lens, an 80-200mm zoom lens, a 28mm f2 wide angle lens, a 6mm f2.8 fish-eye lens, a Nikon F3T camera body with standard lens and motor drive, a magnifying viewfinder and a bellows unit.

Right An SLR camera designed for use with roll film. This is a Mamiya RZ 67, which gives ten exposures on a roll of 120 film with an image size of approximately 6 × 7cm. As well as accepting a wide range of lenses and accessories, this camera, unlike the Nikon, also allows the use of different film magazines.

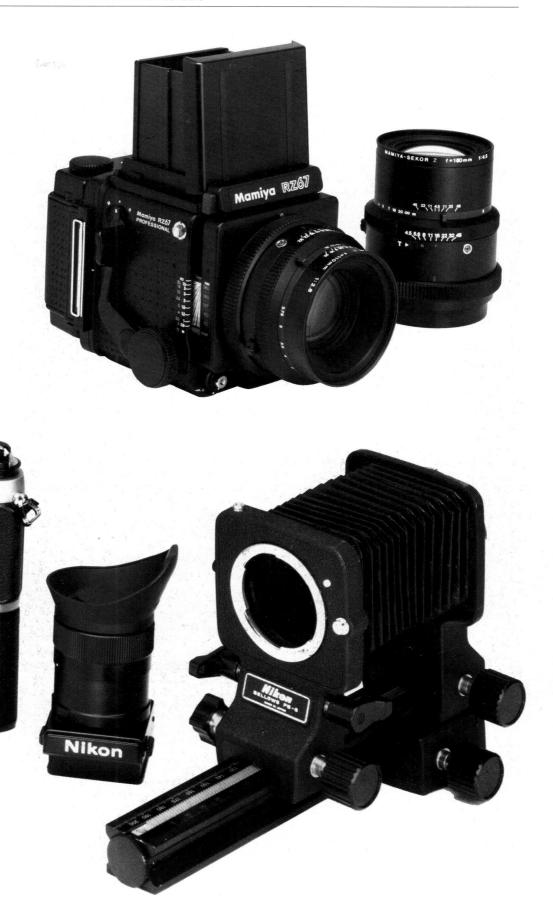

All about lenses

Most cameras with interchangeable lenses are supplied fitted with a **standard lens.** It is one that has a focal length approximately the same as the diagonal measurement of the film format it is to be used with. In the case of a 35mm camera, this is between 45mm and 55mm. With, say, a 2¼ inch sq. camera, it would be 75mm or 80mm. This type of lens gives a field of view of about 40° to 50° and the impression is similar to that of normal sight. However, it can be a considerable advantage to be able to vary the focal length of the lens and the corresponding field of view. Not only does it alter the amount of a scene to be included in the picture area, it can also help you to make use of different viewpoints and alter the perspective and composition.

A **wide angle lens** is one that has a focal length substantially less than that of the standard lens. With a 35mm camera this would be 35mm or less. An extreme wide angle lens is one with a focal length of 20mm or less. A wide angle lens reduces the size of the image within the frame so that more of a scene can be included without the photographer moving further back. It also enables you to approach the subject more closely and still include the same amount of the scene. In doing so the perspective of the image will be altered so that foreground details will appear larger in proportion to more distant objects.

A **long focus** or **telephoto lens** has a substantially longer focal length than that of the standard lens. With a 35mm camera this would be more than about 85mm. This lens enables you to include less of a scene without having to move closer to the subject, or to move further away and still include as much as with the standard lens. Here, too, as with the wide angle lens, the perspective of the image will be altered, but in the opposite direction. Foreground details will appear smaller in relation to background objects that appear from the closer viewpoint.

With both types of lenses these effects are naturally greater according to the difference between their focal lengths and that of the standard lens. A 400mm telephoto will, have a quite dramatic effect on the magnification and the perspective of the image.

Another significant difference between lenses of different focal lengths is that of depth of field. This is the area each side of the point of focus which appears acceptably sharp. With the shorter focal length wide angle lenses this will increase considerably and with the long focal length or telephoto lenses it will decrease.

In addition to variations in focal length, there are also lenses of different optical design which offer certain advantages. A **catadioptric lens** is very small and light in

Above These four photographs show what happens when the same scene is shot from the same viewpoint but with different focal length lenses. The picture top left was taken with a 20mm lens; top right with a standard 50mm lens; bottom left with a 200mm lens; and bottom right with a 400mm lens.

relation to its focal length. (It's all done with mirrors.) This type of lens has a fixed aperture, usually smaller than that of a telephoto lens of similar focal length. The **macro lens** has a greatly extended focusing range, from infinity down to only a few centimetres instead of a metre or so. It is designed to give its optimum performance at the closer focusing range. The **zoom lens** is designed so that its focal length can be varied continuously between fixed limits. This means that a single zoom can replace several fixed focal length lenses in an outfit as well as enabling the image to be framed precisely without having to move the camera. The disadvantage is that zooms tend to be larger, heavier and more expensive than conventional lenses and often have smaller maximum apertures.

The **perspective control** or **shift lens** is a wide angle lens in which the optical axis of the lens can be displaced. Its prime use is in architectural photography as it enables the top of a building to be included in the frame by raising the optical axis rather than by tilting the camera, which would produce converging verticals. To a limited degree, it offers the advantages of a view camera to the smaller format user.

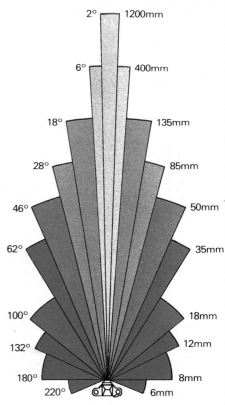

Focal length and angle view for a 35mm camera.

Above A diagram showing the relative angles of view of lenses of different focal length, ranging from the 6mm fish-eye with an angle of view of more than 180° to the long focus 1200mm lens.

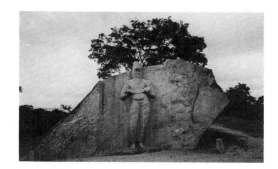

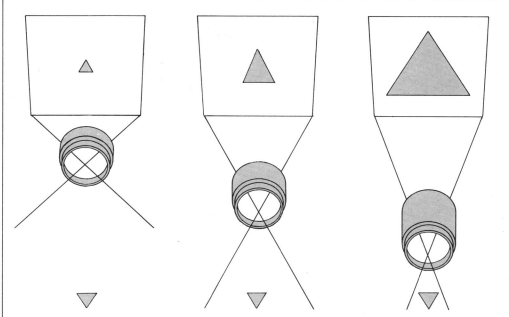

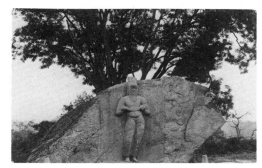

Above These two pictures show how the focal length of a lens can be used to control perspective when used in conjunction with choice of viewpoint. The top picture was taken with a 20mm lens. The bottom picture, which shows a complete change in the relationship between the foreground statue and the background tree, was produced by using a 150mm lens and moving the viewpoint further away so that the statue remained the same size in the frame.

Below Some of the lenses which can be fitted to a 35mm SLR camera. Left to right: a perspective control or shift lens; an autofocus zoom lens; a medium wide angle lens; a 500mm mirror or catadioptric lens; a macro lens; a 35-70mm zoom lens; a 75-250mm zoom lens; a 6mm fish-eye lens; and a 50mm standard lens.

Above Three diagrams explaining the relationship between the focal length of a lens and the size of the image recorder on the film.

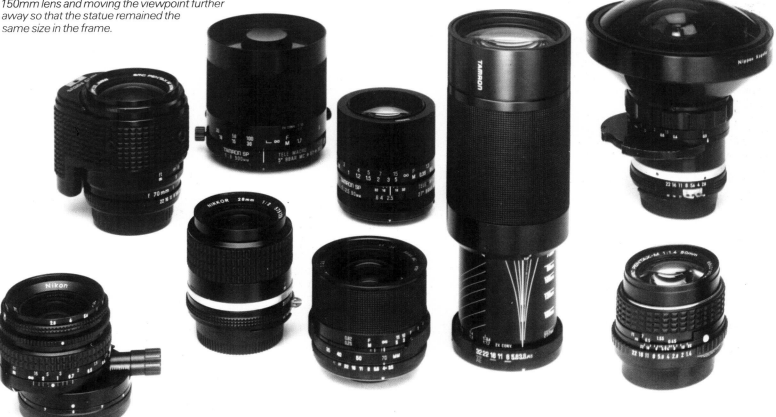

Understanding film

The basic principle of film is quite simple. It goes dark when it is affected by light, and the more light it receives, the darker it goes. This effect produces a negative image of a scene in which the lightest tones are recorded as dark tones and vice versa. At the moment this actually happens, no visible change takes place. It is not until the film is processed that this latent image is revealed.

With a black and white film it is quite easy to see and understand the principle whereby the resulting negative is then exposed in a similar way to another piece of sensitive material, this time on a paper or opaque plastic base instead of a transparent film. The resulting print is then reversed back to its original tones.

Colour film is rather more complicated in construction, although the principle is the same. In this case there are three different layers of light-sensitive emulsion on the film base, each one made to respond only to one primary colour, red, green or blue. The image recorded not only represents a reversal of the tones of a subject but also the colours. When this is also re-exposed to a similar emulsion both the colours and tones are reversed to their original appearance. You cannot see these primary colours clearly when you look at a colour negative because a special masking layer, usually orange, is incorporated into the film to correct inherent faults in the dyes used. In the case of colour transparency film and instant picture film, the reversal of the image takes place during the processing, and only the positive image is left.

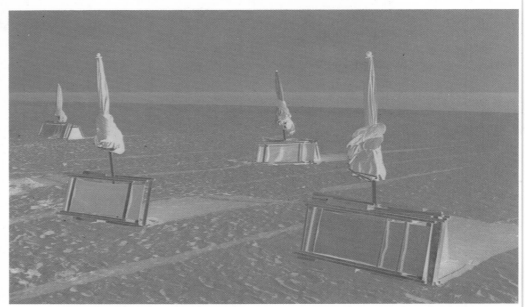

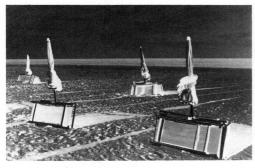

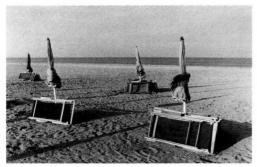

Above and left These four photographs show the different forms a photographic image can take. At the top is a colour negative with both tones and colours reversed, and the overall orange colour cast created by the masking layer. Below is the colour positive image which is produced by making a print from the above negative, or by direct exposure onto transparency or reversal materials. The two pictures to the left show the same relationship between the negative and positive image but in this case recorded on black and white film.

The way in which a film responds to the light falling upon it is governed by its sensitivity or *film speed*. This is established during the manufacturing process and is expressed as a number on the film packet. There are methods of denoting the speed of a particular emulsion: the DIN system in which the sensitivity is doubled as the film speed number increases by three digits, so that 21DIN is twice the speed of 18DIN; and the ASA system, which indicates a doubling of the film speed by a doubling of the film speed number, so that 100ASA is twice the speed of 50ASA. The ISO number, now widely used, simply expresses both numbers, so that ISO

COLOUR TEMPERATURE CHART

°K	Light sources
19000	Light blue sky, shade (19000)
18000	
17000	
16000	Average blue sky, shade (16000)
15000	
14000	
13000	Blue sky, thin white clouds (13000)
12000	
11000	
10000	
9000	Hazy sky, light shade (9000)
8000	Cloudy sky, light shade (8000)
7000	Overcast sky (7000)
	Daylight tube (6500)
6000	Electronic flash (6000)
	Noon sunlight (5800)
	Blue flashbulb (5500)
5000	
	Sunlight 2 h after sunrise (4400)
4000	Moonlight (4000)
	Clear flashbulb (3800)
	Photoflood (3400)
	Tungsten flood (3200)
3000	
	100W lamp (2800)
	Sunrise (2500)
2000	
	Candlelight (1400)
1000	

Above This picture shows the effect of shooting colour transparency film in lighting conditions different from those for which the film is balanced. In this case daylight-type film was used for a scene illuminated with tungsten light, which produced an orange cast. If artificial light film is used by daylight the resulting film would have a blue cast.

Above A colour temperature chart in degrees Kelvin. It ranges from clear blue sky to a single candlelight.

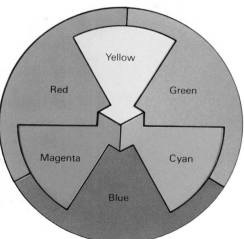

Right A colour wheel which demonstrates how the primary colours mix to give the resultant white, or secondary hues.

100/21 is the same as 21DIN or 100ASA.

The speed of a film affects the quality of the image because the size of the grain – the clusters of silver halides which comprise the emulsion – increases with the speed of the film and will become more apparent when the image is enlarged. Because of this a slow, fine-grained film can be enlarged to a far greater degree without apparent loss of quality or sharpness than a fast film with a coarser grain structure. This applies to both colour and black and white films, although in the latter case the particular developer in which the film is processed can also affect graininess.

With colour transparency films there is another important consideration: the colour quality of the light source used to illuminate the subject. There is a considerable difference between the colour temperature of daylight and that of tungsten lighting and if pictures are taken without the appropriate film there will be a pronounced colour cast. Daylight film used in artificial light will have an orange cast and tungsten light film used in daylight will have a blue cast.

Below These two prints illustrate the difference in grain structure between a fast film and a slow film when enlarged 15 times. The picture on the right was shot on ISO 400/27 film, and that on the left on ISO 25/15 film.

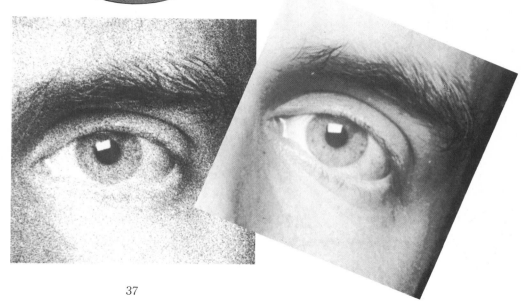

Using film

There is an extremely wide variety of film types and speeds available from a large number of manufacturers, each having their own particular uses and characteristics. In order to get the best from your pictures, you must learn which film to use for a particular circumstance. The speed of the film is a consideration that is applicable to most types and the same decisions will apply whether you are shooting black and white, colour transparency or colour negative. A slow, fine-grained film will produce an image of higher quality which can be enlarged to a higher degree than a faster film. (The only exception to this is the chromogenic black and white films such as Ilford XP1, which when rated at ISO 400/27 or faster, can still give comparable grain to conventional films a quarter of the speed.)

For general photography in good lighting conditions a medium-speed film is a good compromise between sensitivity and high-image quality. With a colour film this would be between ISO 100/21 and ISO 50/18. With black and white emulsions, medium speed film is considered to be a little faster, at about ISO 160/23. Both the speed and grain of black and white films can, however, be modified by processing techniques. The slow films of, say, ISO 25/15 offer the highest image quality and are the best choice when the subject requires the rendition of fine detail or large prints are required. The image quality of Kodachrome 25 can for example be superior to that of a faster film on a larger format.

A fast film is considered to be one of more than ISO 200/24 and should be used when poor light is combined with a need for a fast shutter speed or a small aperture, such as with sports photography. Poor light alone is not always a good reason to use a fast film. If the subject is static and the camera can be mounted on a tripod, a slow film can still be used, often to advantage.

Even the fastest black and white and colour transparency films can be uprated by modified processing to give a higher speed than that indicated on the packet by as much as two to three stops. This can be useful in some situations, such as available light photography. It is at the cost of increased grain size and loss of image quality, but often these factors can contribute to the atmosphere of such pictures.

Whether you choose colour slide film or colour negative film depends on your prime requirement. If it is for prints, it is usually best to shoot on colour negative film, since the prints from this film will tend to be cheaper and of higher quality. It is possible to make colour slides from colour negative film and prints from colour slide film, but as a general rule it is preferable to use the appropriate film. One exception to this could be someone who wants to start colour printing at home. It can be easier for a beginner to make prints from colour slides. It is also worth bearing in mind that colour negative film is rather more tolerant of exposure error and colour quality and the beginner would probably find it a more suitable choice, especially with a simple camera. With colour transparency film you must also select the right type of film for use in artificial light. Although daylight-type film can be used with electronic flash, artificial light film must be used with tungsten lighting. However, you can buy colour conversion filters to allow them to be interchanged.

In addition to the normal films for general photography there are a number of specialist films that may be interesting to those who like to experiment and create effects.

Right This picture shows the type of subject and lighting conditions for which medium-speed film is ideally suited, offering a good compromise between film speed and image quality.

Nikon F3, 70mm lens, 1/250 sec. at f8. Ektachrome 64.

Above When poor lighting conditions are combined with a moving subject as in this shot, then the choice of a fast film is usually unavoidable.

Nikon F3, 400mm lens, 1/500 sec. at f5.6. Ektachrome 200.

Right In good light conditions, or when the subject is quite static and contains fine detail, use slow film to produce greater definition and image quality.

Nikon F3, 150mm lens, 1/125 sec. at f8. Kodachrome 25.

Filters for black and white

When you take a picture on black and white film, the resulting image is technically speaking a record of the relative brightness levels in the original subject. Since normal panchromatic film is sensitive to all the colours in the visible spectrum, the picture will not distinguish between individual colours in the scene but simply respond to them according to the amount of light they reflect. So a bright blue and a bright red of equal reflectance would record as equal grey tones with no distinction between them. This is one reason why pictures taken in black and white can sometimes appear unexpectedly flat and dull compared to the original scene.

When taking black and white pictures, you must learn to view a subject in terms of its tonal qualities rather than its colour quality. It is possible to modify the film's response to individual colours in the scene with the use of coloured filters. The principle is quite simple if you think of it in terms of the primary colours, red, green and blue. Imagine a subject in which there are three objects, one red, one green and one blue, standing on a grey background. Photographed without a filter, the resulting picture would show all the elements as equal tones of grey. However, if a red filter were placed over the lens it would hold back the light reflected from the green and blue objects and record them as darker tones and would record the red object as a lighter tone. The grey background being an equal mixture of all three colours would remain unaffected. The same thing would happen when a green or blue filter was used. The object of its own colour would be made lighter and the other two colours darker.

This bold discrimination only happens when the subject colours are fully saturated and the filters used are very strong. In normal circumstances the effect is more subtle and the filters used are often paler tints. A good example of how this works in practice is in landscape photography where the sky is blue. Without a filter, blue sky will record as a quite pale grey, partly because the panchromatic film is slightly more sensitive to blue and partly because the sky is usually a lighter tone in the image in any case. A yellow filter would make the sky a slightly darker grey, giving an impression in the print similar to that of the original scene. With an orange filter, the sky would record as a substantially darker grey with any white clouds standing out in bold relief. With a red filter the sky would take on a quite dramatic appearance, recording as nearly black.

Other situations in which filters can often be used to enhance the quality of a black and white shot include the use of a green filter to record the foliage of a summer landscape as a lighter and more defined tone. This filter will often add a dramatic quality to a sunset in black and white shots. A deep blue filter can be used effectively to accentuate the skin texture in character portraits. Conversely, a red filter can be used to reduce skin blemishes, although the model's lips will appear too light without make-up. A red filter is also very useful in penetrating atmospheric haze and adding clarity and contrast to distant details.

All such filters will require an increase in exposure according to their density; this can be calculated by means of the filter factor which is supplied with the filter: ×2 requires one stop extra, ×4 two stops and so on.

Above *These two pictures demonstrate how a yellow filter can improve the tonal rendering of blue sky. The bottom photograph is unfiltered and the sky has recorded too light in tone, with little definition in the white clouds. In the top picture a medium yellow filter has been used, making the sky a darker shade of grey which throws the clouds into stronger relief. The filter required half a stop additional exposure.*

Nikon F3, 105mm lens, 1/250 sec. at f16 and between f16 and f11 with the filter. Ilford XP1.

Right These four pictures show how the tonal rendering of a coloured subject can be controlled by the use of filters. The red and green peppers are on a blue background and in the unfiltered picture all three colours have recorded as a similar tone of grey. In the picture far right, a red filter was used. The picture below right was taken using a green filter. The photograph below far right was taken with the aid of a blue filter.

Pentax 6 × 7, 150mm lens, unfiltered f22, red filter, f11, green filter, f11 blue filter, f8. Studio flash. Ilford FP4.

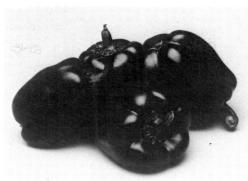
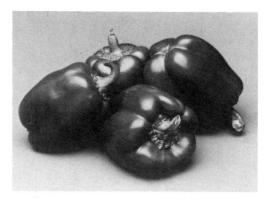
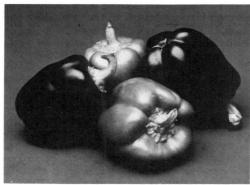
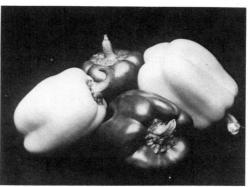

Below In this landscape picture a deep red filter was used to make the sky a much darker tone of grey and to create a strong contrast between it and the clouds. The filter has also caused the green landscape to record as a darker tone, and has improved the clarity by eliminating the ultraviolet light. Its overall effect has been to considerably increase the dramatic effect of the photograph.

Nikon F3, 35m lens, 1/25 at f8; two stops additional exposure were given to allow for the filter. Ilford XP1.

Filters for colour

The filters used for colour photography are generally much paler than those used for black and white, since a filter of a strong colour will create an equally strong colour cast on the film. They fall broadly into two categories, colour correction filters and colour effect filters.

The former are designed to correct an imbalance between the colour quality of the light source and that for which the film is intended. An obvious example of this is when daylight-type film is used in artificial light. Without a filter the resulting transparency would have a strong orange cast, because the colour temperature of artificial light is much lower than that of daylight. In order to correct this, a blue filter must be used. When artificial light film is used in daylight, an orange filter must be used to counteract the potential blue cast.

However, the colour temperature of daylight can vary considerably. It can be much lower when the sun is lower in the sky and much higher when it is cloudy. Since daylight-type colour film is designed to give optimum results under quite precise conditions and at a specific colour temperature, such variations will be quite apparent on the film. When the colour temperature is too high, the film will have a blue cast and a yellowish filter must be used to correct it. When it is too low it will produce a reddish cast and a blue filter must be used to correct it. The blue filters are in the 82 range (A, B and C according to strength) and the yellowish filters are in the 81 range, again A, B and C.

There are two other quite common instances when you might get a blue cast in daylight conditions. Ultraviolet light, although invisible to the eye, will be recorded by the blue sensitive layer of the film. And if you are shooting in open shade, when there is a blue sky, your subject will be largely illuminated by light reflected from the sky and will be bluer on film than you saw it. The ultraviolet problem often exists on overcast days at high altitudes, and by the sea. It will do no harm to leave a **UV filter** permanently in position on the lens.

A **polarising filter** does not alter the colour quality, but simply helps to create stronger and richer colours by eliminating some of the light scattered from non-metallic reflective surfaces. It is a neutral grey in appearance and requires an exposure increase in the order of one to two stops.

The **graduated filter** is another very useful attachment for colour photography. It is half tinted and half clear, so it affects only part of the image. It is ideal for adding colour and density in sky tones and can be bought in a range of colours as well as grey.

Above These two photographs show how a filter can be used to correct the blue cast resulting from shooting when the colour temperature of the light source is higher than that for which the film is balanced. The top picture taken on an overcast day is unfiltered and an 81B filter was used for the picture below it, producing richer and warmer colours.

Nikon F3, 150mm lens, 1/30 sec. at f8.
Kodachrome 64.

Right A polarising filter was used for the bottom photograph. You can see that it has had the effect of making both the sea and the sky a much richer and deeper colour as well as adding to the clarity of the image when compared to the unfiltered top picture. It required an increase in exposure of one and a half stops.

Nikon F2, 20mm lens, 1/250 sec. at f8.
Ektachrome 64.

Camera accessories

A few basic accessories can greatly extend the scope of even a simple camera and in many cases improve the quality of the results. A good **camera bag** is a vital requirement both to protect your equipment and to keep it readily accessible. There are a variety of types, ranging from the soft, lightweight canvas or nylon types which are ideal for carrying on the shoulder and holding your immediate needs, to the more substantial suitcase type, which offers maximum protection and is best suited to travelling and transportation, but less convenient as a 'working case'. When choosing a case make sure that there is adequate space for all your equipment and film with some left over to accommodate new items.

A **tripod** should be considered as an obligatory accessory. It will free you from the limitations of having to use shutter speeds of faster than about 1/60 second, enabling you to shoot in low light levels and to use small apertures for maximum depth of field. And it will allow you to set up, aim and focus your camera with greater precision, very useful for subjects such as close-ups and still lifes. With portraits, a tripod will allow you to leave your camera in position while you adjust lighting and leave you free to communicate more directly with your model.

A **filter system** is also invaluable, since it will enable you to exercise more control over the tonal and colour quality of your pictures as well as creating interesting effects. The integrated systems such as the Cokin are excellent, because the filter holders can be adapted to fit a wide range of lens mount sizes. They can also accommodate any one of a very large range of filters from basic colour correction to a variety of special effects such as starburst, colour burst, soft focus, prisms and so on. An efficient **lens hood** is also useful, since it can reduce the risk of flare as a result of bright light falling directly onto the lens. This can be obtained as part of the filter system or as an attachment supplied for a particular lens.

Since most lenses only focus as close as a metre or so, a means of reducing this distance will bring a further range of close-up subjects into your repertoire. If you have a viewfinder camera this will need to be a **supplementary lens,** a weak positive lens fitted to the camera lens like a filter. They are available in a range of strengths and progressively reduce the close focusing distance of your lens. However, if you have an SLR, a **bellows unit** or **extension tubes** which fit between the camera body and the lens are a more expensive but more satisfactory alternative.

A small **flash gun** which can be used to illuminate or supplement the lighting of relatively close distance subjects will also extend your range. These are available in a wide variety of types, power and prices. The simpler versions are provided with a guide

Below This is the effect you get when you use a starburst filter. It only works when there are bright, spectacular highlights in the picture and is most effective when there is an essentially dark background. It comes in a variety of configurations giving different numbers of light streaks. Unlike the colour burst filter, above, it can be equally effective in black and white shots.

Nikon F3, 35mm lens, 1/50 sec. at f11. Ilford FP4.

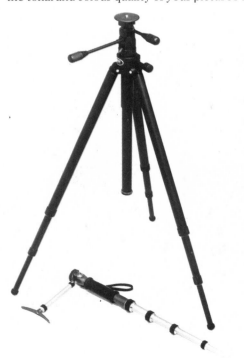

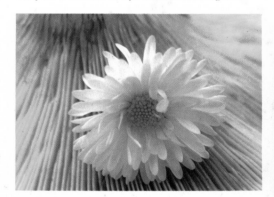

Above A supplementary lens, extension tubes or a bellows unit are necessary for a picture like this close-up of a flower if your camera is fitted with a normal lens. A tripod is also obligatory for this type of picture.

Nikon F3, 150mm lens with extension tube, 1/8 sec. at f16. Ektachrome 64.

Left Two types of camera support. A tripod with a pan and tilt head, and the more portable monopod.

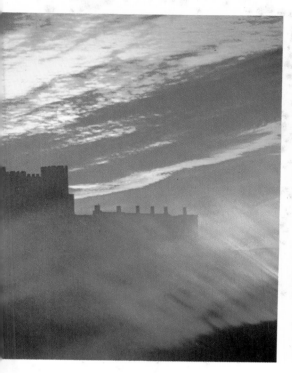

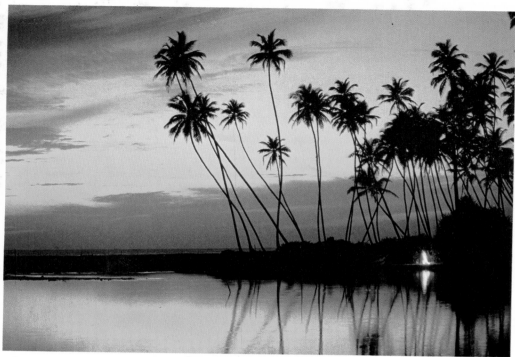

number for exposure calculation, but more sophisticated types have computerised exposure control. You simply set the film speed and the aperture, and the flash gun regulates the correct amount of light according to the distance from the subject. Another system, called **dedicated flash**, enables the camera's own TTL metering system to determine the correct amount of light.

Above left A colour burst filter or diffraction grating was used for this shot of Dover Castle, Kent. Like the starburst, it works only when there are bright highlights in the picture area. Its effect also depends on the aperture size and the focal length of the lens. The streaks are more defined with short focal length lenses and at small apertures.

Nikon F2, 200mm lens, 1/125 sec. at f5.6.
Ektachrome 64.

Above This shot of a tropical sunset was taken well after the sun had gone down. The scene was in fact quite dark and needed an exposure of several seconds, making the use of a tripod a virtual necessity. A tripod is one of the photographer's most useful accessories, greatly extending the scope of even a simple camera.

Nikon F3, 35mm lens, 4 sec. at f5.6.
Ektachrome 64.

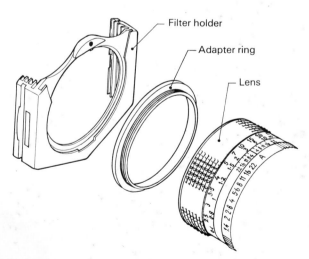

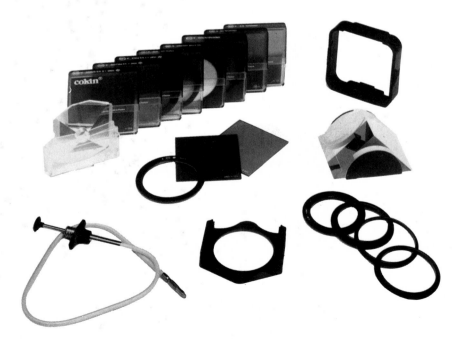

Right Anatomy of the Cokin filter system: the filter holder, bottom centre, and adapter rings; bottom right, that allow it to be fitted to a wide range of lens sizes; the filter holder; some of the correction effects filters and attachments that can be slotted into the basic holder, with, top left and centre, provision for several to be combined and rotated in the mount.

Lighting equipment

Although the small portable flash gun can be used to create a pleasing lighting quality, its use is rather limited, as are the effects which can be created with a single source of light. For photographers who are interested in subjects where the quality and control of the lighting is of particular importance, such as portrait, nude and still-life work, then a more elaborate and flexible system is necessary.

Such a system need not necessarily be expensive. Indeed, it is possible to use normal domestic lights for some pictures, but the brightness level of the ordinary light bulb is not really great enough for most needs. An inexpensive method is to use **photoflood bulbs.** These are like ordinary domestic bulbs, but are overrun to produce a much higher output of light at the cost of a much shorter working life, a mere few hours. These bulbs can be fitted into aluminium reflectors which can in turn be mounted on tripod stands.

Another method is the system using **tungsten halogen bulbs.** They are more expensive but more efficient than the filament type bulb, and give a more constant quality of light through their working life. This type of lighting is available in kit form, with three or four **heads** complete with stands and reflectors which can be packed into a suitcase. In addition a range of accessories to control and modify the quality of the light is also available.

The third method of studio-type lighting is **electronic flash.** Unlike the small portable units, this is designed to run from the mains and is also fitted with modelling lights, which are tungsten filament or halogen bulbs combined into the head along with the flash tube to enable the effect of the lighting to be assessed as it is set up.

This type of lighting is available in two forms. The more powerful version is a single, large powerpack into which a number of individual flash heads can be plugged. The smaller units each contain a combined power unit and flash head. These are more portable and can be obtained in the kit form, complete with suitcase-style container. When using a number of flash heads, only one needs to be synchronised with the camera. The others can be fired simultaneously by means of a light sensitive **slave cell** plugged into their synchrosockets.

Most lighting units are supplied with a basic reflector, but different types of reflectors and diffusers can be obtained to control the quality of the light. The **umbrella reflector** is particularly popular because it provides a relatively large soft source of light but is quite portable. **Window lights** are another method of creating a diffused light. These are simply large panels of frosted

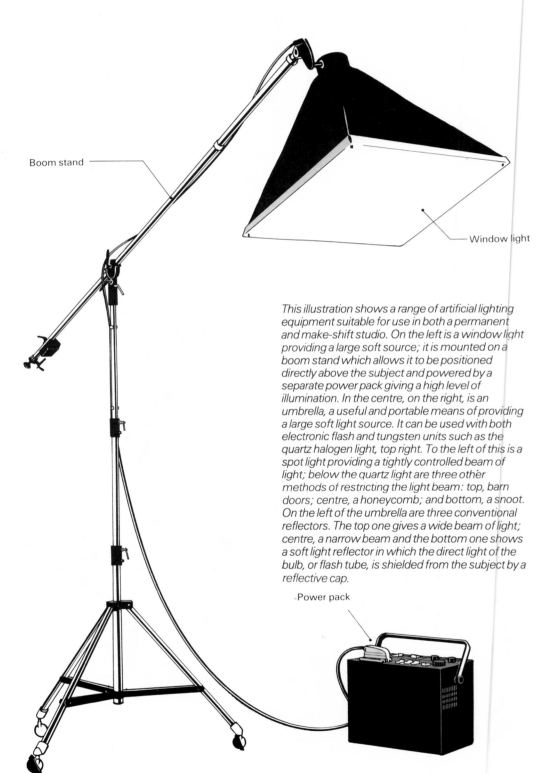

Boom stand

Window light

This illustration shows a range of artificial lighting equipment suitable for use in both a permanent and make-shift studio. On the left is a window light providing a large soft source; it is mounted on a boom stand which allows it to be positioned directly above the subject and powered by a separate power pack giving a high level of illumination. In the centre, on the right, is an umbrella, a useful and portable means of providing a large soft light source. It can be used with both electronic flash and tungsten units such as the quartz halogen light, top right. To the left of this is a spot light providing a tightly controlled beam of light; below the quartz light are three other methods of restricting the light beam: top, barn doors; centre, a honeycomb; and bottom, a snoot. On the left of the umbrella are three conventional reflectors. The top one gives a wide beam of light; centre, a narrow beam and the bottom one shows a soft light reflector in which the direct light of the bulb, or flash tube, is shielded from the subject by a reflective cap.

Power pack

plastic a metre or more square which can be mounted onto the front of the reflector. Although less convenient in use, a cheaper and often more effective means of diffusion can be achieved simply by covering a large wooden frame with tracing paper.

Where a harder more directional light is needed, to create highlights for example, a **spotlight** or a **snoot** is a useful addition. The advantage of a spotlight is that it can be focused to tightly control the cone of light which it emits and produce a particularly hard, sharp shadow.

In addition to the normal tripod or wheel base stands, a **boom stand** is also useful as it enables a light to be positioned immediately above the picture area without the stand itself being in shot.

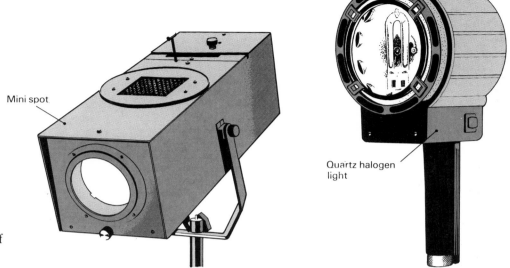

Mini spot

Quartz halogen light

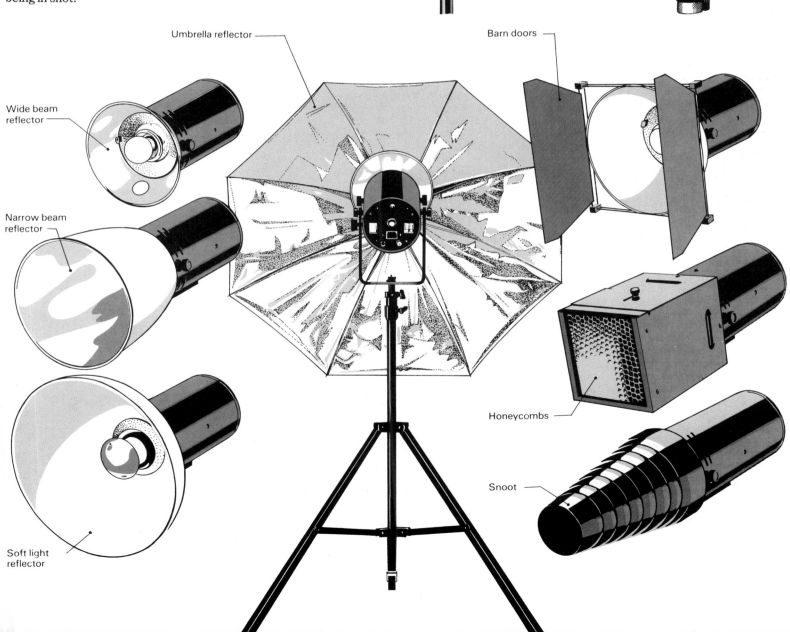

Umbrella reflector

Barn doors

Wide beam reflector

Narrow beam reflector

Honeycombs

Snoot

Soft light reflector

The Essential Skills

Handling a camera

A camera is a tool. Like any other tool, it is difficult to use well until you are familiar with it and know how to handle it properly. It really is worth the small amount of effort involved to practise using your camera until it becomes second nature. Not until then will you be able to devote your full attention to the subject and the techniques of actually taking pictures.

Even just knowing how to load your camera quickly and carefully will help you to prevent spoilt films and lost opportunities. No matter what type of camera you have, always load and unload in subdued light, even if this is just the shade of your body, when shooting in sunlight. Always make sure that the film is loaded correctly and is taking up properly before closing the camera back and that it winds on when you start shooting. Many disappointments have occurred as a result of the film being unexposed through not winding on. This is a particular hazard with 35mm cameras. The fact that the film counter operates is not always an indication and you should learn to detect the different tension in winding between when the camera is empty and loaded correctly. With many cameras, the rewind knob rotates when the film is winding on. With a 35mm camera it is also important to fire off three blank frames before you start shooting to avoid the risk of fog or damage in processing. When you approach the end of the film, wind on a little more gently to avoid the risk of pulling the film off its spool.

The way you actually hold the camera is also important and this will depend to a large degree on both the type of camera and your own preference. With many of the small compact and cartridge cameras you must be careful that your fingers do not protrude over the lens, as this will not be visible in the viewfinder. You should experiment with ways in which you are able to hold the camera firmly but with your hands positioned to reach and operate the main controls with the minimum disruption to the basic grip. You will also find that it is often necessary to hold the camera in a different way when taking vertical pictures. Experiment to find the most comfortable arrangement. However you hold the camera, it should result in you being able to squeeze rather than press the shutter release to minimise the risk of camera shake. This can be a particular problem with the small lightweight cameras.

If you watch a professional photographer operate a camera, he does it without hesitation and almost subconsciously. This is of course because of constant use, but this ability can be acquired with a little practice. The easiest way is to establish a set routine of procedure when taking a shot, so that eventually it will become quite automatic, like using the clutch and gear lever when driving a car. It is not too important as to the exact sequence as long as it is always the same. Before each sequence of pictures, check that the camera is loaded, that the film speed

setting is correct for the film in use and that any override or exposure compensation devices are at zero. Make sure that there are no unwanted filters or attachments on the lens and with non-SLRs that the lens cap has been removed – easily overlooked. Even when using an automatic camera, learn to check the exposure settings the camera has selected and make sure they are in keeping with the lighting conditions. This will act as a double check against film speed dial errors as well as avoiding spoilt pictures through a malfunction. Also check that the aperture and shutter speeds set are suitable for the depth of field required and will avoid the risk of blur. Last but not least, make sure that the image is framed and focused correctly.

Above When holding a small camera, such as the disc camera shown in this illustration, it is important to ensure that your fingers do not intrude into the field of view.

Below The correct position for a film cassette loaded into the back of an SLR camera.

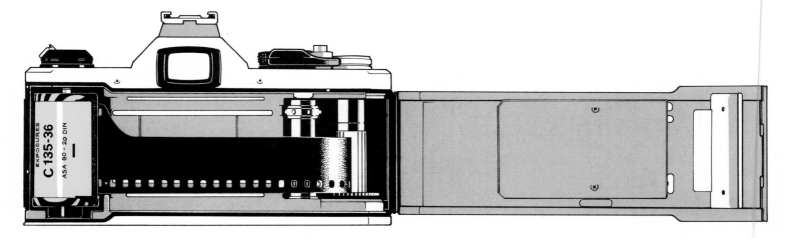

Above Holding a 35mm camera in the horizontal position. This stable and comfortable method with the camera held steady by bracing your elbows against the body.

Above An elbow braced hold to steady the camera. This technique is often used when shooting in an upright position.

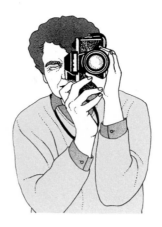

Above Holding a 35mm camera in a vertical plane, as this illustration shows, allows both elbows to be braced against the body for extra support.

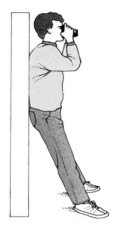

Above Leaning against a wall or firm upright enables the body to be firmly braced to make sure that slow shutter speeds can be used without the risk of camera shake.

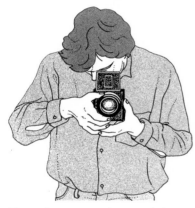

Above A camera such as a twin lens reflex can be used at eye level in the way shown here when the focusing magnifier is used.

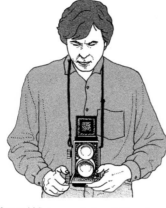

Above When used at waist level, a TLR or SLR without a pentaprism can be given additional support by pulling the camera body down against the neck strap as shown here.

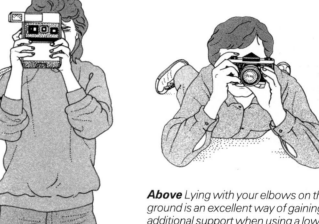

Above Lying with your elbows on the ground is an excellent way of gaining additional support when using a low viewpoint.

Below When using an instant picture camera such as the Polaroid SX70 illustrated here, it is vital to hold it so that your fingers do not obscure the film exit aperture.

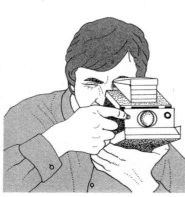

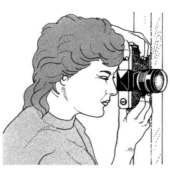

Above Bracing the camera against a firm upright support, such as a door-frame, in the way shown here, can often allow for quite slow shutter speeds to be used without the risk of camera shake.

Above This illustration demonstrates how the body can be used as a 'tripod' to give the camera extra stability.

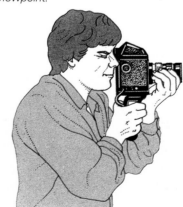

Above A pistol grip can make holding a camera at eye level more convenient and stable, especially when a motor drive is used with a camera such as this Rolleiflex SLX.

Focusing and sharpness

In the purely technical sense, there are two vital ingredients for a good picture, correct exposure and a sharply recorded image. The definition of the picture is dependent on a number of factors. The first is that the image projected onto the film is in itself as sharp as it can be within the ability of the lens. Obviously a high-quality lens will produce a sharper image than a simple inexpensive one, but provided the image is focused and recorded successfully, the difference will not be too apparent at small degrees of enlargement. Accurate focusing is vital at distances of less than four to five metres.

In order to record a correctly focused image sharply, it is important to ensure that there is no movement of either the camera or the subject. Even with a static subject, such as a view, there is a risk of blur if the camera is jarred when the shutter is released. Hold the camera firmly and squeeze the release gently to make the exposure.

The shutter speed you select will have a significant effect on this factor and it should be considered risky to use a shutter speed of less than $\frac{1}{60}$ second unless some additional support is used, such as a tripod. As a general rule it is best to standardise on a shutter speed of $\frac{1}{125}$ or even $\frac{1}{250}$ second for general purposes where the lighting conditions and the choice of aperture permit. The problem of camera shake is much greater when a long focus lens is used and with a hand-held camera $\frac{1}{250}$ second or less should be used with these.

In addition to the choice of shutter speed the aperture you use will also affect the sharpness of the image. When you focus on a subject, there will be an area of sharpness in front of and behind this point. This is known as depth of field and it varies according to the aperture used. At wide apertures this zone of sharpness will be at its minumum and it will progressively increase as the lens is stopped down. Most lenses have a depth of field scale marked on the focusing mount which indicates the zone of sharpness at a given aperture.

There are other factors that also affect the depth of field. At close focusing distances it will be substantially less than when you focus at subjects further from the camera and it is considerably less with long focus lenses, but more depth of field is obtained with wide angle lenses. It is important to know that depth of field extends further behind the point of focus than it does in front; the proportion is about $\frac{1}{3} : \frac{2}{3}$, so if you want to obtain maximum sharpness throughout the image, it is best to focus rather closer than the midway point and to use the smallest aperture you have. Where you want to restrict the depth of field, select the widest aperture you can.

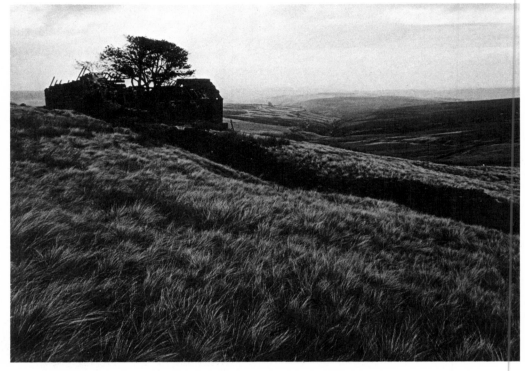

Above *A small aperture was used for this landscape picture in order to obtain sufficient depth of field to ensure that both the foreground and distant details were sharp. The lens was focused at a point about one third of the way between the two extremes.*

Nikon F, 28mm lens, 1/60 sec. at f16. Kodak Tri X.

Below and left *This shows how the depth of field at a given aperture and focusing distance relates to the indicator ring on the camera's focusing mount. As the focusing distance increases and the aperture decreases, the depth of field becomes greater.*

Depth of field for 50mm lens

Distance (m)

Aperture (f no.)

Depth of field with focusing ring set at 3 metres

Depth of field with focusing ring set at 1.5 metres

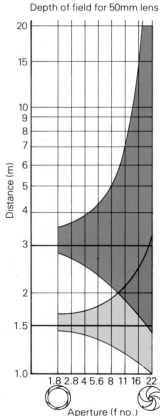

Focusing scale

Depth of field scale

Aperture scale

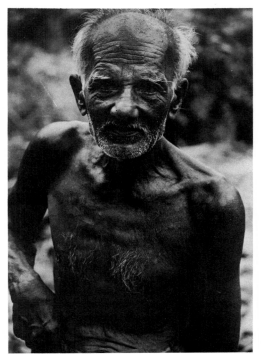

Above The effect of a picture like this is dependent upon a really crisp, sharp image, accurate focusing, and a shutter speed fast enough to avoid the possibility of camera shake when the camera is hand held

Nikon F3, 150mm lens, 1/250 sec. at f8. Ilford XP1.

Left A wide aperture was used in this portrait to restrict the depth of field. This threw the background out of focus and created a bold separation between it and the sharply focused subject.

Nikon F3, 150mm lens, 1/500 sec. at f4. Ilford XP1.

Right These two photographs demonstrate the way in which depth of field is affected by the aperture of the lens. The top picture was taken using a small aperture so both the foreground winch, and the distant boat are equally sharp. In the lower picture a wider aperture was used and although the foreground details are sharp, the distant boat was out of focus.

Nikon F3, 105mm lens, top 1/30 sec. at f22.
bottom 1/500 sec. at f4. Ilford XP1.

Recording movement

There are two ways to produce an unsharp image. Either it is out of focus, or it is blurred as a result of the image moving on the film during the exposure. This is controlled by two factors: the duration of the exposure – the shutter speed – and the nature of the movement. To photograph a moving subject so that it records as a sharp image means that you must select a shutter speed brief enough to arrest its movement on the film. This in turn will depend on both the direction and the speed of the movement. A movement across the camera will require a faster shutter speed in order to freeze it than movement towards it of the same speed, and a faster shutter speed will be needed when the subject is closer to the camera and larger in the frame.

When the movement is quite fast, such as a horse running, it will be necessary to use the fastest shutter speed available. Even so, if it is close to the camera and moving directly across it, a shutter speed of $\frac{1}{2000}$ second may not be fast enough. In these circumstances, pan the camera by swinging it in a smooth arc in line with the subject's movement so that it is held steady in the frame and make the exposure during this action. Using this technique, it is often possible to use much slower shutter speeds and still obtain a sharp image of the subject except peripheral details, such as a horse's lower legs or the wheels of a car, for example. This approach can have advantages of its own. Although the subject itself will record quite sharply, the static elements of the scene – the background and foreground – will become blurred, as they are now effectively moving across the film. In many instances, this effect can enhance the impression of speed and movement because when the image is completely sharp and 'frozen' it can often appear quite static.

You can take this technique a stage further and combine very slow shutter speeds with a panned camera to produce an image which is virtually totally blurred. The effect will be to create swirls of colour and tone in which bold details, colours or tones will produce the impression of lines in the picture. This approach, particularly in colour, can create quite exciting and dramatic effects, often with an almost abstract quality.

Right A fast shutter speed was used to capture the individual droplets of water as this Sri Lankan mahout splashed water over his elephant at bath time. The backlighting has effectively highlighted the spray against the darker tone of the background. The exposure was calculated for the highlights, allowing the man to be silhouetted.

Nikon F3, 150mm lens, 1/1000 sec. at f4.
Ektachrome 64.

A variation on this technique is to mount the camera on a tripod and use slow shutter speeds with the camera static. In this way, the moving elements of the picture will create a blurred image, but the stationary parts will appear quite sharp. This can be a particularly effective way of photographing moving water. In some instances, exposures running into seconds or even minutes can transform the most ordinary scenes into quite compelling images.

If you own a quite simple camera and want to obtain sharp images of moving subjects, the lack of very fast shutter speeds need not necessarily be a deterrent. With many actions there is often a moment of minimum speed and if this is anticipated and the exposure made at the critical moment it is possible to take successful shots. A child on a swing, for instance, could be photographed at the moment he or she reached the turning point of the swing, rather than during the up or down movement.

Right The quality of the water in this picture of Yosemite was produced by mounting the camera on a tripod and giving an exposure of several seconds. In order to allow such a long exposure, a neutral density filter was fitted and a small aperture was used.

Nikon F3, 35mm lens, 4 sec. at f22.
Ilford XP1.

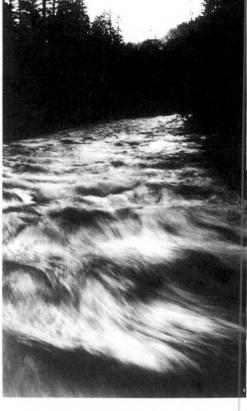

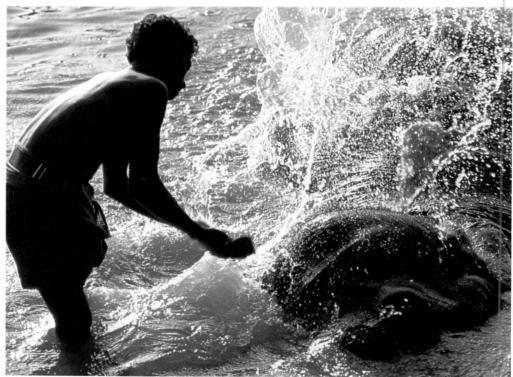

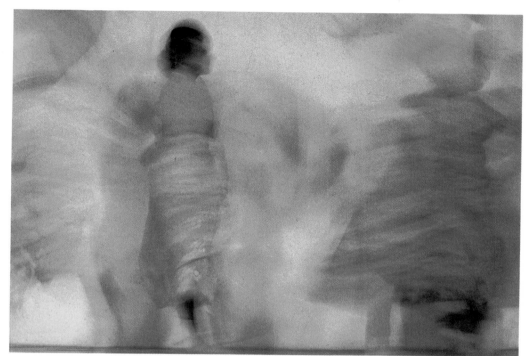

Left A very slow shutter speed combined with a moving subject and a panned camera has resulted in this near abstract picture of folk dancers. The effects of this technique are difficult to predict, and a number of exposures had to be made with varying shutter speeds and panning speeds before this final image was achieved.

Nikon F3, 105mm lens, 1/4 sec. at f11.
3M 640T Film.

Below For this picture, taken at a Californian rodeo, a fairly slow shutter speed was chosen to create a degree of artistic blur as the camera was panned with the fast-moving rider. This has greatly enhanced the effect of speed and action, but still allows adequate sharpness to be retained in the most important areas of the subject. This effect is more pronounced when there is a bold contrast of tone or colour, as in the background of this shot.

Nikon F3, 200mm lens, 1/60 sec. at f16.
Ektachrome 64.

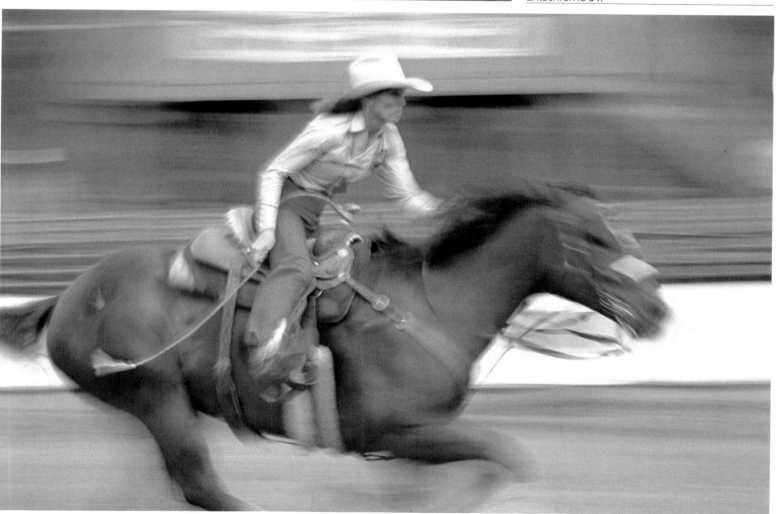

Understanding exposure

In order to understand how to calculate exposure correctly, you must learn how an **exposure meter** works. The ordinary type of exposure meter, whether it is a separate hand meter or an integrated meter, measures the light reflected from the area of a scene within its field of view. It is calibrated on the assumption that the subject contains a full range of tones from light to dark and is of normal contrast without excessively large or bright highlights and with only a small proportion of dark shadows. It 'assumes', in short, that if all the tones were mixed up together, like the remnants of half a dozen different paint pots, the result would be a medium grey. If you were to take a reading from a piece of grey card, the result would be a perfect facsimile. The problem is that if a reading were taken from a piece of white or black card, the exposure the meter indicated would still record it as grey. Consequently, if anything within the meter's field of view alters the balance of the mixture, then the

Right Through the lens (TTL) metering on an SLR. Automatic metering will give a correct exposure for a subject of average tone and contrast when the film speed is set on the dial.

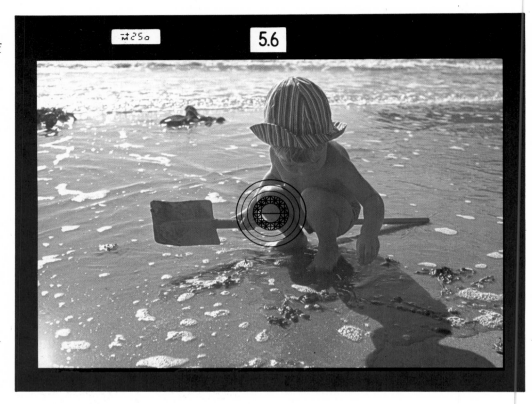

Above A flash meter, left, for incident light readings, a Weston Euro Master meter, centre, for both reflected light and incident readings, and a spot meter, right, for readings from small, precise areas of the subject.

meter will be misled. Fortunately, very many of the normal pictures taken do provide an even balance of tones and in these circumstances you will get an accurate exposure indication. But you do need to be aware of the situations in which the meter will be misled and know how to overcome them.

One of the most common circumstances in which a meter needs to be used and interpreted carefully is when there are bright highlights or light sources in the picture area such as with backlighting, shooting with the sun in the picture or illuminated night scenes. All of these conditions will make the 'mixture' much lighter than it should be and cause the meter to suggest less exposure than is needed. The solution in these situations is to take a close-up reading so that the highlights are excluded from the meter's view and not taken into account.

Underexposure will often result when a large amount of sky is included in the picture area or within the meter's field of view. In this case, you should aim your meter or the camera down to avoid the sky while taking the reading. Another situation which can induce underexposure is when the subject contains primarily light tones, such as a snow scene or a picture of someone wearing white. In this case, it is best to take a substitute reading from an object of normal tone in the same lighting. Kodak produce an 18% grey card for such purposes, but you will usually be able to find something suitable within the scene.

An alternative method is to make an **incident light reading.** This requires the use of a separate meter with an incident light facility and the reading is made by aiming the meter from the subject position towards the light source. Thus it measures the light falling on the subject as opposed to that reflected.

The same problem will exist when the subject consists of primarily dark tones, such as a low-key portrait. In this instance the mixture will be much darker than the average grey and the meter will suggest more exposure than is necessary. As with a light-toned subject, the best solution is either an incident light reading or a substitute reading.

Right These series of photographs show the results when using a conventional averaging system to calculate exposure when applied to a variety of subjects and conditions. The shot on the left, in each case, illustrates the way the subject appeared 'to the eye', and the picture on the right shows the result of using a normal exposure reading without making the necessary allowances. The average subject, top, produced a correct result, but the dark subject below it is recorded too light. The light subject below that is recorded too dark, and the back-lit subject, bottom, is also recorded too dark.

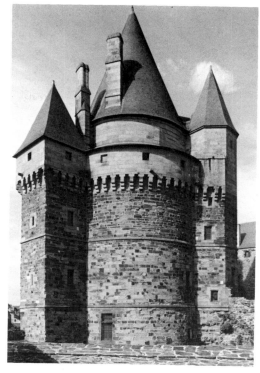
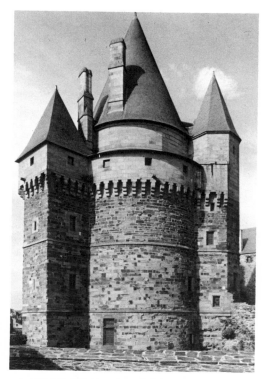

Exposure and the image

If you were to photograph a subject under very precise conditions and were able to make a direct comparison between the photograph and the original, like a test card on a TV set for instance, then the question of correct exposure becomes a quite objective factor. However, most photographs are simply not like that and the term 'correct' when applied to exposure refers more to whether the resulting photograph reflects or emphasises particular qualities in a scene rather than to a facsimile reproduction of what you saw. Because of this it is important that you learn to judge and calculate exposure not only in terms of the brightness level of the subject but also in the way it affects the image.

The term 'correct' when applied to a subject of normal contrast means an exposure that will record detail in both the lightest and darkest tones. When a picture is overexposed, the result is an image in which the detail is lost in the lighter tones and the darker tones become weak and lacking in density. In addition, the colours will appear weak and desaturated. Underexposure, on the other hand, will produce an image in which the details in the darker areas will be lost and the lighter tones will become veiled and dull and the colours recorded as darker and richer hues. Both under- and over-exposure can in certain circumstances enhance the quality of a photograph.

One of the most important aspects of photographic technique is the effect of exposure and its control over image quality. The most effective way of learning this technique is to experiment with exposure variations over a wide range of subjects and lighting conditions. This is known as **bracketing,** and involves making additional exposures each side of the reading judged to be 'correct'. With most colour transparency films, a difference in half a stop each side will show a significant change in image quality. To begin with it can be more instructive to vary it by one stop each side in half-stop increments. This will also help you to discover the limitations and characteristics of a particular film. Although it may seem wasteful, the experience you gain will help you to judge more easily in the future where more or less exposure will benefit the picture and to predict quite accurately the quality and effect of the results.

With subjects of normal or low contrast, overexposure will help to create images with a 'lighter' mood and more delicate quality in which colours are recorded as softer more pastel hues. It also tends to reduce the effect of texture. Portrait photographers often slightly overexpose to create a more flattering quality and to give the model's skin

a smooth, flawless appearance.

Underexposure, on the other hand, will tend to emphasise the textural quality of a subject and will record colours as richer and more saturated hues. A degree of underexposure will often enhance subjects with bold, bright colours, particularly when they are of relatively low contrast. Underexposure can also affect the mood of a picture, creating a more sombre or dramatic quality. This effect is used quite frequently in subjects such as landscape photography and character or dramatic portraits, often to the point where the darker tones are allowed to become black, emphasising the highlights and mid tones.

Above The effect of this picture was created by overexposing by one stop more than the meter reading indicated. This has resulted in the quite dark, strong colours of the subject being recorded as pastel shades, giving the picture a rather unusual sketchy quality.

Nikon F3, 150mm lens, 1/30sec. at f5.6. Kodachrome 25.

Right In this picture the exposure was reduced, giving between half and one stop less than the exposure reading indicated. This has had the effect of producing an image with richer and stronger tones and colours than the 'correct' exposure would have created, emphasising both the mood and the texture of the picture.

Nikon F, 105mm lens, 1/250 sec. at f5.6. Ektachrome 64.

Below This sequence of pictures demonstrates the effect that exposure has on the image. The 'correct' exposure, indicated by the exposure reading, is the central image in which both the tonal range and the colour quality of the subject is most accurately represented. The three lighter images show the effect of giving half a stop, one stop and one and a half stops extra exposure. It can be seen that the highlights lose progressively more detail, the shadows become lighter, and the colours less saturated as the exposure increases. The opposite effect occurs with the darker pictures, where the exposure has been progressively decreased in half-stop increments.

Nikon F3, 150mm lens, exposures ranging from 1/250 sec. at f8 to 1/250 sec. at f4; the central 'correct' exposure was between f5.6 and f8. Ektachrome 64.

Natural light

We are able to see and take photographs because light rays radiating from a source strike the surface of an object and are reflected and then focused by a lens to create an image of that object. The main source of light is the sun and what happens to its rays both before and after it reaches the surface of what we are seeing and photographing will affect its appearance and our reaction to it.

Although the sun itself is in effect a constant small source of light, like a light bulb in a dark room, there are many factors which affect its quality and direction and our perception of the world around us. When the sun is high in a deep blue sky in the middle of a summer's day it creates a very hard, intense and directional light casting dense and sharply defined shadows. However, as its position in the sky changes and the atmospheric conditions change, the nature of its light also changes radically. One of the most important aspects of photography is to be aware of these changing qualities of sunlight and to know how to make the best use of them.

In photographic terms, there are three main factors concerning light: brightness, quality and direction. Brightness is only a relative factor and can be controlled by exposure. Quality is a vital factor and will be a constant variable. The same scene can change its appearance in the space of a second when a cloud passes in front of the sun, for example, making the shadows weaker, reducing the contrast of a scene, and even changing the mood. Clouds, mist and atmospheric haze all have the effect of making the quality of daylight softer. Instead of the small source of the sun the sky itself becomes the source, like a large reflector.

The colour quality of daylight is also a variable factor and although we are largely unaware of changes in normal circumstances, colour film will detect and record them objectively. As the sun gets lower in the sky, in late afternoon for example, it passes through a greater volume of the atmosphere, absorbing more of the blue wavelengths and creating a warmer, more orange light. However, after the sun has set and on dull, overcast days the blue wavelengths of light dominate and colour film will record the cooler blue quality. This quality will also be created when a subject is in open shade and is illuminated largely from light reflected from a blue sky. The presence of ultraviolet light will also affect the blue-sensitive layer of the film. although it is not visible. This can occur in cloudy conditions and at high altitudes.

The direction of the light in relation to the subject is also a crucial factor. The changes that take place at different times of the day can also have a considerable effect on the nature and appearance of a scene. At midday,

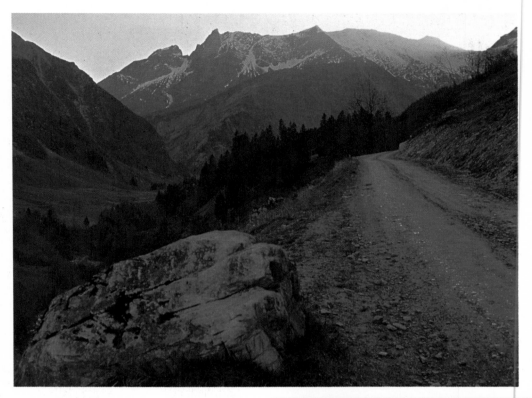

Above Taken just after the sun had gone down, this shot of a mountain landscape in Switzerland has a cool, blue colour quality because the colour temperature of the light was higher than that of a midday sun. The glacial colour cast contributes to the mood of the picture.

Nikon F, 28mm lens, 1/60 sec. at f5.6. Ektachrome 64.

Right The warm, orange quality of this picture of a fallen tree was created by shooting when the evening sun was very low in the sky. The direction of the sunlight has also produced more pronounced shadows, emphasising the texture of the gnarled wood.

Nikon F2, 105mm lens, 1/60 sec. at f5.6. Agfachrome.

for instance, the shadows cast by the sun will be quite small, whereas early or late in the day, when the sunlight rakes across the countryside, the shadows are much longer. The direction of the light is also dependent on the relative positions of the camera and subject. By changing the camera viewpoint you are able in effect to change the direction of the lighting. With the sun behind you there will be a flat, frontal light and with it at right angles to the camera there will be a more directional cross light. Shooting into the sun will create an even more radical change.

Above This picture of a Moroccan market scene was taken in bright clear sunlight around noon, producing a true unbiased colour quality and quite dense and well-defined shadows.

Nikon F2, 20mm lens, 1/250 sec. at f8. Ektachrome 64.

Below The virtually shadowless quality of this picture is the result of shooting on an overcast day when the clouds had softened and diffused the light of the sun. An 81A filter was used.

Nikon F3, 150mm lens, 1/125 sec. at f3.5. Ektachrome 64.

Light and the subject

It is important to understand the nature of light. It is equally essential to be aware of how its quality and direction affect the subject, since it is this that affects the nature and mood of a photograph.

The most basic requirement of light is that it enables us to distinguish the shape of an object. A tree on a hill, for example, with the light behind it, would be seen only in terms of its outline. We would not be able to distinguish its colour, texture or contours only its shape. As the direction of the light changed, however, so it would reveal more about the tree. A frontal light would distinguish its colour and the shape of its leaves. A cross light would emphasise the texture of its bark and the contours of its roots and branches. In this way we can select and use the lighting in order to reveal, emphasise or subdue certain qualities in a subject to control its effect. In a portrait of a girl for instance you may want to use a soft frontal light to minimise the effect of skin texture so as to create a flattering effect, whereas in a character portrait of an old man a harder more directional light to emphasise his lines and wrinkles would be more effective.

A hard light such as sunlight or an undiffused flash or tungsten lamp creates a sharp distinction between tones, whereas a soft, diffused light will produce a more gradual transition from highlight to shadow. This difference becomes much more apparent when the light source is at a more acute angle to the subject, since the shadows will become larger and more dominant in the image. For this reason it is important to be aware of the size and density of the shadows created by the lighting, as this will be the main factor in the nature and quality of your pictures.

The angle and direction of a hard light is more critical than soft, diffused light, and the conditions that exist on a bright sunny day need a careful and considered approach to avoid the unpleasant effect of harsh contrast. The brightness range created by such lighting is often greater than the film can accommodate, resulting in pictures with burnt out highlights and dense, blocked-up shadows. In these conditions, it is important either to select a viewpoint and to frame the picture so that these extremes are excluded and that the subject is predominantly in shadow and set the exposure accordingly, or to ensure that the shadow area is quite small. Where you are able to control the position of your subject – with a portrait for instance – you can avoid this problem on a sunny day by moving into an area of open shade, such as under a tree, for instance. Shooting towards the light will often produce a softer frontal light for this type of subject. A softer light is also more effective for brightly coloured subjects where the presence of deep shadows and bright highlights would distract from the effect of the colours. Subjects with an inherent pattern, fine detail, a bold texture or high relief are also often more effectively photographed with a softer light as hard shadows would obscure detail.

Lighting quality and direction can also affect the mood of a picture. A sunlit scene with bright highlights and crisp shadows will tend to create a more lively mood than a softly lit subject with subtle tones.

Above The rich texture of this image was created by the acutely angled light raking across the front of this old building. The angle and direction of the light can be seen by looking at the shadows projected on the wall from the balconies.

Nikon F, 50mm lens, 1/125 sec. at f5.6. Kodachrome 25.

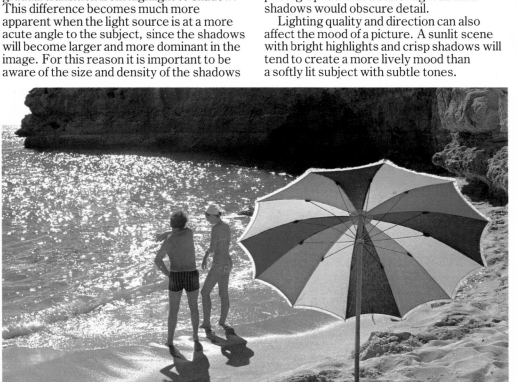

Left The quality and direction of the light is largely responsible for the bright, lively mood of this holiday picture. Shooting towards the sun has created an image of considerable brightness range and contrast. The exposure was calculated for the highlight areas, allowing the shadows to record without detail.

Nikon F2, 105mm lens, 1/125 sec. at f5.6. Kodachrome 25.

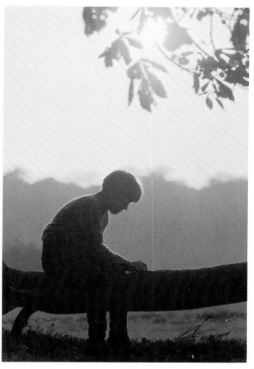

Above *The nature of the lighting in this shot of a young boy reveals only the shape of the subject, virtually silhouetted against a bright sky. There is little or no information about the texture, colour or form of the image, for which a more frontal light would have been needed.*

Nikon F, 200mm lens, 1/250 sec. at f5.6. Ektachrome 64.

Left *Although taken on a bright sunny day, this portrait of a French farmer and his wife was softened with more pleasing light by placing them in an area of open shade. An 81A filter was used to prevent the blue cast that these conditions can create.*

Nikon F3, 70mm lens, 1/60 sec. at f4. Kodachrome 25.

Light and the image

It is not possible to consider lighting solely in terms of the way it affects the subject. Your ultimate concern is its final quality in the recorded image, and the way that film responds to a subject and the lighting is of vital importance.

The ability of film to record an image is dependent on the different brightness levels of a subject, which record as tones on the film. Although we tend to see mainly in terms of colour, the film also 'sees' the tonal values of a scene. In many ways this aspect of photography is easier to understand and control when shooting in black and white, and indeed seeing black and white pictures requires a quite different approach.

The brightness range of a subject is determined by the difference between that of the deepest shadow detail and the brightest highlight. In a subject of normal contrast this would be represented by a difference of about six or seven stops in terms of exposure, and would be adequately recorded by most normal films. A brightness range much greater than this would create a high contrast subject beyond the ability of the film to record, resulting in an image in which either or both the highlight or the shadow details would be lost. A subject which has a brightness range substantially less than six stops would produce a low-contrast image which would reproduce neither a white nor a full black on the film.

The subject itself will have an inherent contrast, but this can be radically altered by the lighting. Take a white billiard ball on a piece of white paper, for example. If lit very softly from the front so that no shadows were cast, it would create a very low-contrast image, but if lit from one side with a hard light, creating strong shadows, you would get a very high-contrast image. These variations in the quality of the image have a significant effect on the nature and mood of a picture. A high-contrast image, for instance, will have a very bold assertive quality in which the shapes and tonal masses will be emphasised. A low-contrast image, on the other hand, will have a more subtle and gentle mood.

The distribution of the tones in an image will also affect the mood of a picture. A shot that contains tones predominantly from the darker end of the scale with only a few, small highlight areas will create a sombre or even ominous mood. This is known as a low-key picture. A high-key picture is one that contains mainly very light tones, with only small details in a darker grey or black. This type of image invariably has a quite delicate and peaceful quality.

We have so far discussed the tonal values of the image only in terms of grey, but colours are also affected of course. If a coloured object, a red billiard ball for instance, is lit softly from the front, the result will be a pure hue with little or no tonal variation. It will be what is called **fully saturated**. If, however, it is lit so that strong shadows and bright highlights are created, the colour quality in these areas will be affected and will be desaturated. In effect the shadow tones will be underexposed, causing the red to become dull and degraded and the highlight areas to be effectively overexposed, resulting in pale washed-out hues. Only the areas of the ball that represent the mid tones and which have received the correct exposure will faithfully record the true colour. Even when shooting in colour, therefore, it is important to be aware of the tonal values of the subject and how they will affect the image.

Left *The very soft quality of this lake scene is the result of photographing an inherently low-contrast subject in the very diffused light of an overcast day, producing an image with a substantially lower brightness range than that of a normal contrast picture.*

Nikon F3, 400mm lens, 1/60 sec. at f5.6. Ektachrome 64.

Left In this picture of the oyster fisheries on the Isle of Oleron in south west France the brightness range of the subject is matched to that which the film can record successfully, producing a picture with a full range of tones and colours.

Nikon F3, 105mm lens, 1/250 sec. at f8. Ektachrome 64.

Right This shot of an old lady in an Israeli street market has produced a low-key picture in which the tones of the image come predominantly from the darker end of the scale. This has produced quite a sombre mood, emphasising the textural quality.

Nikon F, 105mm lens, 1/60 sec. at f4. Ektachrome 64.

Below Strong sunlight creating dense shadows has made a high-contrast picture from this street scene. In this instance the brightness range is greater than the film can record, producing an image with no shadow detail. Consequently the picture has a bold, even dramatic quality.

Nikon F3, 150mm lens, 1/125 sec. at f8. Kodachrome 25.

Above A high-key image has been created in this landscape shot in which the majority of the tones are at the lighter end of the scale. This has made the colours softer and less saturated, producing a picture with a more delicate and gentle quality than that of the low-key picture above.

Nikon F3, 200mm lens, 1/60 sec. at f5.6. Ektachrome 64.

Identifying shape-form and pattern

To create a balanced and pleasing composition from a scene, you must teach yourself to be fully aware of all of the details within the picture area and of the visual qualities of the subject. This will enable you to effectively arrange them.

One way of learning to analyse an image in this way is to first isolate and identify the visual elements of the subject. These are simply the qualities which enable us to put a name to things. The most basic of these is **shape.** This alone can tell us a great deal about an object, and in many instances the shape of a subject will be the most dominant element in a picture. A silhouette is the most basic way a shape can be used in a picture and this can be effective in itself. The shape of a subject becomes prominent when there is a bold tonal or colour contrast between it and the background. A red flower against a green background, for instance, or a dark tree against a light sky. The choice of viewpoint is often an important consideration: the outline of a subject can appear quite different from even a slight change in camera position. Lighting, too, will have an important effect on the apparent shape of a subject and the presence of strong shadows or bright highlights can both accentuate and distort this quality.

While the shape alone can identify an object, it requires the quality of **form** to make it appear solid and three-dimensional. This is an important factor in the ability of a photograph to create an impression of depth and reality. This quality is created primarily by lighting and the tones which this creates within the outline of an object. For this reason the quality and direction of the light are crucial factors. A frontal light, for instance, that produces little or no shadow within the subject will reveal virtually nothing of its form. When the light is directed from an angle, it will produce the necessary graduation. Because form is usually dependent on a quite subtle graduation of tone, a hard light is less effective as it creates greater contrast and a correspondingly more abrupt change from highlight to shadow. Lighting which emphasises form is usually an important element of subjects like landscape, portrait and nude, which have particularly intricate and subtle contours.

Pattern in its most literal sense is a repetition of the same or similar shapes within an image. It can be a powerful element in a composition as it creates a feeling of rhythm and cohesion. Quite often a pattern can be created by implication, the subject suggesting rather than depicting a repeated shape. This often happens when there is some other similarity such as colour between the details. Apart from the more obvious

examples of pattern, such as a pile of bricks or a box of apples, it can also be created by a chance juxtaposition of details like a flock of birds or ripples on water. The element of pattern is largely emphasised by the choice of viewpoint and the way in which the image is framed. In some instances the lighting will also contribute to the effect by emphasising lines and shapes or by creating similarly shaped highlights or shadows. Pattern on its own is seldom entirely satisfying unless it is combined with other visual elements which generate an overall impression.

Top Form is the dominant element of this nude shot. The quality and direction of the lighting has produced an image in which the shadow and highlights emphasise the contours of the body.

Nikon F2, 105mm lens, 1/250 sec. at f8. Ektachrome 64.

Above It is the shape of the rock formation which is the key element in this landscape picture.

Nikon F2, 50mm lens. 1/125 sec. at f5.6. Ektachrome 64.

Left The element of pattern in this shot taken at a Papal mass is the result of a careful choice of viewpoint and by the way the picture is framed. In this case, the pattern is more implied than real but nevertheless gives the picture a rhythm and cohesion which dominates the composition.

Nikon, F3, 200mm lens, 1/250 sec. at f8.
Ektachrome 64.

Below An inherent pattern such as the stacking of planks in a timber yard often needs only a well-chosen viewpoint and tight framing to reveal it effectively. However, such an image can easily appear rather uninteresting unless it has some other quality to contribute to the composition. In this case, the bold colour contrast creates an effective foil to the repetitive shapes.

Nikon F3, 150mm lens, 1/250 sec. at f8.
Ektachrome 64.

Identifying texture-line and perspective

Texture, like form, is an element which can contribute greatly to the realism of a photograph. Indeed, one of the unique properties of the photographic process is its almost uncanny ability to create an accurate impression of the nature of a surface. Even very subtle textures like silk or skin can be photographed in such a way that the images invite a tactile response from the viewer. Texture may be thought of as the form of a surface. For this reason lighting quality and direction is a factor. A very finely textured surface may need a quite hard and acutely angled light which literally skates across its surface to emphasise it. An object with a coarse texture or high-relief surface would need a much softer, less directional light, otherwise large, dense shadows could obscure the details. Some textures create a pattern which may only need a soft frontal light to record it successfully. When texture is the crucial element of a picture, it is important to be acutely aware of the effect of the quality and direction of the light on the surface of the subject. It is also vital that the picture should be critically sharp and accurately exposed as high-image quality is essential. For this reason, large format cameras are often used for subjects like food and still lifes, in which texture is a key factor.

 Perspective, like form, is an important element in terms of the ability of a two-dimensional photograph to create the illusion of a third dimension and the impression of depth. This is achieved because objects of a similar size appear progressively smaller the further they are away. The more noticeable this effect is in a picture, the more heightened is the sense of depth and distance. We can perceive this quality when we look at a scene because we have binocular vision, but in a photograph it must be created by perspective. The effect of perspective is largely governed by the choice of viewpoint. If you look at an object, say a building, from a close viewpoint a similar building some distance behind would appear much smaller, and the impression of depth and distance would be quite great. However, if you were to move further away, the two buildings would appear nearly equal in size and the impression of depth would be diminished. In addition, the effect of perspective can be a strong element in the composition, because the receding effect can be used to lead the eye to an important part of the image.

 In some subjects, the presence of **line** is a very dominant and obvious factor, like the view down a street of houses, for instance, or a railway line. In other pictures, however, the existence of these lines may not be so noticeable but can still be an important

Above A relatively distant viewpoint has produced a picture in which these deckchairs appear to be of almost equal size. This diminishes the effect of perspective and depth and the subject appears to be almost all on one plane. A long focus lens was used to enable a tightly framed shot to be made.

Nikon F, 200mm lens, 1/125 sec. at f8. Ektachrome 64.

Below This picture of a maize store on a French farm relies upon the element of texture for its impact. A quite soft but directional light was adequate to reveal the fairly pronounced relief of the corn and the weathered wood structure. The restricted colour range has given it emphasis.

Nikon F3, 105mm lens, 1/60 sec. at f8. Ektachrome 64.

element and one that you should learn to be aware of. One way of seeing how these lines can build the skeleton of an image is to place a sheet of tracing paper over a well-composed picture and simply trace the main outlines. You will invariably find that the resulting lines will have a pleasing quality of their own. Lighting, too, can create lines through highlights and shadows, and of course there are the lines which define the shapes of objects within the picture.

Right *The effect of perspective and depth has been emphasised in this landscape shot by the inclusion of both close foreground details and distant objects. The boat appears to be about five times the size of the distant building, exaggerating the effect of perspective. A wide angle lens was used.*

Nikon F3, 20mm lens, 1/125 sec. at f5.6. Ektachrome 64.

Below *This picture of the big top going up relies for much of its effect on the presence of strong lines in the image, both those inherent in the subject and those created by the effect of perspective.*

Nikon f2, 20mm lens, 1/125 sec. at f8. Ektachrome 64.

Art of selection

What is it that makes us want to take a photograph? Obviously it is because we have seen something that is visually appealing or that we want to record, for example events and people in our lives. However, to take a successful picture, we must have a much more definite understanding of the reasons why we find a subject appealing and why we want to take a picture of it. The approach you might adopt for taking a picture of your house in order to sell it would be quite different to that which you would apply if you were going to make a claim for damage that had been caused to it. In this case, the underlying reasons and the correct approach is quite obvious. When you are taking a photograph for pleasure the reasons are just as important but are quite often not fully considered, and many of the disappointing pictures that are taken are a direct result of this lack of objective thought.

When we look at a scene, our eyes scan it continuously, feeding a flow of information to our brain, which then selects and edits the images received according to our interest, emphasising those things that we find appealing and subduing unattractive or distracting elements. The camera, however, does no such thing. It records clearly and objectively what is in front of it. Unless it is aimed with thought and care, the result can easily be a confusion of details in which the elements which we found attractive are often lost or dominated by the parts of the image that our brain had thoughtfully edited out. Before even considering taking a photograph, it is essential to make yourself fully aware of why you want to take it, exactly what it is about the subject that you find attractive and, of equal importance, what it is that is *not* appealing and would be best excluded or subdued.

The ability to identify the visual elements is an important first step in this process, since it will teach you to be aware of the things that can actually be recorded by the camera. We are often attracted to a scene not only by its appearance but also by the way it sounds, smells or even provokes a nostalgic memory. When confronted by a seascape, for example, a great deal of its attraction may be to do with the smell of the sea, the sound of gulls and childhood memories. It can be little wonder in these circumstances that a mere record of the visual aspects could be very much an anticlimax. You must learn to see only the colours, shapes, textures and patterns, and by selecting them carefully create a picture which gives a visual impression of these other fragrant or atmospheric qualities.

Many pictures are disappointing because there is too much going on in an image. Indeed, one of the most common faults in beginners' pictures is that they simply do not get close enough to the subject and include too many irrelevant and distracting details, which dilute or even destroy the point of the photograph. Quite often there is more than one picture in a scene and you should always explore a subject fully before you decide how and what to photograph. Many people take a shot from the place they first saw the possibility. It is most unlikely that this will be the best picture. You should always look at a subject from different angles and with different framing to see whether including more or less of a scene will have the best effect and whether other or better shots may not be found than the one you first saw.

Below *This shot of a country market in Sri Lanka shows a fairly broad view of the scene, which was in fact a first impression. Careful framing has produced a well-balanced composition.*

Nikon F3, 20mm lens, 1/125 sec. at f8. Ektachrome 64.

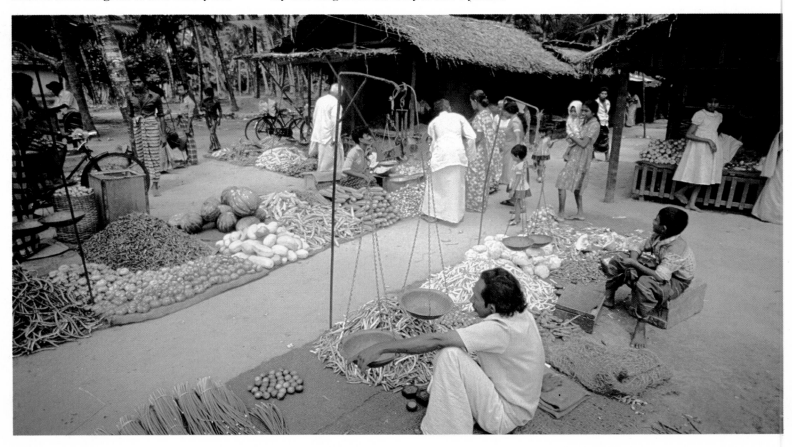

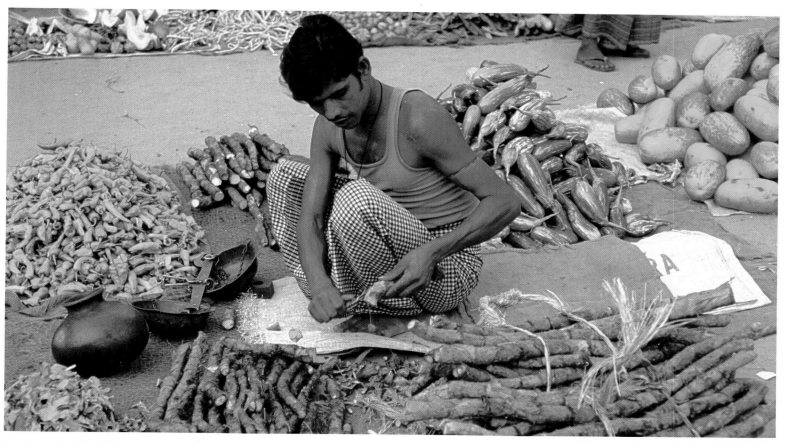

These three pictures were taken in the same market, but show what you can do with a more selective approach. Although they are not, perhaps, the most immediately obvious pictures to take of this scene and show less of the subject, they do tend to have a more direct and uncluttered quality. In fact, a dozen or so successful shots were taken within a short space of time simply by making a closer and more selective exploration of the subject, using different viewpoints and lenses to control the framing of the pictures. A close viewpoint combined with a wide angle lens allows the subject in the picture above to be quite large in the frame, but includes enough of his surroundings to tell the story. A more tightly framed picture, left, was achieved by the use of a long focus lens, and the very tightly framed shot, right, was taken from a close viewpoint with a long focus lens.

Above Nikon F3, 35mm lens, 1/250 sec. at f8. Ektachrome 64.
Left Nikon F3, 105mm lens, 1/250 sec. at f4. Ektachrome 64.
Right Nikon F3, 150mm lens, 1/250 sec. at f8. Ektachrome 64.

Organising the image

Composition is the process of organising the individual details and visual elements of a scene into a balanced and pleasing arrangement. This is very largely a matter of personal taste. It does, however, need to be considered and many pictures taken by inexperienced photographers are the result of just aiming the camera at a subject as if it were a gun, with the most important detail simply centred in the viewfinder. This approach will invariably create a rather static and uninteresting arrangement and, more importantly, make it difficult for other details to be included in a balanced way.

The success of most pictures depends on there being one aspect of the image that is the most important or dominant. This is known as the **centre of interest**, and it is vital that its identity is established before the camera is aimed. In some instances, this will be perfectly obvious, such as a person's face in a portrait, but in other cases it may be less easy to determine. In a landscape picture, for instance, it may simply be a particular area of tone or texture and it can often be a highlight or a shadow. Nevertheless it is important, since it is to this detail that the eye should be most strongly led and around which the other elements of the scene must be arranged to harmonise and balance. Since the centre of the frame is seldom the best position for the centre of interest, you must move the camera around to see where the most effective balance is created. One of the rules of composition states that the centre of

interest should be placed at a point where hypothetical lines dividing the image into thirds horizontally and vertically meet. Although it is unwise to follow such rules slavishly, this advice will often lead to a pleasing if conventional result.

Where the maximum impact is required for the centre of interest, the most basic approach is to simply exclude other details by framing the picture very tightly. This can be an effective method of composition for some subjects such as people or animals where facial expressions are crucial. However, more often it is necessary to include other details either to show more of a scene and to give more information or to create atmosphere and visual impact. In this circumstance the image has to be framed so that these additional details play a subsidiary role to the centre of interest, complementing and enhancing it, not competing with it or distracting from it. You should aim to arrange these other elements either so that they lead the eye towards the centre of interest or that they create a balance, enabling the attention to pass from one detail to the other but with the main point of interest as the dominating feature and focal point.

There are a number of simple techniques which can help in the organisation of an image. Lines of perspective, for example, can be used as a lead-in to the main point of interest. Tonal and colour contrast can be arranged so that the centre of interest attracts the eye more strongly than other

details. Foreground details can often be used to contain the attention and to prevent the eye straying beyond the borders of the image. Such details can be used to create a frame which echoes some or all of the sides of the picture itself, for example an archway or a similar strong shape close to the camera to add emphasis to a more distant subject.

Above *This portrait of a French blacksmith could have been taken by moving in closer to frame his face and exclude other details. However, it was felt that the background contributed to the effect of the picture, so it was included, but in such a way that it created a pleasing balance with the subject and was not allowed to become a distraction.*

Nikon F3, 35mm lens, 1/125 sec. at f5.6. Ektachrome 64.

Left *Although the centre of interest in this shot — the two people — is quite small in the frame they remain in effect a strong focus of attention, partly because they are boldly contrasted against the background and partly because they have been placed in the strongest part of the image, at the intersection of thirds.*

Nikon F3, 400mm lens, 1/125 sec. at f5.6. Ektachrome 64.

Above Using foreground details to create a frame within the borders of a picture is often an effective way of organising the elements. The overhanging branch of a tree has been used in this landscape shot to prevent the eye straying away from the main part of the image. At the same time it helps to emphasise the effect of perspective and the impression of depth.

Nikon F, 28mm lens, 1/125 sec. at f5.6. Ektachrome 64.

Left The road in this landscape shot has been used to create a strong line of perspective which leads the eye into the picture and towards the centre of interest. The effect is further heightened by the bold tonal contrast between the backlit road and the remainder of the image.

Nikon F3, 200mm lens, 1/125 sec. at f8. Kodachrome 25.

Choosing a viewpoint

When you are shooting a subject like a portrait or a still life, it is possible to a large extent to control directly many of the visual aspects of the subject such as the lighting, the background and the composition. However, the majority of pictures taken of outdoor subjects offer far less opportunity to manipulate the subject to suit your purpose. In most cases, your only variable is the choice of camera viewpoint.

Viewpoint dictates how much of a subject is included in the frame. By moving closer you can frame more tightly, creating emphasis and excluding unwanted details. By moving further back, you can create more space around the subject and include other details and elements of a scene. However, whichever way you go will also affect the perspective of the image and the relationship between the various elements. By moving closer, for instance, the foreground details of the scene will become larger in proportion to the background objects. A more distant viewpoint will make more distant objects appear larger in comparison to the details closest to the camera. Moving to the left or right will also have a significant effect on the juxtaposition of objects within the picture.

Even quite small changes in the camera viewpoint can have an important effect on the composition of the picture and it is vital to be aware of this changing relationship between objects on different planes in a scene.

The relationship between subject and background is perhaps the most important concern in selecting a viewpoint and the one that can suffer the most if ill-chosen. Most cameras are designed to be used at eye level, and that, indeed, is where most pictures are taken from. Consequently, a picture taken from a higher or lower viewpoint will often have a degree of impact just because it is out of the ordinary. You should always consider the possible benefits of shooting from, say, a kneeling position, or finding a higher viewpoint. This can often be an effective way of creating a more suitable background. A low viewpoint could remove distracting background details and allow the subject to be positioned against the sky. The composition too will be affected by such changes. A low viewpoint often creates a more dramatic quality, emphasising perspective and creating images with a more vigorous and dynamic mood, whereas a high viewpoint will often produce pictures that emphasise shapes, textures and patterns and have a more graphic quality.

Lighting is also an important factor that will be affected by camera viewpoint, particularly on a sunny day when the lighting is quite hard and directional. The juxtaposition of highlight and shadow will be dependent on this factor.

Above and right These three pictures show how the composition and nature of an image can be altered by the choice of viewpoint. In each case, both the shape of the tree itself and its juxtaposition with the wooden framework in the water is completely different, although nothing but the camera position was changed.

Nikon F3, 105mm lens 1/250 sec. at f8. Kodak Tri X.

Above A very low viewpoint was responsible for the effect of this urban landscape. A wide angle lens has emphasised the dramatic perspective which the viewpoint has created and a polarising filter makes the blue sky a darker and richer colour.

Nikon F3, 20mm lens with a polarising filter, 1/125 sec. at f5.6. Kodachrome 25.

Right This picture was taken from a high viewpoint, creating an unconventional image. The choice of viewpoint has made the beach the background of the shot, producing a simple and uncluttered picture.

Nikon F3, 200mm lens, 1/125 sec. at f5.6. Ektachrome 64.

Colour contrast

It is hard to believe today that not so very long ago photography was a black and white medium and that photographers had to develop the technique of ignoring the colour element of a scene and visualise it in shades of grey. Film technology now makes the accurate reproduction of colour a simple and automatic process and one that is largely taken for granted. A colour photograph is now so commonplace that photographers who wish to make personal and expressive statements with their pictures very often choose to do so by working in black and white. The abundance, ease of production and realism of colour images has resulted in a general tendency for the majority of colour photographs to become little more than a simple record of a scene. The photographer who wants to lift his or her work above this level must do so by applying the same selective and controlled approach to the colour content of their subjects as the Victorian photographers applied to the tonal gradations of theirs.

The first step in this process is to understand the nature and relationship of colours. We are all familiar with the spectrum and the bands of colour that it creates, starting with red and progressing through orange, yellow, green, blue and indigo to violet. This band of colours and the position of individual hues within it has a great deal to do with the effect that colour has in an image. It is important to learn to see a subject in terms of these colours and to be aware of their relationship.

The most dominant quality that colours can have in a picture is when they are in contrast with each other. This happens when the largest areas of colour come from widely spaced areas of the spectrum band. There is little contrast, for instance, between red and orange, but considerable contrast is created

Above *Tight framing has helped to produce a picture of almost stark simplicity dominated by a single colour. The bright red railway wheel is thrown into bold relief against the black shadowed background, emphasising the shape and line.*

Nikon F3, 105mm lens, 1/125 sec. at f5.6. Kodachrome 64.

Right *Although there is a lot going on in this picture, its effect is primarily reliant upon the strong colour contrast between the red truck and the blue background. Careful choice of viewpoint and framing has excluded distracting colours and allowed the juxtaposition of these two contrasting hues to dominate the composition.*

Nikon F3, 150mm lens, 1/125 sec. at f8. Kodachrome 64.

when red is juxtaposed with blue or green. Contrast will also be created when a colour is placed against white or black. The degree of contrast will also be affected by the saturation of the hues involved. Fully saturated primary colours will create a more dramatic contrast than that between softer, pastel colours.

For this reason, they should always be within the main point of interest. If they occur in the background of the picture, they will create a distraction in the same way that a bright highlight would.

Right *Although this picture of beach huts contains a mixture of bright colours they have been organised and controlled by a strong composition creating the element of pattern.*

Nikon F3, 24mm lens, 1/125mm sec. at f8 with a polarising filter. Kodachrome 64.

Below *This landscape picture depends entirely upon its colour content for its effect. It is the colour contrast between the red tree and the surrounding greenery that creates the composition. Without this the picture would be both meaningless and pointless. A long focus lens was used to isolate a small area of the scene.*

Nikon F3, 200mm lens, 1/125 sec. at f8. Kodachrome 64.

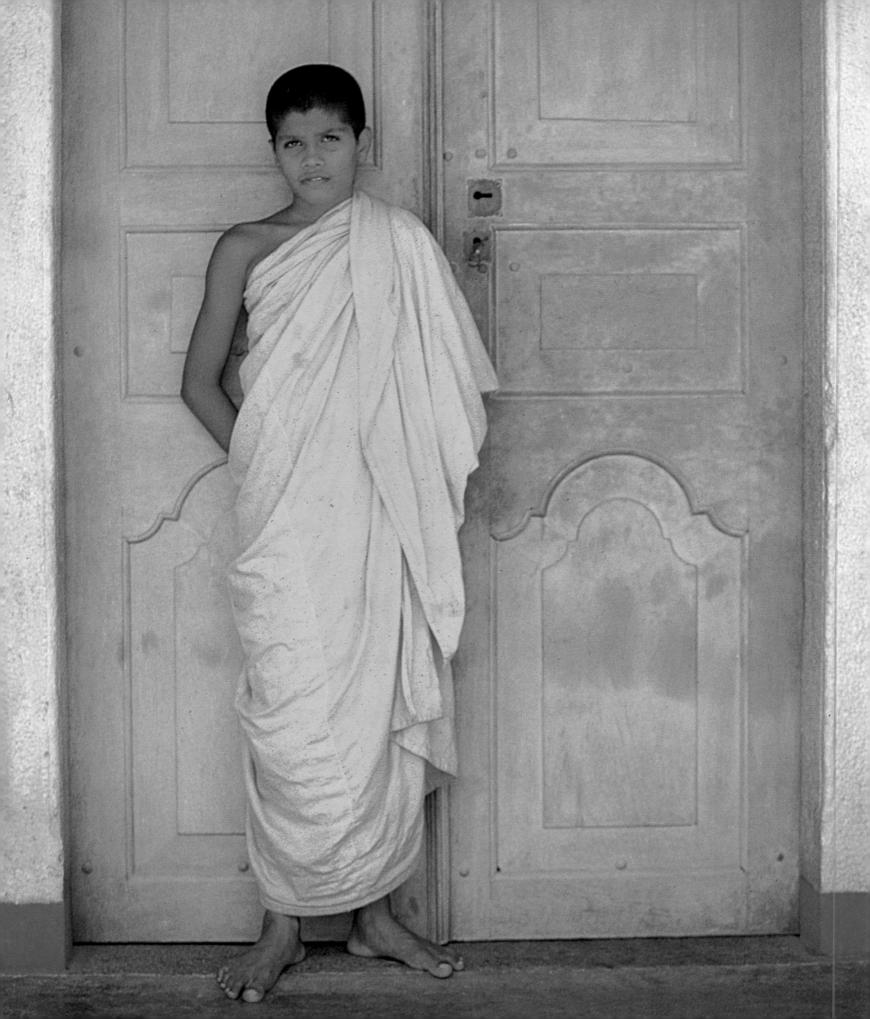

For most subjects over which you do not have direct control, the only chance you have to organise and select the colours in your image is in the choice of a viewpoint and in the way the picture is framed.

When this relationship between colours exists in a subject it needs a very careful and considered approach to avoid confused and fussy images. Paradoxically, a scene which contains a variety of bright contrasting colours is more likely to produce a poor colour photograph than a more subdued subject. The reason is that the presence of bold colours in an image can easily override the other elements and unless the colours are distributed and used to create a balanced composition, the result will invariably be disappointing even if other aspects of the picture are well considered.

As a general rule, the most effective way of using bold contrasting colours is to limit them to just two or three basic hues. The most striking colour photographs are often those that contain just one dominant colour for the main point of interest, with a background of a contrasting colour. The warm colours such as red, orange and yellow are the most dominant and have a powerful effect.

Left This photograph of a young Buddhist monk relies entirely upon the use of colour for its impact. The choice of viewpoint and framing has resitricted the picture to two hues which have created a strong contrast.

Nikon F3, 150mm lens, 1/125 sec. at f5.6 Ektachrome 64.

Left Although this picture is primarily monochromatic and the area of colour is only a tiny proportion of the whole picture, the effect is still very 'colourful'. This is because the bright windsurfers are in bold contrast to the background and also are placed in a strong position within the frame.

Nikon F3, 400mm lens, 1/250 sec. at f8. Ektachrome 64.

Below This type of subject requires a very careful approach as a mixture of bright, contrasting colours can easily create a confusing image. Using the colours as a foreground element leads the eye towards the centre of interest.

Nikon F3, 20mm lens, 1/250 sec. at f8. Ektachrome 64.

Colour harmony

The opposite effect of colour contrast is created when the dominant colours of a subject are close together in the spectrum. In this case their relationship instead of being bold and assertive is quieter and more restrained, like the blues and greens of a summer landscape compared to the garish quality of a seaside pier for instance.

Like colour contrast, a harmonious quality is also partly dependent on the saturation of the colours as well as their respective positions in the spectrum. Soft pastel colours or dark and subdued hues will be more likely to create this quality even when they are slightly opposed. The distribution of colours is not quite as critical in this type of picture as it is with contrasting hues, and their presence will be less likely to dominate other elements of the composition. For this reason, a subject in which qualities such as pattern, texture or form are important to the effect of the picture will be more telling when it also has a harmonious colour quality. In addition, the ability of a picture to create a sense of mood or atmosphere is also likely to be enhanced when it contains harmonious colours.

The easiest way of creating this quality in a picture is by excluding contrasting colours from the image by the choice of viewpoint and in the way the picture is framed. Harmony can be most readily achieved by using colour that is limited to tonal variations of the same hue, such as the greens in a landscape shot, for example. However, the effect can still be produced when a wider range of colours is present, as long as they are distributed in a way that enables them to blend or where one particular hue dominates the picture. When this occurs, the mood will be largely dependent on the nature of that colour. A picture dominated by a colour from the orange to red end of the spectrum will tend to have a warm and inviting quality, while a photograph dominated by blues or greens will have a cooler, or even bleak atmosphere.

Colour harmony can also be created by other factors. Lighting and atmospheric conditions can cause an essentially brightly coloured scene to record on film in softer more subdued colours. A landscape photographed on a heavily overcast day would have a quite different colour quality to one shot in bright sunlight. Pictures taken in mist or rain invariably have a harmonious quality. Exposure can also be used to emphasise and in some cases create this effect. Overexposure will reduce the colour saturation of an image, creating softer pastel hues. Underexposure will make them darker and more subdued. The overall colour quality of the image can also be an important factor. A picture that has a colour cast as a result of being photographed in warm evening sunlight

or in the bluish quality of dusk will tend to have a harmonious quality because the colour cast will bring the natural colours of the scene closer together and have a unifying effect. This can also be artificially created by the use of colour correction filters. In some circumstances, fog or pastel filters can be used to soften and blend the colours in an image as can a soft-focus attachment for a similar effect.

Above Colour harmony has been created in this picture by the simple expedient of limiting the image to a single colour with tonal variations of the same hue created by highlight and shadow. This has helped to emphasise the elements of texture and pattern within the image, qualities which can be diminished by a wide range of colours.

Nikon F3, 105mm lens, 1/125 sec. at f8. Kodachrome 25.

Left Soft lighting and a little mist have created a harmonious quality in this landscape shot, reducing the saturation of the colours and helping them to blend to make an atmospheric picture. Bright sunlight and a clear blue sky would have produced a more colourful but less evocative shot.

Nikon F2, 300mm lens, 1/60 sec. at f5.6. Kodachrome 25.

Right Tight framing and an effective choice of viewpoint have restricted the colour range in this landscape shot to the same area of the spectrum, resulting in a harmonius image.

Nikon F2, 200mm lens, 1/60 sec. at f5.6. Kodachrome 25.

Below Although this shot of a French café contains a variety of colours, the picture is dominated by a single colour which is responsible for both its mood and quality. The essentially monochromatic nature of the picture also helps to emphasise the elements of pattern, shape and line upon which the composition depends.

Nikon F3, 70mm lens, 1/125 sec. at f5.6. Ektachrome 64.

Colour and the subject

Because colour is such a powerful element in an image, it can often be as important – in some cases, even more important – than the subject itself, to the extent that where the colour content of a scene is incompatible with the subject – if it creates the wrong mood for example – it would be preferable to shoot in black and white. Understandably, most people respond primarily to the subject content of a picture and an inexperienced photographer may well often decide to shoot in colour simply because the camera happened to be loaded with that film. Yet a good colour photograph invariably requires that you respond first to the colour content of an image and then decide how it can be most effectively used in terms of the subject. In some of the most telling colour photographs the subject is either of little importance or is even unidentifiable.

The use of colour to create pictures with an entirely abstract appeal is one way of learning to become aware of and to control this important factor in a picture, as well as producing good pictures in the process. This approach is largely controlled by the careful selection and juxtaposition of the elements. This is turn is dependent upon the way the image is framed and by the choice of viewpoint. One advantage of this type of picture is that you are seldom at a loss to find a potential picture, since it depends more upon the way you see and interpret things than on what you see.

The use of close-up equipment and techniques can greatly extend the scope of this approach to colour photography. Many commonplace and familiar objects can reveal details of considerable beauty and visual interest when looked at more closely. Photomicrographs of crystals and cell structures can be used to create images that have more in common with an abstract painting than with a photograph.

Where the subject is of prime importance, on the other hand, you must learn to be very sensitive to the effect of colour and use the ways of controlling both the quality and the reaction between colours to enhance the effect of a picture. Many of the most popular types of picture, such as portraits and landscapes, can often be disappointing because the element of colour has not been fully considered. Skin quality is vital in portraits and nudes and the difference in the

effect of a picture which has a natural and pleasing flesh tone to one that has a cold or pale quality can be quite dramatic. Lighting can be a vital factor in this respect, and so too can exposure. Do not overlook the possibility of using filters to enhance the colour quality of this type of subject. Often the addition of, say, an 81A filter to add a little warmth to a skin tone can make all the difference. Similarly a polarising filter used for a landscape shot will reduce the light reflected

from foliage and sky and increase the depth and effect of the colour.

It is also most important to appreciate just how much the colour quality of a subject can be manipulated by exposure techniques. This is something that can be most effectively learned by bracketing exposures. In this way you will not only be more likely to obtain the precise effect you want to achieve but also to learn how to predict the effect of your finished picture when making the exposure.

Right *A field of cabbages is not, on the face of it, a stimulating subject for a photograph, but by recognising the colour content potential a striking colour picture has been created.*

Nikon F3, 200mm lens, 1/125 sec. at f8. Ektachrome 64.

Right Close-up pictures, such as this shot of a leaf, often reveal striking and effective colour qualities that can be controlled relatively easily by the choice of viewpoint and in the way the picture is framed. Many commonplace and largely unnoticed objects can be used effectively in this way once you learn to respond to the colour content first and the subject second.

Nikon F3, 150mm lens with extension tube, 1/30 sec. at f11. Ektachrome 64.

Above This is a good example of a picture which does not benefit at all from its colour content. Indeed, it would be more successful in black and white. In this shot, the colour element is simply a confusion and a distraction which diminishes the appeal of the subject rather than contributing to it.

Nikon F3, 105mm lens, 1/250 sec. f5.6. Ektachrome 64.

Above A portrait like this picture of a girl depends very largely upon a pleasing skin quality. Soft lighting has helped to create a flattering effect without unpleasant shadows and an 81A filter was used to guarantee an attractive warm flesh tone. The bluish quality that can result from shooting into the light or in open shade can make skin appear cold and waxy.

Rolleiflex SLX, 150mm lens, 1/125 sec. at f5.6. Ektachrome 64.

Flash technique

A small flash gun is probably the first major accessory that most people buy. It can be an invaluable aid to increasing the scope of your photography and the conditions in which you can take your pictures. However, unless it is used with a little thought and care, it will more often than not simply create a barely adequate record of a scene or occasion. Many inexperienced photographers simply accept the harsh, stark quality of direct flash as inevitable. It need not be so. With a little experience it is possible to use even a small flash gun to create quite pleasing lighting effects.

The most common fault with flash pictures is that the subject is harshly and flatly lit, with a background that is either a black void or submerged in shadow. It is important to appreciate that the light from any small source diminishes in brightness the further it travels. Since the correct exposure is calculated according to the distance the flash gun is from the subject, anything that is appreciably further away will be considerably underexposed. In addition, objects that are in front of the subject will be overexposed and

bleached out. For this reason when a flash gun is aimed directly at the subject, it is vital that all of the important elements of the scene are on a similar plane and will be illuminated with a more or less equal amount of light.

Using a flash gun in this way can also create two other problems. One is the familiar red eye effect. The other is that when the flash gun is attached to the camera it provides a completely frontal light and creates no modelling within the subject. Both of these faults can be overcome by the same means: moving the flash gun away from the camera and holding it or supporting it about a metre above and to one side of the camera. This will create a better impression of form. It will also prevent the light being reflected back into the camera from the retinas in the eyes of your subjects, which produces the red Martian glow.

When you are taking pictures in a room that has white or pale walls or ceiling, it can often be more satisfactory to use the bounce flash technique. This involves aiming the flash gun at the walls, the ceiling or both and reflecting its light from these surfaces onto

the subject. This creates a much softer and more even lighting with better modelling. It also eliminates the hard-edged shadows which are a characteristic of direct flash. However, it will require an increase of exposure. A dedicated flash gun, or one that has a sensor that remains aimed at the subject when the flash is aimed at the ceiling, will allow for this, but in other cases you must estimate the distance from the flash to the ceiling and then to the subject, divide this into the flash gun's guide number and open up about one stop to allow for the light scattered by reflection. Where a suitable white decor is

Below *These three pictures demonstrate different ways of using a small flash gun. In all three pictures the subject has been placed close to a light-toned background to ensure that subject and background are both lit to a similar level. The diagrams show how the flash gun was positioned for each shot.*

Rolleiflex SLX, 80mm lens, pictures 1 and 2 f16, picture 3 f5.6. Kodak Tri X.

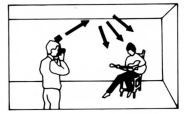

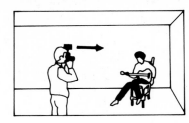

not available, you can also bounce the light from a large white reflector or soften it by diffusing it with a tracing paper screen, for example.

Most people using flash usually just set the shutter speed of their camera to the flash setting, which with a focal plane shutter is usually about ¹⁄₆₀ to ¹⁄₁₂₅ second. However, by using a much slower shutter speed, you can make use of the ambient light. In this way the foreground subject can be illuminated by the flash but the background can be recorded by the existing lighting. The actual shutter speed selected will, of course, depend on the brightness of the ambient light. It can be calculated with an exposure meter in the normal way for the aperture required for the correct flash exposure.

Right What happens when you make use of the ambient light is shown in these two pictures. The picture far right was taken with the shutter speed set for normal flash synchronisation. In the picture near right a slower shutter speed was used to record the light from the fire as well as the flash.

Rolleiflex SLX, 150mm lens, near picture 1/8 sec. at f8, far picture 1/125 sec. at f8. Kodak Tri X.

Below Two types of flash gun. The Vivitar 285, left, is designed to fit into the accessory shoe of the camera. It has a zoom device for controlling the spread of light, a tilting head for bounce flash and a built-in sensor to give auto exposure control. On the right is the Metz 60 CT, a more powerful 'hammerhead' style gun designed to attach to the camera by a bracket.

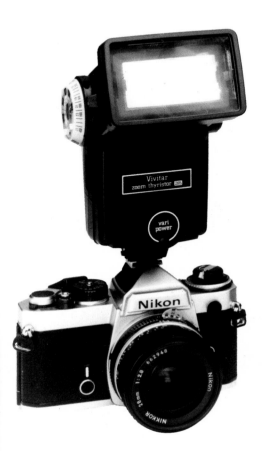
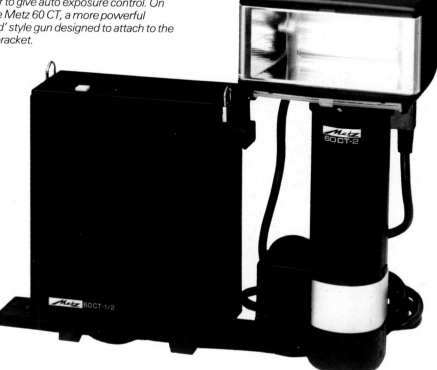

Available light

When the level of illumination drops beyond a point at which normal exposure settings cannot be used easily, the choice is either to use supplementary lighting such as flash or simply to make the most of the available light and find ways of overcoming its inadequacies. There are occasions when this approach is preferable. In some situations, it is simply not possible to illuminate a scene artificially, such as street scenes at night or stage performances where flash is not permitted. Even when it is possible to use extra lighting, it is sometimes not advisable. It may destroy the atmosphere created by the ambient light, or it may intrude or distract the subject.

The immediate problem you encounter when using low levels of available light is that the normal settings that you are accustomed to using in outdoor lighting are no longer appropriate. Even with fast film, you will need to use very wide apertures and relatively slow shutter speeds. This creates its own set of problems. With wide apertures, depth of field will be very restricted and focusing must be precise. This can be particularly difficult when the light is poor. A useful method is to find a bright highlight in an important detail of the subject and focus on that.

Poor light usually means shutter speeds below which it is normally considered safe to hand-hold a camera. The risk of camera shake is greatly increased at settings less than 1/60 second. In these circumstances it is vital that the camera should be handled carefully. A firm grip and a gentle squeeze to release the shutter will do much to overcome the problem. Even so, it is preferable to find some additional support for the camera. Obviously a tripod is the ideal solution, and if the subject is static, speeds of several seconds or longer are no problem. If a tripod is not available or convenient then you should find some other means of stabilising the camera. Kneeling, sitting or squatting can enable you to rest your elbows on your knees and this can eliminate much of the risk of camera shake.

Ways of using slow shutter speeds are only useful if the subject is fairly static. When this is not the case, it is preferable to use very fast films, possibly combined with push-processing. The indicated speeds of most fast black and white and colour transparency films can be uprated by two or even three stops, either by using modified processing times or by the use of speed-enhancing developers. If you do not process your own films this service is offered by professional processing laboratories at a small extra cost. Of course, this gain in film speed is not without cost and the grain and contrast of the image are increased, resulting in a general lowering of the quality. However, this can often enhance the atmosphere of many situations.

When shooting in colour, available light photography often involves having to use mixed light sources such as daylight and tungsten, for instance. To create the most natural effect it is best to use the film type that is balanced for the light source.

Below *This picture of The Strip in Las Vegas was taken with the camera mounted on a tripod. It was shot before dark while some light remained in the sky and some detail in the shadows.*

Nikon F3, 200mm lens, 1 sec. at f11. Ektachrome 200.

Left Although the light level was low for this shot of a lime kiln, the use of flash would have completely destroyed the atmosphere and the quality of the lighting. A hand-held camera was used, braced against a wooden beam for additional support, allowing the shutter speed to be fairly slow.

Nikon F3, 50mm lens, 1/15 sec. at f2.
Ektachrome 200.

Right Taken just before dusk, this shot of the Tivoli Gardens in Copenhagen is lit with a mixture of daylight and artificial light. The use of daylight film has created a pleasing colour quality, with natural tones in the daylight-lit areas but a warm glow where the tungsten light predominates.

Nikon F, 50mm lens, 1/30 sec. at f2.
Ektachrome 200.

Below Artificial light film was used for this shot of a street kitchen in Sri Lanka, illuminated by a gaslight. The exposure was calculated by taking a close-up reading from the subject — being careful to exclude the gaslamp itself — and the picture was tightly framed to avoid the inclusion of large areas of dense shadow.

Nikon F3, 50mm lens, 1/30 sec. at f1.4.
3M 640T Film.

The Visual Themes

Landscape-basic approach

Although photography like many other crafts has become quite specialised, if there is a common theme to be found in most people's work it is almost certainly landscape. Why this urge for the great outdoors? Apart from simple pleasure, one reason is that landscape subjects are totally accessible. They do not require the use of specialised knowledge or equipment, as do wildlife or still-life work. More to the point, landscape displays one of the most important and exciting aspects of the medium, a constantly changing interaction between light and subject.

The equipment needed for successful landscape photographs is as diverse as the subjects and approach, ranging from the immaculate and detailed images produced on large-format cameras to the softer, more evocative and even abstract pictures that can be created with even a simple instrument such as an instant picture or cartridge camera. For the 35mm SLR photographer who likes to exploit the use of different attachments, the many styles of landscape provide endless opportunities.

Black and white photography lends itself particularly well to landscapes. The mood and quality of natural light can be transposed with powerful effect to the rich tones and textures of a fine black and white print. However, just as photographers such as Ansel Adams and John Blakemore have explored these aspects of the subject, so too have photographers like Ernst Haas and Franco Fontana responded to the powerful effects of

the colour content of the landscape subject, creating equally striking images but in a totally different way.

For many people the term landscape conjures up an image of a broad vista or a beautiful view, but this is only one way of interpreting the theme. It can just as easily be a close-up of a gnarled tree or the sea-carved striations of a rock formation. Indeed, even the rural connotation of the word is not entirely appropriate, since city streets and the urban environment in general provide many opportunities for the photographer.

Whereas many pictures consist of a subject and a background, the landscape image is more often a unified image consisting primarily of large masses of tone or colour rather than defined details. The process of composition in these terms can encourage a less formalised approach than some other subjects. It is easy to think of landscape as a passive subject for the camera, allowing the photographer to adopt a more studied and introspective approach. While this is sometimes the case, more often a landscape picture can have a degree of spontaneity and immediacy that requires a swift response to capture a subtle change of light. The unique quality which exists in the 'slice of life' type of picture is just as readily apparent in a landscape shot. It is equally unlikely that the same elements and circumstances will ever be combined in the same way again, as anyone who has seen a good picture and decided to return to take it later will know.

Above The broad view is only one aspect of landscape photography and in some ways the most difficult to achieve successfully. The close foreground details in this shot help to lead the eye into the image.

Nikon F, 28mm lens, 1/125 sec. at f8. Kodachrome 25.

Left This picture depends to a large degree for its impact upon the swift response to a fleeting moment when the clouds allowed the sun to create a dramatic lighting effect lasting for only a few seconds. Frames exposed just before and just after this one do not have the same strong quality.

Nikon F3, 20mm lens, 1/250 sec. at f8. Ektachrome 64.

Right Isolating relatively small areas from a scene is an approach which often makes it easier to control the composition of a picture and to produce images with greater impact and a more definable centre of interest.

Nikon F3, 150mm lens, 1/60 sec. at f8. Ektachrome 64.

Above Landscape photography does not have to be restricted to the countryside. The urban environment also has considerable potential. This shot taken in San Francisco uses the shapes, patterns and textures of the buildings to create an effective composition. A long focus lens was used to isolate a small area of the scene.

Nikon F3, 200mm lens, 1/125 sec. at f8. Kodachrome 25.

Landscape-sky and water

The sky is very frequently an important element in a landscape picture and needs to be given special consideration. The main problem with photographing skies as part of a larger picture is that they are, in effect, a part of the light source, since the sky acts as a reflector. This means that an exposure which is adequate to record detail in darker foreground tones will often leave the sky overexposed, resulting in weak tones and a lack of detail and colour. There are a number of ways of overcoming this. With a blue sky with white clouds for example, a polarising filter can often be used when shooting in colour to make the sky a deeper colour and cause the clouds to stand out in bold relief. When you are shooting in black and white, a polarising filter can still be used, but you can also use colour contrast filters. A yellow filter will give a quite subtle effect, recording the blue sky as a slightly darker shade of grey. An orange filter will produce quite a dark tone and a red filter will create a dramatic effect, with the sky recording as almost black.

These techniques can only be used with a blue sky. On a cloudy day, other means are necessary. One of the most effective ways is to use a graduated filter. This is a tinted glass or plastic filter which graduates off to a clear tone at the half-way mark. It can be moved up and down within its mount so that the demarcation line coincides with the horizon. In this way it can be used to make the sky a darker tone without affecting the exposure for the lower half of the image. As well as neutral grey, it is available in a range of colours and usually in two different

Above A polarising filter was used for this Normandy landscape to make the sky and foliage a darker and richer hue without affecting the colour quality of the image. It required an increase in exposure of between one and a half and two stops. In black and white shots, a similar effect can be created by using an orange filter.

Nikon F3, 85mm lens, 1/125 sec. at f5.6. Ektachrome 64.

Below The effect of this sunset picture was created by calculating the exposure for the sky and ignoring the foreground, simply allowing it to become underexposed and silhouetted.

Nikon F3, 200mm lens, 1/250 sec. at f5.6. Ektachrome 64.

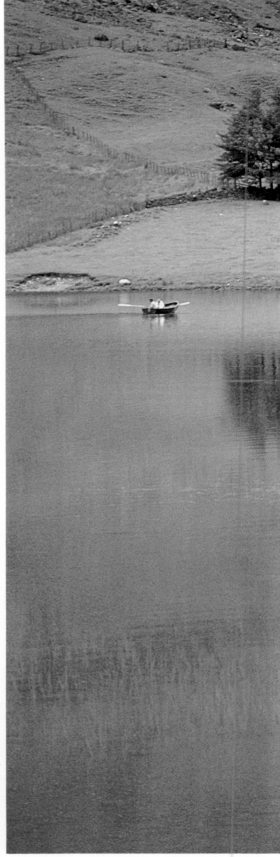

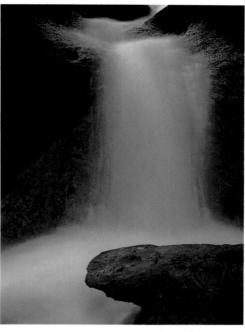

Left The still water of this Welsh lake has created an almost mirror-like reflection of the surroundings. The rich tones and sombre colours of the mountain beyond seen in its surface have been used as a dominant part of the composition.

Nikon F3, 150mm lens, 1/125 sec. at f5.6. Ektachrome 64.

strengths. You can also combine two or even more. The most natural effects will be achieved when shooting in colour with the neutral type, but the coloured variety can be helpful when you want to add colour to a sunset, for example.

Often the most effective skies are achieved quite naturally. Storm clouds, for instance, can produce areas of quite bright sky which will illuminate the landscape, as well as very dark tones. This sort of scene usually needs no artificial aids other than accurate exposure. You can also create quite dramatic pictures when there is an interesting sky simply by finding a striking foreground shape which can be used as a silhouette and underexposing the shot to emphasise the effect of the sky. This technique can be effective with sunsets.

Water can also be a dominant element in landscape pictures either as an incidental detail, such as a river, or as the *raison d'être*, as with a seascape. The effect of water in a shot will be partly dependent on the sky, since it is this which creates the tones reflected in the water's surface. The movement of the water will also have a significant effect. Still water can create an almost mirror-like reflection of its surroundings, whereas moving water can produce a textural effect when fast shutter speeds are used.

Above In this picture an exposure of several seconds was given with the camera mounted on a tripod using a very slow shutter speed.

Nikon F3, 105mm lens, 4 sec. at f22, with a neutral density filter. Kodachrome 25.

Below A graduated filter was used for this shot of the River Loire to allow full exposure for the foreground without the sky being overexposed.

Nikon F3, 24mm lens, 1/125 sec. at f8. Ektachrome 64.

Landscape-depth and distance

A photograph is an image that exists in only two dimensions, yet it can often effectively create the impression of three. This is a quality that can contribute to the effect of landscape photographs, particularly when the purpose is to convey an impression of a specific place. A landscape shot of a distant subject can easily result in a picture which exists on only one plane, with subsequent lack of depth in the image. Most types of picture consist of a subject and background on two different planes, but the landscape picture must often be contrived to create this effect. For this reason the foreground can be a particularly important element in the composition.

In most other subjects, the main point of interest is the closest object to the camera, but when shooting landscapes it is often necessary to think in terms of foreground and subject rather than subject and background. The inclusion of foreground details accomplishes two things. It establishes the presence of another plane and it also emphasises the effect of perspective. The closer the foreground is to the camera, the greater this effect will be and it can be further enhanced by the use of wide angle lenses. You should develop the habit of always looking at the possibility of including foreground details in this way, since this one simple factor can make the difference between a flat, dull shot and a really good picture. In this respect the choice of viewpoint becomes a vital consideration.

Although a change in camera position of a metre or so will have no effect on more distant details, it can make a dramatic difference to the relationship between foreground and a more distant subject. The effectiveness of foreground interest can be increased by using it to emphasise the composition as well as the impression of depth. For example, you can use such details to create a frame within the borders of the picture. Including the overhanging branch of a tree is a good example of how you can create depth and improve the composition of the image. Another useful technique is to find a foreground detail that recedes into the picture, such as a road or a fence.

The tonal range of the image can also help to improve the quality of depth and distance. Try to keep the darkest tones closest to the camera, becoming progressively lighter towards the distance. This is where the silhouetted foreground frame can be particularly effective. Look out for a natural recession of tones produced by atmospheric haze. Sometimes called *aerial perspective*, it will be most marked when there are quite well-defined planes within the subject, such as a series of contours in a landscape or a

mountain range. It can often be created after the sun has gone down, leaving almost silhouetted shapes which become lighter in tone towards the horizon. Unlike linear perspective, aerial perspective can sometimes be more emphatic when a long focus lens is used. In black and white pictures the effect can often be enhanced by using a deep blue or green filter. However, in circumstances where you want to eliminate or reduce the effect of atmospheric haze a red filter can be used effectively.

Above *A wide angle lens was used in this seascape to accentuate the effect of perspective by including close foreground details in the picture, making the rocks appear much larger than the distant island and emphasising the effect of receding planes.*

Nikon F3, 20mm lens, 1/125 sec. at f8. Kodachrome 64.

Above The effect of distance is created in this shot of Rye, Sussex, both by the lighter, slightly misty tones of the distant scene and by the lines created by the river, which lead the eye into the picture.

Nikon F3, 150mm lens, 1/125 sec. at f5.6.
Ektachrome 64.

Right This picture of California's Death Valley relies upon aerial perspective to create the impression of depth. Aerial perspective is caused when dust in the atmosphere makes the more distant planes appear lighter in tone.

Nikon F3, 400mm lens, 1/60 sec. at f8.
Kodachrome 64.

Left The impression of depth and distance has been considerably enhanced in this shot by the inclusion of the tree in the foreground. Its silhouetted shape creates a bold contrast, producing a quite strong three-dimensional effect.

Nikon FG, 35mm lens, 1/125 sec. at f8.
Ektachrome 64.

Landscape-light and mood

There is no aspect of photography in which the quality and direction of light is not vital. However, more than anywhere else light is, or can be, an integral part of the subject in a landscape photograph. It is probably true to say that even quite small changes in the lighting of a landscape will have a more significant effect on the nature and mood of the picture than with other subjects. One of the most instructive things you can do is to observe the changes that take place in a familiar landscape as the quality and the direction of the lighting alters over a period of time. Try returning periodically to the same place at different times to take a series of pictures. Of course, you do not have any direct control over the lighting quality of a landscape. As a rule, it is either a question of responding to a scene at a moment when the lighting creates a pleasing image or waiting at – or return to – a potential subject until the lighting is more favourable.

The choice of viewpoint can affect both the direction and the quality of the light, particularly on a sunny day when the light is strongly directional and the shadows are dense and well defined. Even a slight change in camera position can have a significant effect in such circumstances.

Lighting affects two important aspects of

landscape photography, the quality and nature of the image and the mood or atmosphere of the picture. It is often said that the best time to take landscape pictures is early or late in the day. This is because the sun is then at an acute angle to the terrain, revealing its contours and textures more effectively, whereas at midday it can produce a rather flat and featureless effect. Like most frequently repeated advice it is based on sound principles and if followed will be unlikely to produce disappointing results. It presupposes however that firstly you will only be photographing in sunlight and that elements such as form and texture are more important to the picture than anything else. A sunny day is by no means the only suitable condition for landscape photography and the crisp, clear detail that such lighting reveals is sometimes undesirable when the intention is to create pictures with an atmospheric quality. Indeed, the element of mood is often dependent on the suppression of detail so that more is left to the viewer's imagination.

Lighting affects both the tonal and colour quality of the picture and these are vital elements in the creation of mood. Quite often shooting on days and at times when the light is what would normally be considered poor in terms of quantity can be far better than a

bright clear day as far as quality is concerned. The cool blue light of dusk, for example, could produce quite evocative images of a scene that seemed quite uninteresting when the sun was shining. Learn to judge the potential of those days when you might not normally consider going out with your camera. A dark overcast and stormy sky can, for example, produce rich, low-key images, and a foggy or misty day can create pictures with a delicate high-key quality. Bad weather can often contribute considerably to both the quality and the mood of an image. Rain, fog and snow are all capable of transforming otherwise unremarkable scenes into powerful and compelling pictures.

Left and right *These two pictures of Roscoff in Brittany demonstrate how dramatically the mood and effect of a landscape picture can be affected by the quality and direction of the light. They were taken from the same viewpoint, one at dusk just after the sun had gone down and the other in the early morning light. Only the outline of the buildings remains the same. Not only are the basic visual elements greatly influenced by the lighting but also the mood of the photograph.*

Left Nikon F3, 150mm lens, 1/4 sec. at f8. Ektachrome 64.
Right Nikon F3, 105mm lens, 1/125 sec. at f8. Ektachrome 64.

Left Low evening sunlight raking across the countryside has effectively revealed the contours and textures in this Dartmoor landscape. In addition, the warm light has created a pleasing colour quality which contributes to the atmosphere.

Nikon F2, 105mm lens, 1/60 sec. at f5.6. Kodachrome 25.

Above This picture of the Vosges mountains was taken during a snow storm almost at dusk. In terms of quantity, the light was poor, but the cold, bleak quality of the subject has been enhanced by the subdued lighting, creating a quite stark mood.

Nikon F3, 200mm lens, 1/15 sec. at f5.6. Ektachrome 64.

Landscape-composition

There is a considerable difference between the way we see everyday scenes and objects and the way we must learn to see in order to take good photographs. This difference is particularly marked in the field of landscape photography. When we look at something small, a flower, say, our attention is focused totally upon it and extraneous details are masked out. When we look at something vast, a mountain-ringed lake, for example, the opposite happens. Our eye takes in everything in a sweeping, panning manner often not consciously noting individual details but building them into an idealised montage of the whole scene. When we take a photograph of such a scene in the same way, the result is inevitably confused and disappointing because everything is recorded with equal emphasis. For this reason selectivity is vital when taking a photograph. You must learn to examine the scene in an analytical way, observing everything that you find appealing and interesting and, just as importantly, details that are distracting or unattractive.

In order for the eye to find a picture pleasing and visually satisfying there must be a point to which it is most strongly attracted. This centre of interest is something which is usually quite obvious with other subjects, but which may be elusive in a landscape picture. When you analyse a scene, you should decide which of the elements or details within it can be used as a focal point. It may be a simple decision, such as a building in an otherwise empty landscape, or it may be something as subtle as a shape on the horizon or even just a highlight or a shadow.

Once you have established a centre of interest it becomes easier to decide how to frame the picture. Firstly, you must determine where within the picture area it will be most effective. The most common mistake of inexperienced photographers is to simply aim the camera so that the most important detail is centred in the viewfinder. This is rarely the most satisfactory position, since apart from tending to create rather static and symmetrical pictures it also makes it more difficult to include other details in a balanced way. It is usually more effective to place the centre of interest between the centre and one corner of the image.

The position of the horizon line is also of importance in the composition of the picture and it will often also affect the mood. As with the centre of interest, it is rarely the best solution to use a centrally placed horizon. As a general rule it is most effective when it divides the picture into a proportion of one to two or one to three. When it is closer to the bottom of the frame, it will tend to create an impression of space and will therefore suit subjects where the sky is particularly interesting or important to the composition. Placing the horizon near the top of the frame will usually produce a more confined mood and at the same time emphasise foreground details and the effect of perspective.

Apart from choice of viewpoint, one of the most effective ways of controlling both the framing and composition of a landscape picture is in the use of lenses. A long focus lens will enable you to isolate small details of a distant scene and frame quite tightly. At the same time it will minimise the effect of both perspective and depth and will tend to create pictures in which the element of design is accentuated. A wide angle lens, on the other hand, will allow you to emphasise foreground objects and enhance the effect of perspective.

Below *There is no specific object which makes a centre of interest in this picture. It is created by the tones and shapes of the clouds and their reflection in the wet sand. The picture was framed so that this focal point and the surrounding details created a balance around the centrally placed horizon.*

Nikon F3, 20mm lens, 1/125 sec. at f8. Ektachrome 64.

Below In this sunset picture, the horizon has been placed near the base of the frame in order to emphasise the sky. A long focus lens was used to isolate a small area of the scene and the exposure was calculated to create rich tones in the sky, allowing shadow details to become silhouetted.

Nikon F3, 400mm lens, 1/250 sec. at f8. Ektachrome 64.

Above and right These two pictures of a deserted beach show how much the nature and composition of a picture can be controlled by the choice of viewpoint, the focal length of lens and the way the picture is framed. The picture above was shot on a wide angle lens. Changing to a longer focal length and a different viewpoint and altering the picture from a landscape shape to a portrait format has produced the shot on the right.

Nikon F3, 35mm and 70mm lenses, 1/250 sec. at f8. Ektachrome 64.

Left This tightly framed shot has eliminated the sky completely and focused the attention on a quite small detail of the scene. This has produced a picture with a more confined and intimate atmosphere, emphasising the shape, colour and texture of the trees.

Nikon F3, 150mm lens, 1/60 sec. at f8. Kodachrome 25.

Buildings-basic approach

Photographing a building can pose a number of quite different challenges and can give you the opportunity to stretch both your technical and visual skills. A building embodies all of the basic elements of an image – shape, form, texture, pattern and perspective. Some or all of these can be combined to create a wide variety of pictures.

In its most basic form, an architectural photograph aims to provide an accurate record of a structure, clearly presenting its most significant features. In this type of picture, the camera viewpoint should be selected so that it not only shows these features but also creates a true impression of the structure's dimensions and perspective. This can be done most effectively by choosing a camera position which enables two sides of the structure to be seen, usually from one corner. This will create two vanishing points which will also help to create an impression of solidity and form in the picture. The vanishing point is the place at which converging perspective lines appear to meet. These lines can have a very dominant effect on the composition of the picture and they are directly controlled by the choice of viewpoint. The closer the camera is to the building the more extreme will be the angle of convergence and the closer the vanishing point. A more distant viewpoint will create a more gradual converging effect and a less extreme perspective. When two faces of a building are included in the picture the direction and quality of the light will also be important. Bright sunlight illuminating only one side could produce excessive contrast

Above *Lighting is an important factor in architectural photography. This picture of Lullingstone Castle was taken when the sun was at an angle that illuminated the whole scene.*

Nikon F3, 85mm lens, 1/125 sec. at f8. Ektachrome 64.

with inadequate detail in the shaded wall.

While in some instances you will want to create a straightforward record of a building, and this can indeed be both challenging and instructive, there is also great potential in architecture for producing more creative and interpretive pictures. Even from a record point of view, it can sometimes be more informative to take a series of close-up pictures rather than attempt to include the whole structure in one go. This can be a useful approach when viewpoints are restricted, as in urban locations for instance. Pictures which isolate specific details of construction and decoration can fully exploit elements such as texture and pattern and in some cases can be used to create quite abstract pictures in which the identity of the building becomes of little importance. A long focus lens is more effective for these types of

Left *A more distant viewpoint has enabled these buildings in downtown Los Angeles to be shown in the context of their setting in the city's central square. The inclusion of the park in the foreground has also introduced a rather less familiar impression of the American cityscape and created an effective juxtaposition with shapes and patterns of the buildings.*

Nikon F3,. 28mm PC lens, 1/125 sec. at f8. Kodachrome 25.

shots, as it enables you to get tightly framed details from a more distant viewpoint and reduces the effect of perspective, often an undesirable element in such pictures. A tripod is particularly useful, since pictures of this type must be perfectly sharp and are best taken on slow, fine-grained film for maximum image quality. It is often an advantage to use a small aperture to obtain adequate depth of field.

It is also important to remember that most architects design buildings so that they relate to their surroundings. Consequently more powerful and evocative pictures can often be taken by using a more distant viewpoint from which the building is seen in the context of its setting. In such pictures, the mood and lighting of the photograph can be more important than the clarity of its detail and construction.

Right *A close viewpoint and a wide angle lens have been used to produce this almost abstract image of an office building. The restricted colour range has helped to emphasise the elements of shape and pattern and the diagonal lines created by the converging verticals have added impact to the composition.*

Nikon F3, 24mm lens, 1/125 sec. at f5.6. Kodachrome 25.

Above *A long focus lens was used to isolate a small area of this English country church. The tightly framed image emphasises the textural and pattern elements of the subject, creating a bold but simple design.*

Nikon F3, 150mm lens, 1/250 sec. at f8. Ektachrome 64.

Above *A careful choice of viewpoint has resulted in this effective juxtaposition between the street lamp and the distant skyscraper in the centre of San Francisco. The exposure was calculated to create an almost silhouetted effect.*

Nikon F3, 150mm lens, 1/60 sec. at f8. Kodachrome 25.

Buildings-interiors

While converging horizontal lines in an architectural picture are acceptable and usually desirable, the same does not always apply to converging vertical lines. They can present a particular problem when shooting from a close viewpoint. Fortunately the effect is only created when the camera is tilted up or down. If the back of the camera is kept perfectly parallel to the vertical line of the structure it will not occur. The simplest solution is to use a distant viewpoint and a long focus lens, which will virtually eliminate the effect. This is not always possible, particularly in towns and cities, where a close viewpoint must be used, and especially with wide angle lenses. The problem can be overcome either by finding a higher viewpoint – ideally at a point half-way up and opposite the building you are photographing – or to keep the camera level from the ground level position and find some foreground interest to occupy the lower half of the picture. An alternative method, used by professional architectural photographers, is to use a view camera with a rising front or a perspective control lens. The principle in both cases is the same. What happens in effect is that you raise the optical axis of the lens in relation to the film, which allows you to include more at the top of the picture and less at the bottom without tilting the camera upwards. But it can, however, be effective simply to allow the verticals to converge.

Very often the interior of a building can provide equally good opportunities for pictures as the exterior. Providing a little care is taken, impressive pictures can be taken with quite simple cameras. The main difficulty will be the low level of illumination, since to light a large interior artificially is either impractical or will require complex lighting arrangements. A tripod will be an invaluable accessory as it will enable you to use slow shutter speeds or time exposures if necessary. Both tungsten lighting and window light can be used satisfactorily, provided viewpoints are chosen that avoid the inclusion of extremes of contrast. As a rule it is best to shoot away from windows and to avoid including light sources in the picture area unless they are quite small. When shooting in colour you must, of course, use the appropriate type of film. If both daylight and tungsten are present you should use film which is balanced for the predominant source of illumination. You should also beware of the presence of fluorescent lighting. Although it appears similar to daylight it will create an unpleasant green cast on the film. Correction filters in the order of CC30-40 magenta will help to correct this with most types of tubes as long as you are shooting on daylight-type film.

Above A tripod was used so that a longer exposure could be given in this interior shot, which was taken in available light.

Nikon F3, 20mm lens, 2 sec. at f8. Ektachrome 200.

Below When calculating exposures for this type of picture, it is important to take it close up.

Nikon F3, 150mm lens, 1/60 sec. at f8. Ektachrome 200.

Above Deliberately tilting the camera upwards has made a virtue out of the problem of converging verticals in this shot taken in Los Angeles. The bold diagonal lines create a strong sense of design and impact. A graduated filter was used to produce a darker tone in the sky at the top of the picture to help contain the attention within the frame.

Nikon F3, 20mm lens, 1/125 sec. at f8. Kodachrome 25.

Left These two pictures demonstrate the effect of a perspective control or shift lens. In the shot near left the shift was not used and the camera was simply tilted upwards to include the top of the building. The sides of the structure can be seen to converge quite noticeably in comparison with the shot on the far left, which was taken with the camera held vertically and the shift used to include the top.

Nikon F3, 28mm PC lens, 1/250 sec. at f8. Ektachrome 64.

Sport-the basics

Photography has become an integral part of our leisure and entertainment. Television in particular has made it possible for us to experience the excitement of many spectacles and events with an almost intimate view of the proceedings. This is perhaps most noticeable in the ever-increasing popularity of the coverage of sport and action events. One reason for this is that such occasions are extremely photogenic. The excitement and drama of a competitive event is very visual and a camera enables us to see the most significant moments in clear and vivid detail.

Although the television camera provides the most effective means of following the action of a sport, it is usually the still camera that enables a precise moment to be isolated and preserved and in doing so often creates the most dramatic and memorable images. The ability to produce such pictures depends largely on good camera technique and complete familiarity with your equipment. Not only is it necessary to be able to anticipate and react to an extremely brief moment, it is also necessary to be able to judge elements like lighting and composition in the same context.

While specialist sports photographers have a most impressive array of lenses and equipment, this is largely necessary because of the limited opportunities for securing the most suitable viewpoints at large national events. In situations where there is more freedom to choose a camera position, at amateur or local events, for instance, or at practice sessions, good pictures can be taken with much more modest equipment. Having said that, a long focus lens would be an invaluable accessory. At field or arena events a lens of less than, say, 200mm would be very restricting. Where a close viewpoint can be used, a wide angle lens combined with a low viewpoint can often help you to create dramatic pictures.

Choice of viewpoint and successful anticipation of the moment to shoot are two of the most important considerations in action photography, but will of course vary according to the nature of the event. In this respect, a sound knowledge of the sport is helpful. The action is not the only consideration in choosing a viewpoint, however. The quality and direction of the light and the background must also be considered since the most dramatic moment will be ineffective if the lighting is poor or the background is distracting. Spectators, for example, can often create such problems. You can often get round this by taking a low viewpoint so that the subject is seen against the sky rather than a confusing rabble of fans. Alternatively, differential focusing will often

allow distracting backgrounds to be thrown out of focus, particularly when long focus lenses and wide apertures are used.

While sunlight will let you use fast shutter speeds without fast film, it can restrict the choice of viewpoint. The softer light of a cloudy day will make a variety of different viewpoints available without a significant change in the nature of the lighting. When the light is poor or you are shooting under artificial lighting choose a fast film, particularly if you are using very long focus lenses with relatively small maximum apertures. In some cases it may be necessary to uprate the film by push-processing.

Above *The impact of this picture depends upon precise timing of the exposure as a dramatic moment such as this lasts for only a brief time and requires a swift response. The degree of actual movement is often much less at times like this and it is often possible to shoot with a slower shutter speed than with normal action.*

Nikon F2, 600mm lens, 1/500 sec. at f8. Ektachrome 200.

Above The combination of a wide angle lens and an unusual viewpoint can often produce pictures with great effect, as in this shot of aircraft. In this case the camera was mounted on a bracket and fired with a long release. Such photographs require a camera with motor wind and, where lighting conditions are changing, automatic metering as well.

Nikon F3, 16mm lens, 1/500 sec.
Kodak Tri X.

Right Many sports events take place under artificial lighting with a reduction in brightness level compared to daylight. This will usually involve the use of fast and also uprated films to enable fast shutter speeds to be used in addition to the use of wide aperture lenses. In this picture the light sources themselves have been used as an effective element of the composition.

Nikon F3, 24mm lens, 1/250 sec. at f2.
Kodak Tri X, rated at ISO 1600/33.

Sport-lenses and viewpoint

Successfully recording movement is the basic consideration in sport and action photography. There are a number of ways of approaching the problem. Where the lighting is adequate, the most elementary method is simply to use a very fast shutter speed – 1/1000 or 1/2000 second is fast enough to freeze most movements encountered in sports such as athletics and football. The exact shutter speed which will stop a particular movement is dependent on a number of factors, the size of the subject in the viewfinder and the direction of travel, for example. A faster speed will be needed when the direction of travel, is directly across the camera and the subject is quite close, but a slower speed can often be used when the action is towards the camera or the subject is further away. Where a completely frozen image is required the safest solution is to use the fastest practical shutter speed. This is not always possible. Often speeds as low as 1/250 or slower must be used and in these circumstances other precautions must be taken to ensure a sharp picture. Where the movement is directly across the camera, it is very helpful to pan the camera by swinging it smoothly to follow the direction of the action, holding the picture steady in the viewfinder and then releasing the shutter smoothly when the subject reaches the best position. Alternatively, try to choose a moment at which the action reaches a natural peak. At this moment the speed is often considerably less and often coincides with the most dramatic or significant moment, such as a horse going over a jump.

Freezing the subject completely is by no means always the most effective way of conveying speed and action in a picture and indeed a degree of blur can be a positive advantage in this respect. The best way to combine a sharp image of the subject with a blurred background is to use the panning technique with a quite slow shutter speed. If the panning is done very smoothly, shutter speeds of 1/60 second or more are possible. In some circumstances it can even be effective if the subject itself is blurred, particularly where the movement is in more than one direction.

Movement is not the only factor which causes sharpness problems. Focusing too can be difficult with a moving subject, particularly when long focus lenses with their shallow depth of field are used and the subject is moving towards the camera. Although it is possible to alter the focus of the lens as the subject gets closer to the camera it is by no means easy. In general it is best to prefocus the camera at a predetermined point and release the shutter when the subject moves into focus.

Above When the action is moving towards the camera panning techniques cannot be used and it is necessary to depend upon a fast shutter speed to freeze the movement as in this picture of a skier.

Nikon F2, 400mm lens, 1/1000 sec. at f5.6. Kodachrome 64.

Right When the subject is moving towards the camera focusing can be a problem. With photographs such as this shot of a motorcyclist, the best solution is to prefocus at a specific point.

Olympus OM2, 180mm lens, 1/500 sec. at f5.6. Ektachrome 64.

A long focus lens is not only more difficult to focus but also harder to handle, and camera shake can be a considerable problem, even with shutter speeds of 1/250 second or less. A tripod, monopod or similar support should be used wherever possible. A motor drive or winder can be helpful by leaving the hands free to concentrate on handling and focusing the camera, although using it in the sequence mode will not necessarily guarantee the capture of a precise moment of action any more successfully than would a manual exposure combined with good anticipation.

Above With many sports the choice of viewpoint is restricted and in order to obtain a tight shot of a subject a long focus lens is a necessity. In this photograph of American football, such a lens has also the advantage that its more limited depth of field will throw background details out of focus, isolating the subject from the surroundings.

Nikon F3, 600mm lens, 1/500 sec. at f8.
Ektachrome 200.

Right Although moving very fast directly across the camera's view, it was possible to obtain a sharp image in this shot using a relatively slow shutter speed by panning the camera. In addition, the background details have become blurred, accentuating the impression of speed and movement.

Nikon F2, 180mm lens, 1/250 sec. at f8.
Kodachrome 64.

People-basic approach

People are probably the single most popular subject for the camera. Quite apart from being a means of recording family and friends for posterity, they offer tremendous scope and variety to the perceptive photographer. It is by no means something that necessarily requires complicated equipment or techniques. Even a quite simple camera such as a disc or cartridge can be used to take effective pictures of people, and the pleasure of looking at a collection of personal photographs in the family album can often be greatly increased just by a more considered and careful approach.

Most people tend to feel rather selfconscious and vulnerable in front of a camera and this is the reason for the disappointing results that many inexperienced photographers produce. Learning to make a subject feel relaxed and uninhibited is the first step in taking better pictures. Being thoroughly familiar with your camera is vital in this respect, since nothing is more distracting for the model than a photographer fumbling about with his

camera. The ability to operate your camera effortlessly will also allow you to devote your full attention to the person you are photographing. Carrying on a normal conversation will be far more effective in producing natural and relaxed expressions than simply asking your subject to smile into the camera. This is another common cause of disappointing pictures, as few people other than professional models are able to respond naturally to a command in this way. You should also make sure that your model is seated or positioned comfortably, since this can also help to produce a more pleasing picture.

Sympathetic lighting is also an important factor and you must learn to see the effect of shadows and highlights on a person's face and choose a position where this creates a pleasing effect. As a general rule, a soft and fairly frontal light is best unless you want to create a more dramatic image. A hard, direct light such as sunlight or flash on camera is best avoided. Don't overlook the possibility of using light from a window when indoors.

Background can make or ruin a picture. Avoid fussy and distracting backgrounds and position the subject and/or the camera so that there is a degree of separation between the model and the background. Since the face and expression are usually the most important elements in pictures of people, you should also ensure that you are close enough to your subject. Many beginners' pictures are spoiled by ignoring this simple rule. With a viewfinder type of camera in particular it is easy to include more than you need because the viewfinder shows less of the subject than the film actually records. As a rule a three-quarter length or head-and-shoulders shot is more effective than a full-length picture unless the background or setting is of particular interest. However, when using a camera with a standard focal length lens, be careful not to get too close, as this can produce unpleasant perspective effects, distorting the appearance of the face. A long focus lens such as an 85 or 105mm is ideal for portraits as it produces a quite close-up image from a more distant viewpoint.

Above This studio portrait relies upon careful lighting to create a quite flattering quality. The choice of background, the pose and even the make-up have all contributed to the effect.

Nikon F2, 150mm lens, f16, studio flash. Ilford FP4.

Below Basic tungsten lighting, a photoflood bulb in a simple reflector, was used for this natural and spontaneous portrait of a young child taken 'at home'. A tightly framed picture has emphasised the expression.

Nikon F, 105mm lens, 1/125 sec. at f5.6. Kodak TriX.

Above The light from a window was the sole source of illumination for this portrait. Its quite strong directional quality emphasises her profile, and contributes to the mood.

Rolleicord, 1/60 sec. at f5.6. Kodak TriX.

Right Although taken outdoors, this portrait has used a carefully composed image to introduce a note of formality. The wall and shutter of his house were used as a compositional device for the picture, as well as a background for the subject.

Nikon F3, 70mm lens, 1/250 sec. at f5.6. Ilford XP1.

People-informal portraits

Although the snapshot approach to photographing people can be used to take very satisfactory pictures with a little care, there are occasions where a more pleasing and perhaps flattering result can be produced in an informal situation without resorting to the posed type of studio portrait.

When photographing someone outdoors you may have no direct control over the lighting and the background but you can at least influence them indirectly by choosing a suitable place for the photograph. For most portraits it is best to select a fairly plain and uncluttered area to provide the background. Make sure it provides a degree of tonal or colour contrast to the subject so that there is a degree of separation between them. Where a fussy setting is unavoidable it can sometimes be effective to use selective focusing to suppress the detail. Place your subject some distance from the background and use a fairly wide aperture to throw it out of focus, creating a softer and smoother tone. The effect will be accentuated by using a long focus lens. In some instances the background can play a more dominant role, contributing to the mood or composition of the picture. In this case you must choose a viewpoint and frame the picture in such a way that the subject remains the main point of interest and the background details become a balanced and complementary addition.

The lighting will also be influenced by the choice of setting. As a rule direct sunlight is best avoided. Apart from the fact that it creates dense, hard-edged shadows and excessive contrast, it can also cause the model to squint and be generally ill at ease. On a sunny day it is best to place your subject in an area of open shade, where the light is softer and less directional. When shooting in colour this can cause a blue cast on the film and you will need to use an 81A filter to offset it. An alternative method of photographing in sunlight is to shoot into the light. This will create a softer light and produce an attractive rim of highlight around the subject which can give additional separation from the background. This type of shot will also usually need an 81A filter. You will need to be careful of exposure calculation, since backlighting can cause underexposure if the reading is taken in the normal way. It is best to take a close-up reading from a mid tone in the subject. The light on a dull day is quite soft. However, be careful that it does not create an excessive top light, producing shadows under the eyes, for example. One solution is to place your model under a tree or in a doorway, where the light will be more frontal. One way to get your subject to relax and be natural is to make sure that he or she is seated or positioned comfortably.

Above Direct sunlight was used for this portrait of two farmers taken in a remote part of southern Spain. Although the effect is rather harsh and unflattering, it was felt that it contributed to both the mood of the setting and to the rugged quality of the men's personalities. A fairly high viewpoint has enabled the relatively plain tone of the field in which they are standing to be used as a background.

Nikon F3, 105mm lens, 1/250 sec. at f8. Kodachrome 64.

Right The bold effect of this shot of a clown was produced by asking him to stand in front of the dark, plain tone of the circus tent. This provided a strong contrasting background and has added considerable impact to the shot. The picture was softly lit by the light of an overcast sky.

Nikon F3, 105mm lens, 1/125 sec. at f5.6. Ektachrome 64.

Above This relaxed and spontaneous portrait of a French butcher was taken while he was sweeping out his shop. With his broom as a 'prop', he reflects the security and familiarity of his surroundings. The bold colour and shapes of the background make an effective contrast to the white-clad figure.

Nikon F3, 50mm lens, 1/125 sec. at f4.
Ektachrome 64.

Left This 'street' portrait makes use of a rather more fussy background to help create the mood of the scene. The reflections in the window behind him add an extra dimension to the shot.

Nikon F3, 105mm lens, 1/125 sec. at f5.6.
Kodachrome 64.

Right The harsh effect of direct sunlight has been avoided in this portrait by shooting into the light and allowing the subject's stetson to create an area of open shade. The small amount of sunlight filtering through the brim has helped to retain the sunny effect and contributed to the mood of the picture.

Nikon F3, 150mm lens, 1/250 sec. at f5.6.
Ektachrome 64.

People-studio portraits

Although daylight and an outdoor setting can be an ideal way of taking informal portraits, a studio can give you much more control over lighting and backgrounds, as well as providing a more comfortable and private setting. The facilities needed to take good portrait photographs indoors can be quite modest. The main requirement is enough space to work in and two or three lights with adjustable stands together with a suitable background and a means of supporting it. A wide range of effects can be obtained with these few items.

Good portrait lighting should begin with the positioning of the main light, the *key light*. This will create the shadows in the image and the subject modelling, and so both its quality and direction are critical. For a fairly conventional effect it is best to start with the

key light at about 45° to the subject and a little above his or her eye level. The exact position will depend on a number of factors, the angle of the model's head and the mood of the picture, for instance, but this is a good starting position from which you can make finer adjustments. If you use a direct light in a conventional reflector you will get quite dense and well-defined shadows. While this can be effective in some circumstances, in general a more pleasing and manageable basic lighting will be created if the key light is diffused so that the shadows are softer. This can be done with a diffusion attachment or a tracing paper screen, or a reflector such as an umbrella reflecting the light from a large white surface.

Even when a soft light source is used, it is still likely that the shadows will be too dense

Below *These seven pictures show the effect of different lighting positions. A single undiffused light source was set up just above the model's eye level and at about 90° to the camera position in the first picture. The diagram shows how the position was changed to create the effect in each of the pictures. When the light is closest to the camera in picture 4, the amount of shadow and modelling on the subject's face is at a minimum. It increases as the light is moved to a more acute angle. In all these shots, the model is full face to the camera, but the quality and direction of the lighting will also be affected by the angle of the head, so you must always be conscious of the nature of the shadows created by this factor.*

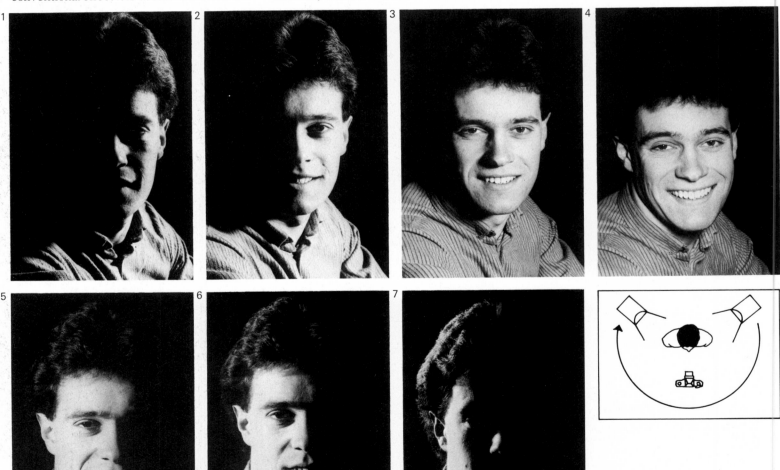

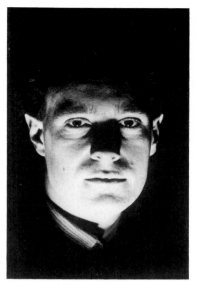

Left and Right *These two pictures show how the nature of the lighting is changed when the light source is moved substantially higher or lower than eye level. The picture on the left shows what happens when the light is placed almost at floor level. In the picture on the right, the light is about one metre above the head.*

Below *This picture sequence shows how the quality of the key light, placed about 45° to the camera, can be controlled by adding other lights. Picture 1 shows the effect of a single diffused light. Picture 2 shows the shadows reduced by adding a fill-in light, in this case a white reflector placed close to the model as shown in the diagram. Picture 3 shows a second light source to highlight the hair. In picture 4 the same light is directed at the background.*

1

2

3

4

and the contrast too high. It is important to remember that the brightness range of the subject can easily exceed that which the film can reproduce. Although the contrast may appear acceptable because our eyes adjust to the extremes, the film is not able to do so and the result may be a loss of detail in either the highlights or the shadows or both. It can help to judge this by viewing the subject through half-closed eyes. The density of the shadows can be reduced by using either a reflector placed close to the subject on the shadow side or a second light as a fill-in. Be careful that this light does not eliminate the shadows completely or create shadows of its own, as this can look unattractive.

It can also be effective to use another light to backlight or rim light the model. By placing a light behind and above the model you can create highlights on the edge of the face or around the hair. This can help to separate the model from the background as well as adding a little sparkle to the picture. Fit a snoot or a cardboard shield to this light so that it illuminates only the area required and does not spill into other parts of the picture. An additional light can also be used to illuminate the background. This can add interest to a plain background tone as well as creating separation. For example, a light can be placed on a low stand, hidden behind the model and aimed at the background to create a pool of light behind the head. These are very basic techniques. Once the principles have been understood you will be able to experiment and discover many ways to vary the effect and the mood of a picture by controlling the lighting.

Right *This profile shot is the last picture from the sequence above. It shows the effect of moving the second light to one side and behind the subject to create a rim light for the profiled head.*

People-children

Children have a universal appeal and make a particularly rewarding subject for the camera. It can often be easier to take a good picture of a child than an adult because children tend to be far less selfconscious and will react more naturally and spontaneously. Most of us have had posed pictures taken in the studio or at school as a child. This is probably the least satisfactory way of doing it, largely because children become easily bored and lose concentration. However, if a fairly posed shot is wanted of a young child it will help if you can find something to interest them while the pictures are taken. If you treat them as you would an adult and carry on a conversation with them this can often make it easier and will help the child to relate more directly to you if the parent is not present.

In many ways the less formality involved in photographing children the better and this applies to lighting also. A fairly soft light is best as this will enable both you and the child to move about quite freely without having a drastic effect on the lighting. When shooting indoors, a flash bounced off a white ceiling can be quite effective and window light can be used on a bright day. Since the appeal of a child picture is largely dependent on the subject's face and expressions, the most effective way of shooting is usually to move in quite close and frame the picture quite tightly, excluding irrelevant details. A long focus lens is an advantage in this respect since it will enable you to obtain a close-up image from a more distant viewpoint.

When shooting in outdoor situations some of your best shots will be made by photographing children when they are playing and less aware of the camera. A children's playground or just the back garden can be an ideal location for such pictures. The soft light of an overcast day is best. Otherwise try to shoot in open shade or against the light on a sunny day. As a rule it is best to avoid direct sunlight as the shadows it creates can easily produce unpleasant effects and obscure details and expressions. Be careful also of fussy backgrounds. A plain contrasting tone or colour is best and you should choose your viewpoints with this in mind. A low viewpoint means you can use the sky as a background and will often give a better perspective with small children, who are themselves closer to the ground.

Babies present a slightly different problem. It is very helpful for the mother to be present during the photography as she will be most likely to know how to make the baby react well and to coax the best expressions. Soft natural light such as indoor daylight is often best. Be careful of the risk of underexposure when taking readings from a subject which is often of predominantly light tones. The best method is to take a substitute reading from an object of a mid tone placed in the same lighting. Although many photographers think in terms of photographing their own or friends' children, the reportage approach to child photography can also be very rewarding. Shooting pictures of children in their own environment when travelling or on holiday can often produce some excellent pictures as well as providing an evocative record of a place.

Below *Unlike adults, most children enjoy being photographed and will react quite spontaneously to the camera, as this picture of a young boy taken in the Maldive Islands shows. The broken-reeded roof makes an effective background and adds impact to the composition.*

Nikon F3, 150mm lens, 1/250 sec. at f5.6. Ektachrome 64.

Above This picture of a young baby was taken by the light from a window indoors. The tight framing and the pensive, direct gaze of the baby, into the lens, has given the shot some impact. A long focus lens was used to avoid a very close viewpoint, which would have created an unpleasant effect.

Nikon F, 105mm lens, 1/125 sec. at f5.6. Ektachrome 200.

Above and left Getting your subjects to pose and smile is by no means always the best approach to photographing children. These two shots taken in a school playground have captured both appealing and very natural expressions which have been emphasised by quite tightly framed pictures. A long focus lens was used to avoid having to approach the subjects too closely.

Nikon F2, 105mm lens, 1/250 sec. at f5.6. Ektachrome 200.

Right This shot of a young Moroccan shepherd boy was taken while on a travel assignment. A long focus lens and a wide aperture have effectively thrown the background out of focus, subduing distracting details and creating a degree of separation between the subject and background.

Nikon F2, 105mm lens, 1/125 sec. at f4. Ektachrome 64.

People-the nude

The human figure has been a source subject for artists ever since the means to create an image was first discovered. Photographers have found the nude just as challenging and rewarding as painters and sculptors. Apart from the purely subjective visual pleasures of a well-proportioned body, there are other reasons why this should be so. The human form possesses many of the visual elements that can be exploited to create successful photographs. Shape, form, line and texture are all inherent qualities in a nude and, more importantly, are qualities that can be varied at will by the movement of the body and the effect of the lighting, enabling a particularly rich variety of moods and images to be created from the same basic subject. This is one reason why the nude is often a popular choice of subject for photographers who are interested in producing pictures as a means of self-expression. It has often been said that there is a similarity between the nude and the landscape and this is certainly true in terms of the intimate relationship between light and form which the two subjects possess. The

difference is that it is possible to control this effect to a much greater degree when photographing the nude. For this reason the nude offers perhaps the best opportunity for a photographer to discover and experiment with the quality and mood of light.

Just as the nude affords a great variety of visual qualities, so too is the question of style and approach similarly unlimited with this subject. The most obvious approach is, of course, to exploit the sexual connotations of a beautiful body as well as the purely visual, and a large proportion of photographs taken professionally and reproduced in books, magazines and on posters do just this. Although much of this work has little or no photographic merit, there is no reason why a photograph should not be stimulating both aesthetically and sexually. Indeed, many photographers specialising in this subject – such as Helmut Newton, David Bailey, David Hamilton and Sam Haskins – have demonstrated this most effectively. In this type of picture the model's personality will have a considerable effect on the nature of

the image, since there is a much more personal quality in such pictures and the viewer is invited to relate to the subject more as an individual than as an image.

The nude, however, can be just as effective as a basis for producing less personal and more abstract pictures. While this type of work may have less commercial value, the opportunities are often greater where personal and expressive images are concerned. This type of abstraction can vary from a simple anonymity of the model, with the head turned away from the camera, to very tightly cropped pictures in which small areas of the body are isolated to emphasise elements like form and texture. Indeed in many pictures of this type it is often not at all important that the subject is even identifiable as a body.

Although the male nude has never been such a popular subject compared to the female nude, it does have qualities which can be exploited effectively in the more abstract approach. The more muscular form of a man's body contributes its own effect.

Left Shooting into the light and exposing for the highlights has created a bold, contrasty image in which the outline of the girl's body is strongly emphasised. This gives the shot an abstract quality which is accentuated by the model's head being turned away from the camera.

Rolleiflex SLX, 150mm lens, 1/250 sec. at f11. Ektachrome 64.

Below The more direct pin-up approach to nude photography has been given additional interest in this studio shot by the use of props. The sunglasses and a fabric mesh screen placed immediately in front of the model, together with her exaggerated pose, have created a rather intriguing and ambiguous mood.

Rolleiflex SLX, 150mm lens, studio flash, f16. Ektachrome 64.

Above Although less widely used in nude photography, a man's body can be very effective, particularly in the more abstract type of picture where form and texture are exploited. This tightly framed shot was lit by a single diffused light placed almost at right angles to the camera.

Pentax 6×7, 150mm lens, studio flash, f11. Ektachrome 64.

Left This shot taken in Portugal exploits the textural qualities of skin and the rocks on which the model is lying. The rich colour of the sea in the background was emphasised by the use of a polarising filter and additional warmth was given to the suntanned skin by fitting an 81A filter.

Rolleiflex SLX, 150mm lens, 1/125 sec. at f8. Ektachrome 64.

People-the nude model

The most immediate problem that photographers encounter when attempting nude photography for the first time will be simply that of finding a suitable model. If your immediate circle of friends does not include someone who may be approached, then it may be preferable to consider the services of a model agency or a studio club. Although this will obviously involve costs, a beginner may find it easier to work with an experienced model for the first session or two. Don't forget that a girlfriend who may be reluctant to pose for the more sexist type of picture may well like to contribute to some more abstract images.

Having found a model, the next consideration is the venue. The choices fall broadly into three categories, a studio with simple backgrounds and artificial lighting, an indoor location with a choice of settings, furniture and props, and an outdoor location. Although the studio environment offers perhaps the greatest comfort, privacy and control over lighting, it can be a rather sterile atmosphere in which to work and is perhaps best suited to the more abstract approach.

When full-length pictures are taken in the studio, it is vital that the shots are planned in advance and sufficient thought is given to providing the right backgrounds and props to create a particular atmosphere.

An outdoor location is better suited to the photographer who likes to find his pictures rather than construct them, and the freedom from adjusting lights and backgrounds can be less restricting for an inexperienced photographer, allowing him to concentrate more on the model and the image. You must make a reconnaissance trip well in advance of

Right *The position of the figure within the frame has emphasised the vulnerability of the model.*

Rolleiflex SLX, 150mm lens, 1/125 sec. at f5.6. Ilford FP4.

Below *This image is more dependent on the location and composition than the model for its effect.*

Rolleiflex SLX, 150mm lens, 1/125 sec. at f5.6. Ilford FP4.

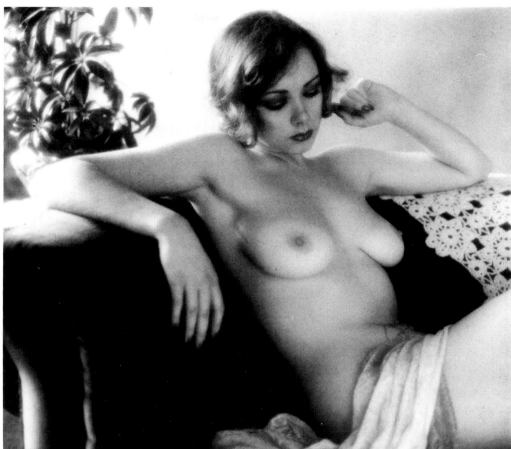

Above *Daylight from a window was used to light the picture, giving it a more natural quality.*

Rolleiflex SLX, 80mm lens, 1/125 sec. at f5.6. Kodak TriX.

Right *A studio shot, lit by a single diffused light, emphasises the shape and form of her body.*

Rolleiflex SLX, 150mm lens, f16, studio flash. Ilford FP4.

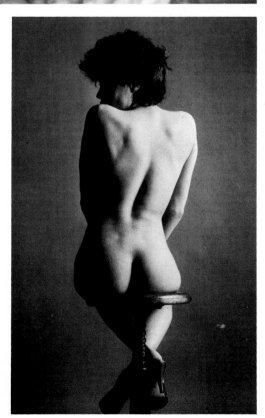

the planned session to find a suitably private place with a variety of backgrounds and settings. Consider also the lighting and whether any props or accessories may help with the shots. With outdoor pictures, a large white reflector can be extremely useful to help control the lighting contrast.

In many ways, an interesting indoor location with adequate light from windows can provide an effective compromise between the variety and simplicity of lighting of an outdoor location and the comfort and convenience of a studio. Daylight indoors is an ideal light source for nudes. With the addition of a large reflector or two it can be used to create a variety of effects. Of course, portable studio flash equipment can also be used to supplement the daylight and increase the range of the lighting.

Reportage

In many pictures of people the photographer has some degree of control over his subject. With a portrait he can adjust a pose and alter the lighting. There are occasions when it is neither possible nor desirable to 'interfere' with the subject in this way, and in reportage or documentary photography the photographer usually plays a more passive role, observing rather than directing. Indeed, it is often preferable that the subject is not even aware of the camera. This type of photography can be particularly rewarding since it fully exploits one of photography's unique qualities, the ability to isolate and preserve a brief moment which encapsulates a mood, significance and composition.

Taking pictures of this type is an excellent way of learning to co-ordinate the various elements of an image purely by the choice of viewpoint and the moment at which the exposure is made. Henri Cartier Bresson's famous phrase 'the decisive moment' describes exactly this awareness of the optimum momentary juxtaposition of uncontrollable elements. The knowledge that

you have successfully achieved this is arguably one of the most exciting and satisfying experiences in photography.

Apart from a perceptive eye and an ability to anticipate, the main requirement for this type of picture is a sound familiarity with your equipment. Not only should you learn to measure and set exposures swiftly and focus quickly and accurately but you should also be able to judge the field of view and to know which lens to use without having to resort to frequent aiming of the camera. This is particularly important when you want your subjects to be unaware that they are being photographed. The candid approach requires you to keep a low profile and as far as possible melt into the background. It is best to avoid using ostentatious camera bags such as the aluminium type and not to carry your camera round your neck, but in your hand or in a pocket. Load film or change lenses in a quiet corner out of sight of your potential subjects.

When you are shooting in a totally alien environment, the presence of a stranger – you – can often create such interest that the

possibility of taking candid pictures may seem impossible. However, if you allow a little time and don't attempt to shoot immediately you will find that such attention will quite rapidly dissipate and that you will simply become part of the scenery.

One of the difficulties of taking this type of picture is that of creating emphasis and preventing the subject being dominated and confused by the surroundings. The choice of viewpoint is a vital factor in this respect, since it is the main way of controlling the relationship between subject and background. You must learn to be aware of how this changes as the camera position is moved. Lenses of different focal length can also help in this respect. A wide angle lens will enable you to emphasise foreground subjects by making them appear much larger in relation to background details. A long focus lens can be used to isolate a small detail of a larger scene and exclude extraneous elements. If used with a wide aperture, its shallow depth of field can help to throw background details out of focus.

Below *A quick reaction and a ready camera captured the doleful expression on the face of this participant in an American street parade, resulting in a picture with a rather humorous appeal.*

Nikon F3, 200mm lens, 1/250 sec. at f8. Kodak Tri X.

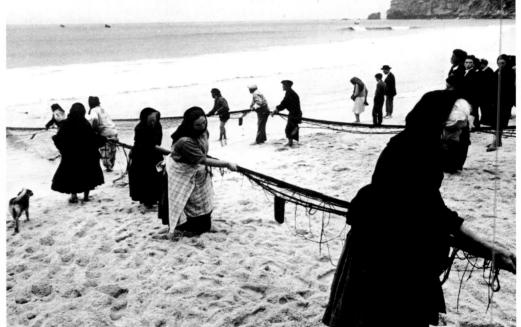

Above *The careful choice of viewpoint has created a bold and well-balanced composition of villagers pulling in the nets in the fishing port of Nazaré in Portugal. A wide angle lens has accentuated the effect of perspective.*

Nikon F, 24mm lens, 1/250 sec. at f8. Kodak Tri X.

Right *Taken in the Orthodox Mea Sheream quarter of Jerusalem this picture required a 'low profile' approach to get an unobserved shot of an intent business transaction. A precisely timed exposure has isolated the significant moment when the shopkeeper's hands moved to check the money.*

Nikon F, 50mm lens, 1/250 sec. at f5.6. Kodak Tri X.

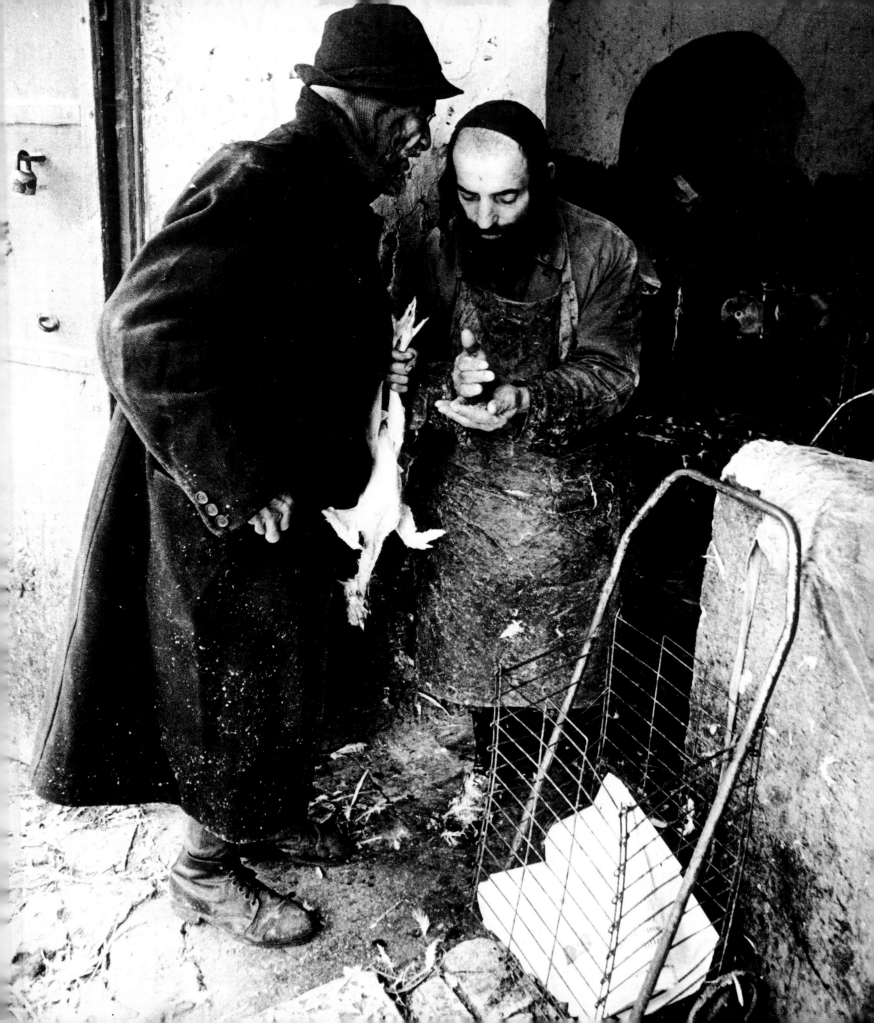

Still-life

Still-life photography is one of the few subjects that offers total control over the elements of the picture. For this reason, it offers an excellent way of learning the basic techniques of lighting and composition. It is also an ideal way of creating pictures of a more personal nature and of encouraging a more creative and considered approach to picture taking.

Although professional still-life photographers have a vast array of expensive and complex equipment, this is by no means necessary for the amateur. Quite modest equipment can be used to produce first-class pictures of this type. It is not even essential to use studio lighting. Daylight indoors can provide a very effective source, but there is no reason why such pictures cannot also be taken outdoors, in the garden, for instance. The main requirements are a good firm tripod and a suitable bench of a convenient height upon which to build your arrangements.

Most successful still-life pictures are the product of a good visual concept to begin with. It is best to sit down with a notepad and jot down a few ideas for objects and backgrounds that may be combined successfully. Try to think in terms of the basic visual elements. Consider objects, for instance, that have a variety of shapes, colours and textures that will either contrast or harmonise with each other. These do not have to be elaborate or even particularly interesting individually. Very effective pictures can be constructed from interestingly shaped vegetables and pieces of fruit, for example, with simple fabric backgrounds and props such as pottery or wooden utensils.

Having decided on a potential group of objects and a suitable background, choose an item that will be the most dominant element because of its size, shape, colour or texture. Place this first on the background. With the

camera set up on the tripod and framed and focused, the effect of this initial object can be judged as additional elements are added and their relative positions altered. There will inevitably be a variety of satisfactory combinations, but it will be very instructive to explore all the possibilities before shooting. You can also see how the effect can be varied by changing the camera position, using a higher or lower viewpoint, moving in closer to emphasise a shape or a detail or further back to include some additional elements.

The quality and direction of the lighting will also be an important consideration. Highlights and shadows can be an important element of the composition as well as affecting the mood and quality of the image. Strong side or back-lighting can be used to create a low-key effect emphasising texture and form, whereas a soft frontal light can produce a more subtle or high-key quality

Above and right *These two pictures taken by daylight show how the direction and the quality of the lighting as well as the composition can be controlled by the choice of viewpoint. The picture above was shot with a frontal light. By moving the camera to the left and slightly rearranging the subject, a more directional lighting quality has been achieved in the picture on the right.*

Rolleiflex SLX, 150mm lens, 1/8 sec. at f16. Kodak Tri X.

accentuating perhaps the colours or the shapes of the objects.

Still-life photography provides an unequalled opportunity to discover the effects that can be achieved by the interaction of colours, objects of a similar colour creating a harmonious quality and boldly contrasting colours producing a more dramatic effect. The still-life is in fact an ideal subject for experimentation with both technique and composition and can help to stretch both your ability and your imagination while leaving your pocket undamaged.

Below and right *These four pictures demonstrate how the composition of even a simple group of objects can be varied by selection and rearrangement. The wine bottle was chosen to be the centre of interest and the other bottles and objects systematically added and taken away to explore the different effects that could be achieved. Like the bottles, the textured wood was found in the depths of a garden shed and the picture was set up in natural light. Even with such basic components, the permutations can produce pleasing results and the process of arranging and rearranging the objects can provide a valuable lesson in composition.*

Rolleiflex SLX, 150mm lens, 1/15 sec. at f16. Kodak Tri X.

Animals

Few photographers fail to respond at some time to the appeal of animals as a subject for their camera. Like portraits, such pictures are largely dependent for their effect on the ability to capture the personality and expression of a creature. Unlike photographs of people, however, there is a far more limited opportunity to control and direct the subject. The most accessible and manageable animals are probably domestic pets, but even these can present some difficulties, and considerable patience is needed to produce good pictures. It can be very helpful to have an assistant who can control the animal by restricting its movements and coaxing the best reactions and expressions from it. This will leave you free to concentrate on the photography.

Most good animal shots rely on tight framing and the exclusion of irrelevant details. This will help to emphasise the subject's features. As a general rule backgrounds should be kept plain and simple and should provide a contrasting colour or tone to add further emphasis to the animal. A long focus lens will be very helpful in both respects, enabling close-up images to be produced without having to get too near the subject. The relatively shallow depth of field will help to keep background details subdued.

Soft directional lighting will help to reveal the fine details of fur and feather without the dense shadows that a hard light would create. It will also allow you and the subject more scope for movement without detrimental effect on the lighting. With indoor pictures, a bounced flash can create a suitably diffused light and at the same time is easily manoeuvrable to allow you to follow the movements of the animal. In outdoor situations, the light of a slightly overcast day is ideal. On a sunny day try to shoot in open shade. Shooting against the light can also be effective when the sun is shining.

Zoos and safari parks can provide a wide choice of more exotic animals, and with a little care in the choice of viewpoint and in the framing of the picture the evidence of captivity can be disguised if required. However, this can sometimes be used to contribute to the picture. It is often possible to make the fences that surround zoo animals invisible by shooting with a long focus lens at a wide aperture with the camera held close to the wire.

Photographing animals and birds in the wild presents a rather different problem, since in most cases it is not possible to approach them. The best solution is to set up a concealed camera as close as possible to a known habitat or feeding ground and simply wait until the subject comes within range. For this type of picture a long focus lens is a virtual necessity.

Do not overlook the possibilities of the semi-tame or partially domesticated creatures such as farm animals. Although they do not have the rarity value of wild and big game creatures they can provide plenty of opportunities for appealing and effective pictures. Good photographs (on slide film) of even quite commonplace animals are in constant demand by publishers and picture libraries and an interest in this type of subject can easily lead to a freelance income and the pleasure of seeing your pictures in print.

Above *Although in general it is best to select a background of contrasting tone or colour, the harmonious quality of this shot creates a pleasing image. The markings of the cat's coat have prevented it from becoming too 'lost' in the chair. Bounced flash was used for the lighting.*

Nikon F2, 105mm lens, f5.6. Bounce flash. Kodachrome 64.

Left *A long focus lens was used for this picture of a deer. The autumn colours and the low evening light contribute to the atmosphere of the picture, and the backlighting and out-of-focus background have helped to isolate the quite small image of the animal from its surroundings.*

Nikon F2, 400mm lens, 1/250 sec. at f5.6. Ektachrome 64.

Right *When photographing animals in captivity it is often possible to eliminate the bars or fences that enclose them if it is some distance away from the subject. However, it was not possible in this picture, so the bars have been used as an element of the composition, helping to emphasise the bold image of the tiger.*

Nikon F3, 150mm lens, 1/60 sec. at f4. Ektachrome 64.

Trees and Flowers

One of the problems of photographing nature is simply that its products are so abundant that individual picture possibilities are easily overlooked in the broad view. Most landscape pictures include trees, but as an element rather than the main feature.

Trees in fact offer a wide range of pictorial possibilities, since they are particularly rich in the basic visual elements. They have interesting and appealing shapes, create dramatic and flowing lines and are rich in colour and texture. As a bonus, seasonal changes bring about a constant variety in these factors. The bare branches of a tree in winter can create bold and assertive images when silhouetted against a dramatic stormy sky or sunset, for example. The sumptuous colours of autumn trees can provide opportunities for stunning colour photographs. A lone tree with an interesting or elegant shape can often be used most effectively as the centre of interest in a landscape shot, and trees in towns and cities can provide an effective contrast to the angular shapes and the harsh textures of the urban landscape.

A closer view of trees will also reveal a rich variety of textures and patterns such as a delicate tracery of spring leaves or the gnarled and contorted branches of an old beech or elm tree. This approach can lead to pictures of a more abstract nature and create the opportunity for experimenting with the ways in which light and form can be used to produce pictures with a strong tonal quality. This type of shot can be particularly impressive in black and white and many leading photographers in this medium have exploited this aspect very effectively.

Flowers, like trees, have an appeal both in the mass and individually and make similarly interesting subjects for photography. However, the vividly colourful nature of flowers can present problems. The type of scene which is most likely to attract attention – a large display of blooms of contrasting colours – is the most likely to make a poor subject for a photograph unless approached carefully and selectively. The most effective pictures are the result of restricting the image to a single dominant colour which is juxtaposed against a contrasting background. The inclusion of too many different colours will simply create a confusing and discordant picture.

Right *This close-up picture depends on texture and pattern and restricted colour range for its impact. An extension tube was fitted for close focusing.*

Nikon F2, 105mm lens, 1/60 sec. at f8. Agfachrome 100.

Below *The sturdy trunk of this beech tree has been made the centre of interest in this shot. It stands out in bold relief against the out-of-focus background. This effect was emphasised by the use of a wide aperture and a long focus lens.*

Nikon F2, 200mm lens, 1/60 sec. at f4. Kodachrome 25.

Left The out-of-focus highlights on the water in the background of this shot have added a degree of interest and created an effective background for the blooms. A wide aperture and a long focus lens have kept the background from becoming too distracting.

Nikon F, 200mm lens, 1/250 sec. at f4.
Kodachrome 25.

Above Strong directional lighting and a careful choice of viewpoint have accentuated the slender trunks of these plantation trees, and the regularity of their positions has created a pleasing design. A wide angle lens was used to exaggerate the effect of perspective and a polarising filter has emphasised the white clouds against the blue sky.

Nikon F3, 20mm lens, 1/125 sec. at f8.
Ektachrome 64.

Special effects-close-up

If there is one accessory that can literally open up a whole new world of potential subjects and encourage a new approach it is the close-up attachment. It can be surprising just what beautiful and unusual pictures can be created from even quite commonplace objects when you take a closer look. All but the simplest cameras will focus as close as a metre or so and this is more than adequate for most subjects. However, to photograph small objects and details it is necessary to focus at much closer distances. There is a variety of accessories that can be used to achieve this. The simplest and least expensive is the close-up lens. It is simply a weak positive lens which fits onto the front of the existing camera lens like a filter. It is available in a variety of strengths so that the camera lens can be focused at progressively closer distances. This is the only attachment which can be used with a fixed lens camera. When using it with a viewfinder camera, it is important to appreciate that the viewfinder will no longer be accurate at close distances and the exact field of view must be estimated. An SLR or a view camera are by far the most suitable types for close-up photography because the exact field of view is shown on the viewing screen and the image can be precisely focused.

There are two main ways of using an SLR for close-ups: by fitting extension tubes or bellows between the camera body and the lens or by fitting a macro focusing lens to the camera. This is a lens that has a greatly extended focusing range, often allowing objects to be photographed at life size.

Below and right *Camera equipment for taking close-up photographs with a 35mm SLR. Below is an SLR with and without an extension tube in position between the camera body and the lens and a selection of tubes. On the right is a bellows extension unit.*

Whichever method is used, there are a number of special considerations to be made. Depth of field is greatly reduced at close focusing distances. It is therefore important that the camera and subject are lined up so that the most important details of the subject are on a similar plane. It is usually necessary to use quite small apertures. You will find with very close subjects that it is often easier to focus by moving the camera closer to and further from the subject rather than by adjusting the focusing ring of the lens.

Above *A long focus lens with an extension tube was used for this close-up of a spider. The shallow depth of field has helped to throw the background details well out of focus, creating good separation between the subject and the background.*

Nikon F3, 150mm lens with extension tube, 1/125 sec. at f5.6. Ektachrome 64.

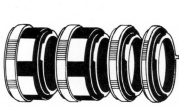

Different widths of extention tubes

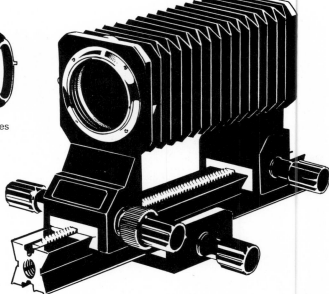

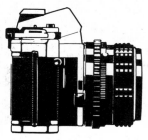

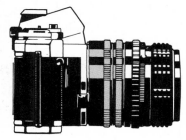

Extention tube fitted between lens and camera

Extention bellows

Above *This close-up of a leaf was photographed against the light so that the pattern created by its veins was emphasised. A macro lens enabled the image to be focused from a close viewpoint, producing a life size image on the film. The camera was mounted on a tripod so that a small aperture could be used, eliminating camera shake.*

Nikon F3, 105mm lens with extension tube, 1/60 sec. at f8. Ektachrome 64.

A tripod is a vital accessory for close-up pictures. Not only will it enable the camera to be aimed and focused more accurately, but will also help to prevent camera shake, an effect which is accentuated with close-up pictures. This type of picture requires the image to be critically sharp. It is advisable to use a cable release to ensure that the camera is not jarred when the shutter is released. In some cases, it can be helpful to use the mirror lock, if the camera has one, to prevent the risk of vibration as the mirror comes up. When shooting outdoors with subjects such as flowers, for instance, it is also important to ensure that there is no subject movement. If necessary set a screen close to the subject to protect it from a breeze or support the stem with a piece of wire.

When you physically move the camera lens further from the film, as with an extension tube or a bellows unit, the brightness of the image is decreased and extra exposure must be given to compensate. This will be allowed for when using TTL metering. In other circumstances you must calculate the increase by a factor obtained by measuring the distance the extended lens is from the film and dividing the square of this distance by the square of the focal length of the lens.

Left *A miniature still-life picture has been produced here by arranging and combining two unrelated objects — a flower petal against the surface of a cowrie shell.*

Nikon F3, 105mm lens with extension tube, 1/60 sec. at f8, Ektachrome 64.

Above *Although an SLR is the best choice for close-up photography, a simple viewfinder camera fitted with a supplementary lens can also be used. Care will need to be taken when framing the picture.*

Olympus RD, with supplementary lens, 1/125 sec. at f5.6. Ektachrome 64.

Special effects-soft focus

Of all the ways in which a technique can be used to manipulate the image recorded by the camera, soft focus is the easiest. Nevertheless it can be one of the most effective. The lens of even quite an inexpensive modern camera is capable of recording fine detail very sharply and clearly. In most circumstances this is what is required, but there are occasions when it can be more effective to suppress some of this detail by interfering with the optical performance of the lens. The simplest way of achieving this is to use a soft focus or diffusion attachment fitted to the front of the camera lens like a filter. These can be obtained as part of a filter system such as the Cokin. The method varies slightly, but the basic principle is to use clear glass or plastic with an indented surface. This creates a soft edge to the main outlines and details of the image but leaves an underlying sharpness. The effect is quite different from an image that is merely out of focus.

There are, however, a number of other ways of creating this effect. Clear petroleum jelly smeared onto a piece of clear thin glass such as a filter, for instance – *never* directly onto the lens – can be formed into swirls, which will create streaks of light spreading from the highlights in the picture as well as reducing the definition. Clear adhesive tape can be stretched across the lens hood to good effect and fine nylon mesh can also create a seductive softness. With all of these methods, however, it is important to leave a small clear hole in the centre of the lens so that there will be a degree of sharpness retained in the image. You will find that the aperture selected will have an effect on the degree of softness.

Above The delicate and almost abstract quality of the close-up of a rose was achieved by stretching clear plastic adhesive tape across the front of the lens hood, leaving a clear area in the centre. This has had a much stronger effect than the picture on the left. As well as reducing the definition of the image it has also lowered the contrast and colour saturation.

Pentax 6x7, 150mm lens, 1/125 sec. at f5.6. Ektachrome 64.

Above The luminous quality of this treescape was produced with a conventional soft focus attachment fitted over the lens. The soft touch has been further emphasised by a degree of overexposure to keep the tonal range of the picture quite light, creating a tranquil mood. A long focus lens was used to isolate a small area of the scene.

Nikon F2, 105mm lens, 1/250 sec. at f8. Ektachrome 200.

Right This portrait of a child was taken with a simple magnifying glass lens mounted on the camera by means of a cardboard tube. This technique makes use of the inherent faults in such a lens rather than introducing faults into a highly corrected camera lens by means of an attachment. Shooting towards the light has created a pleasing halo effect around the boy's head, where the highlights have spread into the shadows.

Pentax 6x7, 120mm lens, 1/125 sec. at f5.6. Ektachrome 64.

Special effects-multiple exposure

One way in which the nature of an image can be altered to a dramatic extent is by combining two or more exposures on one piece of film. Ideally this requires a camera which has a means of double exposing. Most cameras have a device to prevent this, but you can rewind the film and run it through the camera twice, after having carefully marked the starting position. If you have a slide duplicator this can be used to make a multiple exposure from existing transparencies.

There are essentially two ways of making multiple exposures. One is to expose the film sectionally so that each individual exposure is made onto an area of unused film. This involves either using a mask to shield part of the film while one image is recorded and then repositioning it for subsequent exposures, or placing the subject, or subjects, against a black background and altering the framing of the camera or the position of the subject for each exposure.

The second method is to expose the film twice. Where two or more images are to be recorded directly on top of each other considerable care must be taken to avoid a confused result. The exposure time of each image must be reduced, as a sequence of exposures will have a cumulative effect, producing an overexposed result. This type of picture works best when one of the images is quite dominant and the other acts more as a background. This can be achieved by giving the background image considerably less exposure to make it darker, for example, or to use filters to create a bold colour difference between the two images. You must compose the picture so that the light tones of one image are juxtaposed against the dark tones of the other to minimise any loss of detail.

Above This still life of a burning apple was achieved by making two exposures on the same piece of film. The apple was photographed first and its position traced onto the viewing screen. Then a second exposure of a candle flame was made against a black background, the candle itself being masked with a piece of black card. This image was lined up to coincide with the stem of the apple on the traced image.

Above A duplicate transparency was used in this shot to enable two existing slides to be combined, one of a sunset on a beach, the other a close-up of a rain-spattered window. Each exposure was reduced by approximately one stop to prevent the final result being too light.

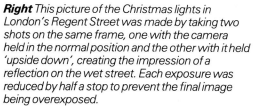

Right This picture of the Christmas lights in London's Regent Street was made by taking two shots on the same frame, one with the camera held in the normal position and the other with it held 'upside down', creating the impression of a reflection on the wet street. Each exposure was reduced by half a stop to prevent the final image being overexposed.

Special effects-slide sandwich

A slide sandwich offers an alternative means of combining more than one image. Unlike the double exposure you are able to judge the precise effect as you do it. The principle is very simple. You simply place two or more slides together in contact with each other. The result can either be mounted for projection or used to make a colour print or duplicate transparency. Unlike a double exposure, the slide sandwich has an additive effect. The density of the picture increases with each image and the dark tones of one image will 'read' more clearly when juxtaposed against a light tone in another image. For this reason, you should select slides that are lighter in tone than normal. As a rule the effect is most satisfying when one image has an essentially plain or even-toned quality and the other image has a well-defined darker shape or outline against a light or even clear background. You will need some form of light box to allow you to manoeuvre the slides and judge the effect. A piece of opal glass or plastic supported above a light source will be ideal.

It is a good idea to sort your slides into those that may be suitable as background images and those that will create the centre of interest. It will help if some of the slides are either of a larger format or have an area of fairly clear space around the subject. Two slides that are tightly cropped and of the same format will allow you no room to manoeuvre. Although you will probably use existing, possibly reject slides for your initial attempts, you will find it more satisfying and effective in the long run to plan the final image and shoot pictures especially for the sandwich.

Left *A profile shot of a girl's head against a black background was juxtaposed against a close-up shot of backlit surf to create this strange effect. Individually the pictures were quite ordinary, but the sandwich has produced an intriguing effect.*

Above *This rather surreal image was produced by sandwiching a landscape shot of a tree against a pale misty background together with a sunset over water. Both slides were slightly overexposed.*

Special effects-projected images

If you have a slide projector this can also be used to combine images in a number of ways. You will need to work in a darkened room. It will help if you have an adjustable stand for the projector and a tripod for the camera.

The most basic way of creating pictures in this way is to simply project a slide onto an object and photograph the result. If you are shooting in colour, use tungsten light film to match the colour quality of the projector. One way of using this method is to project a slide of a suitable subject such as a portrait or a nude, for instance, onto a textured or detailed surface such as a coarsely woven fabric or a piece of grained wood. In this way you can create a fairly subtle result similar to that of a texture screen used in the darkroom.

A more sophisticated effect can be achieved by projecting your selected slide onto a light-toned object with a distinctive shape. If set against a black background the image will, of course, be confined within the outline of the object used, but if it is placed against a white background the image will be continued, creating a more ambiguous effect.

A further variation can be obtained by the angle from which the slide is projected. When aimed from close to the camera position, the result will be quite flat with no modelling within the object, but when used from one side an impression of form will be created. An even more intriguing effect can be obtained by partially lighting the object onto which you are projecting the slide. Rim or backlighting is often best and the light should be controlled tightly by a snoot or similar device so that it does not spill into unwanted areas. In this way the projected image can be made to blend with the solid object.

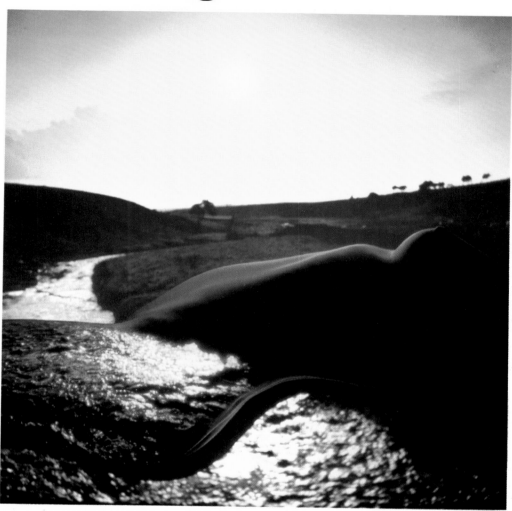

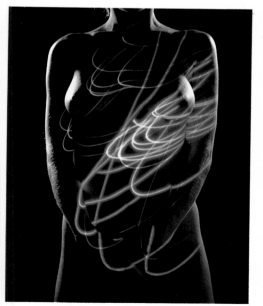

Above In this shot, the model was placed against a white background so that the slide of the landscape continued onto it, making it appear that she is part of the image. In fact the model was standing and the slide projected on its side. The appearance of rim lighting on her body is light reflected from the white background.

Left This picture was produced by projecting a slide of a light pattern onto the body of a girl who was posed against a black background. Rim lighting was used to define the outline of the model's body but was confined with snoots to avoid light spilling onto the front and degrading the projected image.

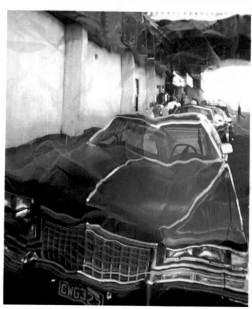

Right The distorted effect of this shot was created by projecting a straightforward transparency of the car onto a crumpled piece of white paper. The projector was placed slightly to one side of the camera to add to the effect.

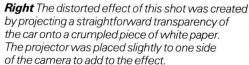

133

Special effects-infra-red

There are a number of ways in which the characteristics of certain films can be used to modify the nature of the image. Perhaps the most striking of these is the use of infra-red film. This is a specialist film designed for scientific purposes and aerial survey work, and is obtainable from Kodak or professional dealers in both black and white and colour emulsions. Instructions are included with recommendations for exposure and filtration when used for creative purposes. The film must be handled carefully and loaded and unloaded in darkness. Some plastic-bodied cameras can cause it to fog.

The black and white film can be very effective when used with a deep red filter. Landscape pictures can be particularly dramatic with blue skies recording as near black and green foliage and vegetation as almost white.

The colour version of the film can also be used to produce some extraordinary images. It is designed to respond to both visible light and invisible infra-red radiation and the result can be a picture in which some details appear quite normal and others as very strange colours. Green foliage, for example, will record as magenta or red.

Kodak recommend the use of a Wratten 12 filter, which is a strong yellow, but you will find that other coloured filters from the warm end of the spectrum can also produce some interesting effects. The film is somewhat more contrasty than a conventional emulsion and you should avoid a very high brightness range in the subject. It is also advisable to bracket exposures quite widely, as the effect will vary considerably according to the brightness levels.

Above, right and below These four pictures show some of the effects that can be created by shooting on infra-red Ektachrome. The top picture was taken on normal Ektachrome film as a comparison, and the shot above right made using the recommended Wratten 12 filter with infra-red Ektachrome. The picture below right was made with the aid of a Cokin sepia filter and the picture below left with an orange filter. It can be seen from these examples how much the colour quality can vary with filtration alone, but lighting conditions and exposure levels will also affect the film's response.

Nikon F3, 105mm lens, various exposures.
Kodak infra-red Ektachrome.

Special effects-using grain

The grain structure of film is usually something that is suppressed as much as possible, but it can be used very effectively to add impact and mood to a picture. The grain is in fact the clusters of metallic silver formed during processing to create the visible image. They are more pronounced with faster films, so that it is best to use a very fast film as the starting point for this technique. The effect can be created in both black and white and colour. The grain will become even more pronounced if the film is uprated and push-processing is used. There is a very high-speed black and white film made by Kodak called 2475 recording film, which has a particularly attractive gritty grain structure when rated at ISO 3200/36.

Even with a very grainy film, the effect will not be fully exploited unless the image is enlarged considerably. For this reason, it is best to compose your pictures so that only a small area of the film is used. A convenient method is to compose the image using a standard or long focus lens and then switch to a wide angle or standard lens respectively to actually shoot the picture.

Since the effect of grain is more noticeable in smooth, even-toned areas it is best to avoid subjects which have a lot of fine detail and contrast. As a rule quite softly lit subjects with large tonal masses are most suited to this treatment. It is also vital that the final enlarged image should be critically sharp, since the ultimate effect of the grain will be dependent on this. With black and white pictures, the grain can often be further enhanced by printing onto a very hard grade of paper.

Above The effect of this picture was achieved by shooting on a fast film (ISO 400/27) and push-processing to one stop faster. The picture was framed so that a small portion from the centre of the image could be considerably enlarged onto a sheet of duplicating film. The resulting picture represents a ×10 enlargement.

Nikon F2, 150mm lens, 1/250 sec. at f16.
Ektachrome 400.

Left This black and white landscape picture was taken on Kodak's specialist 2475 recording film rated at ISO 1600/33. The resulting negative was then enlarged onto a hard grade of paper to accentuate the grain structure. As with the above shot, the picture was framed so that only a small area of the negative was needed and the degree of enlargement could be increased.

Nikon F2, 105mm lens, 1/500 sec. at f16.
Kodak 2475 recording film.

Special effects-tri-colour

A variation on the multiple image technique which can be used to produce a quite different and interesting effect is a method known as tri-colour photography. Colour film is constructed so that the three primary colours in a subject are recorded quite separately on different layers of the emulsion. When viewed together they create the original colours of the scene.

The principle of the tri-colour technique is that three separate exposures are made onto the same piece of film, each one through a tri-colour separation filter, red, green and blue. If the subject is completely static, the picture will appear quite normal, but if anything has moved during the three exposures there will be a multicoloured fringe around that detail, such as the clouds in a landscape shot, for instance. A tripod is an essential accessory for this technique, since the camera must remain in precisely the same position for each exposure. It is also important that the three exposures are carefully balanced so that the static elements of the scene appear as a true colour and do not have a bias. The simplest method is to take an exposure reading without a filter and then make one exposure through the red filter at that setting, then without moving the camera or winding on the film make another exposure through the green filter, giving one and a half stops extra, and finally expose through the blue filter with a half stop more.

As a variation on subject movement you can also try the effects of altering the point of focus between exposures and zooming or even slightly displacing the image. A more subtle effect can be created by using weaker filters, as long as they cancel each other out.

Above and right These three pictures were taken using the tri-colour technique described in the text. The effect above was produced by shooting with a zoom lens and moving the zoom slightly between the exposures so that each image is in a different position. The quite strong colour effect in the water shot, above right, is a result of there being a high degree of contrast in the area where the subject has moved between exposures. In the picture right, although the same principle has been used, the lower contrast of the subject has created a more subtle result.

Nikon F3, various lenses and exposures.
Ektachrome 64.

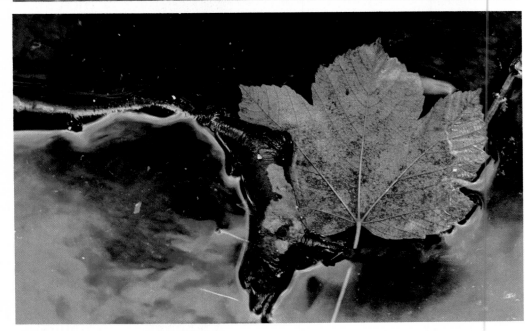

Special effects-utilising blur

Lack of sharpness in an image is something that we usually try to avoid, and effects like camera shake and subject movement are considered to be faults. However, an unsharp image can sometimes be used as a positive quality in a picture and its effects can sometimes be both dramatic and beautiful. Even an image which is simply thrown completely out of focus can be effective with some subjects, as can pictures which contain a sharply focused subject with large areas of out-of-focus foreground and/or background. This effect can be most easily achieved by selecting a subject which is on a different plane from other details in the scene and using a long focus lens and a wide aperture.

Blur caused by movement can be particularly effective and a frequently used technique is to pan the camera with a moving subject so that some or all of the subject is sharp but the background is blurred. The effect can be controlled by the choice of shutter speed. A very slow shutter speed, such as 1/15 second, for instance, with a swiftly moving subject can produce an almost abstract effect. An equally interesting effect can be produced with a moving subject by keeping the camera stationary so that static elements record sharply, allowing the subject to become blurred. If the camera is mounted on a tripod long exposures of seconds or even minutes can be given to create unusual and dramatic images from quite ordinary subjects, such as the light trails formed by moving cars in street scenes at night or a swiftly moving river or waterfall.

An interesting effect can be produced by using flash and daylight combined with either camera shake or a moving subject.

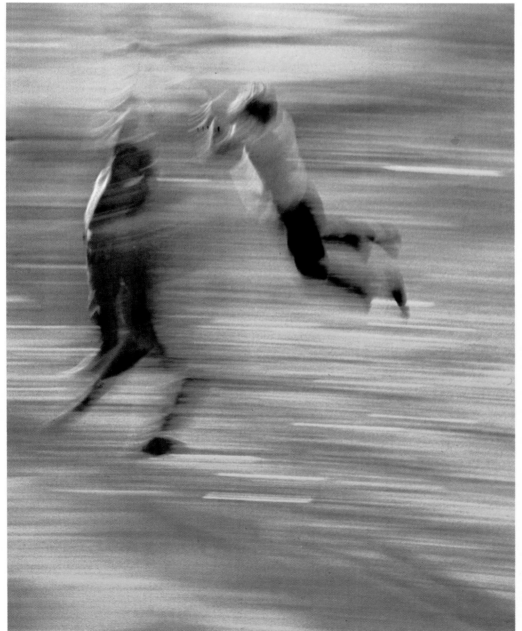

Left The almost abstract effect of this shot of two boys swinging from a rope was produced by panning the camera and using a very slow shutter speed, allowing deliberate blurring.

Nikon F, 105mm lens with a neutral density filter, 1/2 sec. at f16. Ektachrome 64.

Above The effect of this shot was created by mounting the camera on a tripod and using the pan and tilt head to rotate the camera during exposure.

Nikon F2, 24mm lens with a neutral density filter, 1/2 sec. at f22. Ektachrome 64.

Below This shot of Las Vegas was taken by simply throwing the image out of focus. The lens was set at its closest focusing distance and stopped down until the right degree of blur was produced.

Nikon F2, 24mm lens with a neutral density filter, 1/2 sec. at f22. Ektachrome 64.

Photo
Projects

A picture story

In most situations, a photographer aims to produce a single, quintessential image which expresses a particular idea or makes a certain statement about something. Indeed the familiar cliché, one photograph is worth a thousand words, is very largely an accurate assessment of the purpose of photography. It is not difficult to appreciate, therefore, just how effective a series of pictures of the same situation can be, since it is able to combine the visual impact of the photographic image with the narrative power of a story. The most obvious use of the picture story is in the field of journalism. It is an art which was developed and exploited fully in the days of the great illustrated magazines such as *Picture Post* and *Life,* when photographers like Margaret Bourke White and Eugene Smith shot many telling series of pictures.

The picture story can also be a very effective way of approaching photography of a more personal nature. The compilation of a family album or a record of a holiday has much in common with this aspect of the medium and the results will undoubtedly benefit from the planning and consideration that you would give to making a picture story. The basic principle of such a series of pictures is that they should be self-explanatory, with the minimum need for caption material. Each successive picture should say something different about the subject and at the same time complement and relate to the other

pictures in the series. These aims will be more readily achieved if the story is researched and planned before shooting. You should understand exactly what you want the story to say and know where it should begin and end. It should also have a strong element of continuity. This will, of course, partly result from the narrative itself, but you should also aim to create a visual connection between the images – from the mood of the lighting, perhaps, or the colour quality of the pictures. At the same time there should also be a feeling of variety and pace in the sequence. To this end it will help to consider your pictures in the way that film directors plan shooting scripts, with changes from long shots to close-ups and mid-range shots. Making use of different lenses will help in this respect. Use a wide angle, say, to create an establishing shot and then switch to a standard or telephoto lens to focus attention on particular details.

Quite apart from the satisfaction of producing a really good series of pictures in this way, the planning and thought that a picture story requires will also be invaluable in extending your photographic abilities. It will help to give your picture-taking a sense of purpose and impose a discipline, making you fully explore your subject and consider all the possibilities of different viewpoints, lenses and technical skills in order to achieve the most effective result.

All these pictures are part of a picture story on a country market. This selection shows how different aspects of the subject can be chosen so that a composite picture is built up of the place and the people who work there. The effect that individual pictures can have when used in conjunction with each other can be seen in the two shots of the chickens, which display a somewhat grim humour in comparing their different roles in the production of food. A variety of lenses was used to help change the nature of the pictures from long shots to mid-range and close-ups, a device that helps to introduce both pace and variety into the series.

Nikon F3, various lenses and exposures.
Ilford XP1.

Following a theme

Even the most enthusiastic and experienced photographers suffer occasionally from periods when they feel uninspired and unimaginative. At times like these it is possible to go out with a camera and simply not see any pictures. There are a number of answers to this problem, such as travelling to a new and exciting place, for example, or thinking of an idea for a picture story, but one solution which can be less involved – or expensive – and that also provides a source of ideas and inspiration at other times is to have a theme to which you can constantly return. Most experienced photographers will in any case discover after some years that they have been doing this, often unawares. Many photographers find on looking through their files that they have developed a passion for trees, for example, or fishing boats. The pictures on this page are the result of a fascination for windows that was, in the early stages at least, quite subconscious.

Recognising such a motif when it first appears attractive will mean that you will always have a specific type of picture to look for when you go out with a camera, particularly if it is something relatively commonplace. On days when you feel uninspired it will give you a positive motivation, which is an important step in overcoming this state of mind. At the same time, looking for pictures to fit your theme will undoubtedly open your eyes to other possibilities. If your theme is something quite specific, like windows for example, the interest and variety can come from both the different types of the subject and from the way in which you photograph it. Indeed your theme could be one specific object or place that you can return to time after time, looking for new ways of seeing it and photographing it – a particular street near your home, for example, or perhaps a park.

The most useful aspect of any project is to provide both a motivation and a direction for your photography, and the particular advantage of this one is that it is a continuous project that you can keep coming back to until you become bored with it.

Right A tightly framed image has created an effective juxtaposition between the white rectangle of the shuttered window and the contrasting colour and shapes of the leaves and bricks.

Nikon F3, 150mm lens, 1/250 sec. at f8. Ektachrome 64.

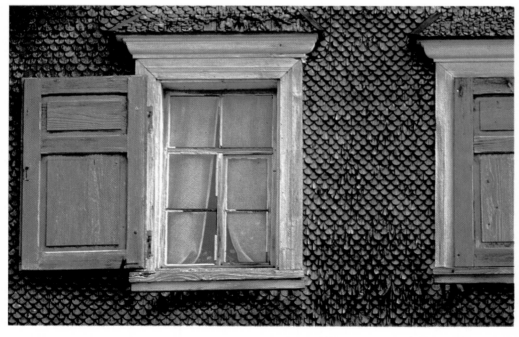

Above A Swiss chalet provided the subject for this window picture. The restricted colour range of the image has helped to emphasise the elements of pattern and texture.

Nikon F2, 150mm lens, 1/250 sec. at f5.6. Ektachrome 64.

Right Unlike the picture above, this picture of the windows in a Dutch house relies for its effect on its symmetry. The framing and choice of viewpoint were made with this intention.

Nikon F, 200mm lens, 1/250 sec. at f8. Ektachrome 64.

Top *A bold but harmonious colour quality has been created between the red shutter and the moss-covered stonework of this barn, photographed in Normandy.*

Nikon F3, 200mm lens, 1/250 sec. at f8. Ektachrome 64.

Above *It is the contrast between the shape and the colour of the windows and the chairs and tables below which gives this picture its appeal. This has been emphasised by tight framing.*

Nikon F3, 105mm lens, 1/250 sec. at f5.6. Ektachrome 64.

Using reflections

Photographers often consider a reflective surface to be rather a nuisance. Indeed they can create problems in some circumstances. Yet an image reflected in a shiny surface can create quite intriguing and unusual photographs, since it is possible to obtain effects ranging from double exposure to a simple addition of interest.

There are two basic ways in which reflections can be used to contribute to the image. One is simply to use the reflective surface as a means of distorting or altering the appearance of an object or a scene reflected in it, without the reflective object being a visible or important element of the picture. The other is to combine the reflective object with the image reflected in its surface to create a type of montage effect. It will help in the selection of a viewpoint, and

the way in which you take the picture, to understand the principle of a reflected image. When light rays from an object are reflected from a surface they leave it at the same angle as they strike it. This means that you must position your camera in such a way that it is aimed at the same angle as the object being reflected but from the opposite side of the reflective medium.

It is also important to appreciate that the focusing distance of the reflected image is not the same as the distance between the camera and the reflective object, but this distance *plus* the distance from the surface to the object which is being reflected. In practical terms, this means that to get both the reflected image and the surface in which it is being reflected equally sharp, you will need to focus at a point between them and to use a

small aperture to obtain maximum depth of field. In most cases, you will need to measure both distances and set the focus manually between them, at one-third of the way rather than half to make the most of the depth of field. Consequently, if you are using an SLR, it is best to view the subject with the camera lens stopped right down, since the impression gained at full aperture – and by the naked eye – can be misleading.

You should also remember that when dealing with non-metallic surfaces a polarising filter can often be useful to control the strength and quality of the reflected image. The balance of lighting between the two objects will also be important in this respect. When the reflected object is more strongly lit than the surface in which it is reflected, it will be more dominant.

Above The bright illuminations have created strong reflections in the dark, shiny parked cars, almost continuing the pattern created by the lights into the foreground of the picture.

Nikon F3, 20mm lens, 1/30 sec. at f8.
3M 640T Tungsten Light Film.

Left This shot of an office building in Los Angeles uses the reflection of another building to create an interesting juxtaposition of shapes and patterns.

Nikon F3, 150mm lens, 1/250 sec. at f5.6.
Kodachrome 64.

Above In this picture of the Christmas lights in London's Regent Street, the image reflected in the wet pavement has created almost a montage effect. To get both images sharp it was necessary to focus the camera at a point between the surface of the pavement and the distant lights and to use a small aperture.

Nikon F3, 50mm lens, 1/2 sec. at f11.
Ektachrome 400.

Left Reflection plays a less dominant role in this shot taken in south-west France. However, it plays an important part in the composition and the bold, clear image is a result of the brightly lit house being reflected in the dark still water, producing almost a mirror image.

Nikon F3, 105mm lens, 1/250 sec. at f8.
Ektachrome 64.

Making a record

The term 'a record photograph' is usually used in a derogatory sense, since it implies that the picture has no aesthetic merit and its only value is to provide a visual record of an object or a place. Yet it is perfectly possible for a picture to be aesthetically pleasing as well as being an accurate record, but in any case the use of photographs as a means of recording is a very valuable aspect of the medium and one that is well worth exploiting for its own sake. The world we live in is going through more rapid and dramatic changes than at any time in its history and pictures of even quite ordinary and commonplace things and events can take on an unexpected and nostalgic quality in even a quite short space of time. A photographer who makes a conscious effort to make a planned record of some aspect of the society in which he or she lives will, in the course of time, have a collection of photographs whose value may be much greater than their pictorial merit alone.

Most photographers do make a form of record without possibly being fully aware of

what they are doing. The family album is a good example. Think how much more valuable and satisfying it could be if you had imagined it and planned it from the point of view of looking at it in 20 or 30 years' time, for example. Details and incidents that you may take for granted or think of as insignificant at the time may well appear much more important and interesting in retrospect. A child's toys for instance, your first car, even the way goods are packaged and advertised are all examples of the things we look back upon with nostalgia and interest but hardly notice at the time.

Of course, you do not only have to consider a record of this type in a historical context. Any particular interest you might have can form the basis of such a project. A penchant for architecture, for example, will provide you with a potential subject whenever you go somewhere new. If you are a collector of some sort this too can be an ideal way of creating both a useful and interesting set of pictures.

Above This elegant and expensive-looking boutique was photographed in the exclusive Rodeo Drive, the shopping mecca of Beverly Hills, California. The juxtaposition of the passing browser and the display dummy adds impact to the shot.

Nikon F3, 200mm lens, 1/250 sec. at f5.6. Kodachrome 64.

Right The mass of detail in this shot of a bookstore taken in San Francisco creates a very busy image. It needed the group of small boys to provide an eye-catching focus of interest.

Nikon F3, 150mm lens, 1/125 sec. at f5.6. Kodachrome 64.

Above left *The appeal of this general store photographed in Sri Lanka relies upon a variety of shapes and patterns within the rectangle of the shop front. A frontal viewpoint with little perspective has helped to emphasise this.*

Nikon F3, 150mm lens, 1/250 sec. at f5.6. Ektachrome 64.

Above *The impact of this shot relies upon the dominant colour of the image. The tightly framed picture has helped to emphasise this, as well as making the most of the bold lettering.*

Nikon F3, 70mm lens, 1/125 sec. at f5.6. Ektachrome 200.

Below *A small detail of a French baker's shop has produced a quite pleasing picture as well as providing a record of an interesting variation of shop display. The reflection in the glass adds interest.*

Nikon F2, 105mm lens, 1/125 sec. at f5.6. Ektachrome 64.

Isolating detail

The subject itself is often the most important element of a photograph. Usually the aim is to take a picture of a specific object or location, and the presence of the elements of composition and quality of lighting, although of importance, are secondary to the identity and nature of the subject. However, when the main purpose of a picture is simply to create a pleasing image rather than to depict a specific object, it is possible to adopt a quite different approach. Indeed many successful pictures can almost be considered abstract in so far as the subject is either unrecognisable or is of no importance.

The simplest method of creating this type of picture is to isolate small areas or details of a scene or object so that the viewer's attention is focused on its graphic qualities. By separating and emphasising this aspect of the subject it is possible to see and present familiar things in a quite different way. There is in fact considerable satisfaction to be gained in this approach. It is relatively easy to obtain a striking image and a favourable response to an obviously picturesque subject, like a sunset, for example. To produce a powerful image from something that other people may well pass unnoticed is directly attributable to your own powers of perception.

The technique for this type of picture is largely dependent on the choice of viewpoint and in the way the picture is framed. Since the aim is usually to isolate and present certain details out of the context of their surroundings, it is possible to ignore many of the normal considerations of composition. Indeed the strangeness or unbalanced quality this can produce can be an important element of such pictures. Unusual viewpoints can often be used to good effect in this respect since even very commonplace objects can be used to create abstract images when viewed from an unfamiliar angle.

Different focal length lenses can also be helpful especially when combined with a well-chosen viewpoint. A long focus lens, for example, can be very effective in framing the picture tightly from a more distant viewpoint. This can reduce the effect of perspective, emphasising the more graphic qualities of an image. A wide angle lens combined with a close viewpoint can produce very exaggerated perspective effects, distorting the relationship between the various planes of the image. As well as being a satisfying project, detail photography is also an instructive way of learning to look at familiar things in a different way – the photographer's equivalent of lateral thinking.

Above *This image has used a juxtaposition of shapes for its effect.*

Nikon F2, 85mm lens, 1/30 sec. at f8. Ektachrome 64.

Left *This shot taken on a dockside relies for its impact on a bold colour contrast which has been emphasised by tight framing.*

Nikon F2, 150mm lens, 1/125 sec. at f5.6. Ektachrome 64.

Below *Moving in close and framing tightly has emphasised the textural quality of this piece of rusty iron on a derelict building.*

Nikon F2, 105mm lens, 1/125 sec. at f5.6. Ektachrome 64.

Above This seemingly abstract picture is a detail of an Italian autostrada rest station.

Nikon F, 200mm lens, 1/250 sec. at f5.6. Ektachrome 64.

Right A restricted colour range has not detracted from the textural quality of this close-up picture of an old Thames barge.

Nikon F2, 150mm lens, 1/125 sec. at f5.6. Ektachrome 64.

Below A stack of logs stored under the eaves of a mountain chalet has created an image with a strong element of pattern.

Nikon F2, 105mm lens, 1/125 sec. at f5.6 Ektachrome 64.

A wide angle approach

The acquisition of new or expensive equipment is, as many photographers ruefully discover, no guarantee of an improvement in the pictures. However, one addition that can make a real difference to your visual approach to a subject is a lens of a different focal length. Many cameras will now accept interchangeable lenses and the development of the SLR system has meant that very reasonably priced lenses in a wide range of focal lengths are available to the amateur photographer. The addition of one or two extra lenses can open up a completely new range of photographic possibilities.

A wide angle lens can be used to do much more than simply include more of a scene in the picture. It will, for example, allow you to have considerably more control over the perspective of an image. In landscape photography you will be able to include quite close foreground details in a shot as well as distant objects, and this will increase the impression of depth and distance. In portraiture you will be able to take quite close-up pictures of a subject but at the same time include large areas of the background or setting. Of course, in architectural pictures you will be able to use viewpoints that a standard lens would not allow. In addition, the greater depth of field of a wide angle lens will enable you to retain sharp focus throughout the image with a subject that extends over a wide focusing range.

Extreme wide angle lenses can also be used in some circumstances to create deliberately exaggerated perspectives, even distortion, such as with the fish-eye or semi-fish-eye types. The effect of many filters and lens attachments will also be enhanced when used with a wide angle lens. You will also find that the effect of even quite small changes in viewpoint will be dramatically emphasised when using a wide angle. Regular practice with such a lens will teach you to become more aware of this aspect of your picture making and help you fully explore the ways of altering the composition and nature of your pictures by the choice of camera position.

The main problem to avoid when using this type of lens is the creation of unnoticed and unwanted perspective effects. You must be particularly careful when selecting a viewpoint and aiming the camera in this respect. Also the ability of the wide angle lens to include a large area of a scene in the frame and to record it all with equal sharpness can result in pictures which have too much going on in them, creating fussy and confusing images. For this reason, it is vital to pay particular attention to the composition of your pictures and to ensure that there is a well-defined centre of interest and a sense of order within the elements of the image.

An interesting project and a very useful exercise would be to explore all the possibilities and effects that a wide angle lens can create by going out and shooting a single roll of film using only that lens and applying it to as many different subjects as possible.

Below *This shot of the hilltop village of Casares in southern Spain relies upon the dramatic quality of the sky for its impact. This was emphasised by the use of a wide angle lens. A red filter was also used to make the blue sky a darker tone.*

Nikon F2, 20mm lens, 1/125 sec. at f5.6. Ilford FP4.

Left *The bold, brash quality of the Sands Hotel in Las Vegas has been successfully recorded in this shot by the use of a wide angle lens. This has exaggerated the perspective of the image, emphasising the strong lines and shapes of the subject.*

Nikon F2, 20mm lens, 1/250 sec. at f8. Ilford XP1.

Above *A wide angle lens has enabled the foreground building in this picture to be used as an element of the composition. It creates a bold frame around the main subject and contains the interest within the borders of the picture, as well as emphasising the effect of depth and perspective.*

Nikon F, 24mm lens, 1/125 sec. at f5.6. Ilford FP4.

A telephoto approach

The first thing you notice when you use a telephoto lens is the enlarged image of the subject in the viewfinder of your camera. This is the main reason why most photographers select a telephoto lens: it enables a close-up image to be obtained from a more distant viewpoint. This is, of course, a valuable asset with subjects like sport and wildlife, where it is often not possible to approach a subject more closely. However, like the wide angle lens, the telephoto has other qualities and characteristics which can be used to enhance the composition and effect of a picture.

The ability to isolate a small area from a distant scene is a powerful aid to creating exciting pictures, since it enables you to focus the attention on the most important aspect of a subject and to exclude unwanted or irrelevant details. This can help to produce pictures with a very direct and simple appeal. It can also be useful in creating a degree of abstraction, by showing elements of a subject removed from their more familiar context.

A long focus lens also allows you to control the perspective of a picture, since the effect of a more distant viewpoint and the exclusion of fore- or midground details will reduce the impression of perspective and depth in a picture. It will also show objects on different planes closer to their true relative scale in the image. This facility can be used to create pictures which have a more graphic quality, in which the element of design becomes a more dominant element of the image. For this reason, a telephoto lens is very useful in emphasising qualities such as pattern, texture and shape and in creating interesting and even unexpected juxtapositions of objects within the frame.

The very shallow depth of field of a long focus lens can also be a valuable creative tool, since it can greatly enhance the effect of differential focusing, creating a marked separation between the subject and background. This can be particularly useful when photographing a subject in a fussy and distracting setting by reducing background details to a soft and unobtrusive blur.

The main difficulty in using a telephoto lens is the need for accurate focusing and the avoidance of camera shake, a problem which is considerably increased with such a lens. Where possible, it is best to use a tripod, certainly with lenses of 200mm or more on a 35mm camera. If this is not possible, then use a fast shutter speed of 1/250 second or less and find a natural support on which to rest the camera.

You will find that spending some time shooting with only a telephoto lens will help you to become much more selective in your approach to a subject and make you more aware of the alternative ways of framing a picture. You may often find in the process that there can be several possible pictures in a situation where you may previously have seen only one.

Below *The long focus lens can be useful for candid pictures since it will let you take close-up shots from a more distant viewpoint. This shot has also benefited from the shallow depth of field of such a lens which throws background details out of focus, creating more separation between subject and background.*

Nikon F3, 200mm lens, 1/250 sec. at f4. Ilford XP1.

Above A long lens was used for this shot. This lens combined with a distant viewpoint has created a compression of the planes within the scene by reducing both the effect of perspective and the impression of depth.

Nikon F3, 400mm lens, 1/250 sec. at f8. Ilford XP1.

Below When it is simply not possible to approach a subject more closely, as in the case of this shot of a Water Monitor, a long focus lens is a virtual necessity if an image of reasonable size is to be obtained.

Nikon F3, 200mm lens, 1/250 sec. at f5.6. Ilford XP1.

Above The use of a long focus lens in this landscape picture has resulted in a tightly framed picture isolating a small area of the subject and emphasising the shapes and patterns created by the trees.

Nikon F2, 200mm lens, 1/125 sec. at f8. Ilford FP4.

To emphasise texture

Texture is one of the key elements of an image. It can be an important element of a composition and a powerful ingredient in producing pictures of outstanding visual and technical quality. Learning to recognise and emphasise the textural qualities of a subject can help you to improve your pictures technically, as well as adding impact.

The textural effect of a subject depends largely upon three factors: the nature of the surface which you are photographing; the quality and direction of the lighting; and the technical quality of the image. Even the most subtle textures can be revealed by the right lighting and the photographic process has an almost uncanny knack of distinguishing between very similar textures and evoking a tactile response from the viewer as well as a purely visual one. In portrait photography, the texture of a subject's face can be used most effectively, particularly in character shots. In landscape photography, the texture can be an important element in creating powerful images as well as adding detail and interest to the subject. In still-life and close-up photography the textural quality of the subject is often the single most important aspect of the picture.

The quality and direction of the light which will most effectively reveal a particular texture will depend on a variety of factors, such as the nature of the surface – whether it has an inherently coarse or fine texture, for example. Its colour or tone will also be a consideration. The most important thing is to be aware of the relationship between the lighting and the subject and to see the effect it has when its quality and direction change. In the studio you will of course be able to control the effect by adjusting the position of the lights, but when shooting in daylight this control must be achieved by the choice of viewpoint and camera angle.

It is also vital to make sure that the image is of high technical quality. The rich quality of a well-lit subject can be totally lost if the image is at all unsharp or incorrectly exposed. Focusing must be very accurate. It is often helpful with fairly close subjects to use a small aperture to ensure adequate depth of field and to use a fairly fast shutter speed or mount the camera on a tripod to eliminate the risk of camera shake. Exposure must be critically accurate. Although a small degree of underexposure can sometimes help to emphasise texture, overexposure should be avoided at all costs. When shooting in black and white, the effect of texture can often be enhanced by printing onto a harder grade of paper than normal.

Above *Shooting towards the sun has here created a bold textural effect.*

Rolleicord, 1/250 sec. at f8. Ilford FP4.

Below *A stormy sky and a strong directional light dramatise this shot of the Devil's Golf Course.*

Nikon F2, 20mm lens, with a graduated filter, 1/250 sec. at f8. Ilford XP1.

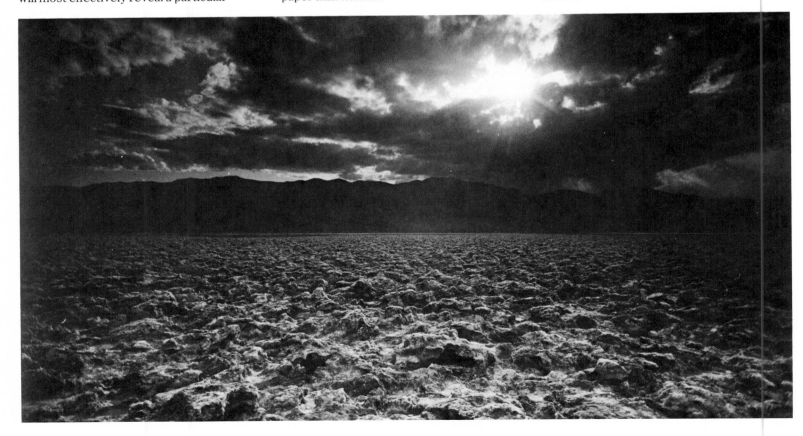

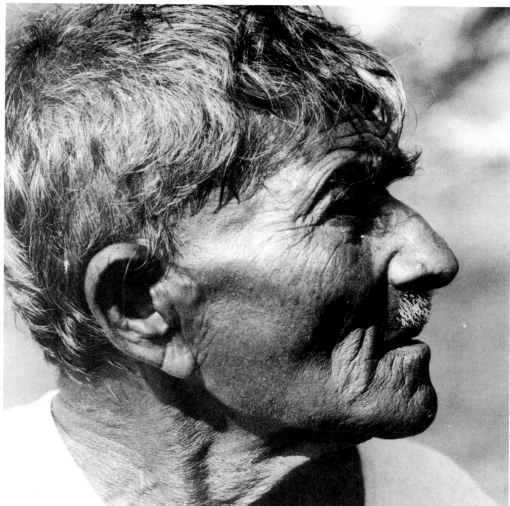

Above The soft but directional light from a window in this wood carver's studio was used to reveal the texture of gnarled hands and wood. The impression of texture is often enhanced when two different surfaces are juxtaposed in this way.

Pentax SV, 50mm lens, 1/125 sec. at f5.6. Ilford FP4.

Above right Very hard directional sunlight was used to capture the 'lived-in' quality of this old man's face. The relative positions of the man's head, the sun and the camera were very critical since the textural effect required the light to quite literally skim across the surface of his features. At a slightly different angle either the shadows would have been too obtrusive or the light would have been too frontal, and the texture would have been lost.

Nikon F3, 150mm lens, 1/250 sec. at f11. Ilford XP1.

Right The combination of a close-up picture and strong directional lighting has accentuated the texture of this weathered wooden post. The dense shadows created in the indentations have contributed an element of pattern to the composition.

Nikon F3, 90mm macro lens, 1/60 sec. at f16. Ilford FP4.

The design factor

The essence of photography is its ability to create a realistic image of a scene. Indeed, the realism of a photograph is one of the reasons that photography has been so grudgingly accepted into the realms of fine art. For photographers who want to try to create pictures with a more aesthetic, interpretive or personal appeal this can be an inhibiting factor. The early photographers attempted to overcome this barrier by giving their pictures the soft, romantic and painterly quality of the artists of that time. Fortunately, attitudes have changed and a good photograph can now be appreciated by most people for its own value, regardless of the style in which it was taken. However, photographers intent on advancing both the technical quality of their work as well as the aesthetic value can learn a great deal by looking at work in other forms of the media and using some of their qualities and ways of seeing in their own approach.

One feature of modern imagery is the use of bold and simple shapes and colours to create pictures with a strong graphic quality, the emphasis laid more on design than the traditional concept of composition. This can be seen in everything, from the work of modern painters to posters, advertisements, set designs, packaging and so on. Happily, photography lends itself particularly well to this approach, especially for those who like to fully exploit the potential of colour film.

Like most good photographs, successful pictures of this type depend more upon a

Above Taken just after a shower in soft light this close-up of lily pads relies for its impact on the jewel-like droplets of water which contrast with the soft green leaves.

Nikon F3, 150mm lens, 1/125 sec. at f5.6. Ektachrome 64.

perceptive and selective eye than on any special photographic equipment or techniques. This makes it a very effective way of learning to acquire a 'photographer's eye'. The subject itself is usually minimally important in this type of picture. Learn to look for scenes which contain bold masses of colour or strong shapes and dominant lines and to experiment with different ways of framing the images so that these are juxtaposed to create the most effective designs. The choice of viewpoint is also an important factor. The designer's approach will encourage you to explore the wide range of possibilities that this factor can control. A long focus or a zoom lens can be very helpful in isolating precise areas of a subject and in some circumstances a tripod will also help to aim and frame the camera accurately.

As a general rule, the elements of shape, texture, line, pattern and colour will be more important to this type of picture than form and perspective, and so this project will help you to adopt a more analytical and selective approach to your subjects.

Left The element of pattern is also a dominant feature of this picture taken on a tea plantation. The strong directional sunlight has accentuated the texture of the sacks and tea leaves.

Nikon, 20mm lens, 1/250 sec. at f8. Ektachrome 64.

Above The shafts of sunlight filtering through the slatted roof of this street market in Marrakesh have produced a picture in which the subject itself is almost lost. The exposure was calculated for the highlights, allowing the shadows to go black.

Nikon F3, 105mm lens, 1/125 sec. at f8.
Ektachrome 64.

Right This shot of a Spanish beach has made a quite bold and simple image purely as a result of being tightly composed and well organised. Careful choice of viewpoint and framing has emphasised the shapes and pattern created by the subject.

Nikon F3, 150mm lens, 1/125 sec. at f8.
Kodachrome 64.

Observing the environment

Old photographs have a fascination for most people because they convey the texture of life in times gone past. Photographs of unfamiliar and interesting places have the same sort of appeal. The most successful pictures of this type rely upon the photographer's ability to capture the flavour of a place or an event and this is by no means something which happens automatically. Indeed, anyone who has had to look through collections of holiday photographs will know how effortlessly easy it is for most amateurs to exclude any atmosphere or interest and tranform even the most magical and beautiful places into dull. Learning to take evocative pictures which capture the mood of a particular place is not only very satisfying in its own right, but will also speed along the development of a perceptive and sensitive approach to photography.

Observation is the key to this approach. You must learn to see a potential subject in terms of the details which characterise the environment. This may be the way people dress, their gestures or expressions, the details of buildings, the street graphics or even the transport. Having isolated these key elements, you can approach your subject either by moving in close to emphasise them by excluding or subduing other details or you can frame and compose the image so that they become either the centre of interest or at least a dominant element.

Even when taking a panorama shot it is usually possible to find a key element which will help to establish the location.

It is very easy to see a potential picture and recognise that it has qualities which make it unusual or different, but still fail to define them. By adopting a highly selective approach and a keen eye for detail, you will soon learn to harness these qualities and incorporate them into your pictures so that they have a positive identity.

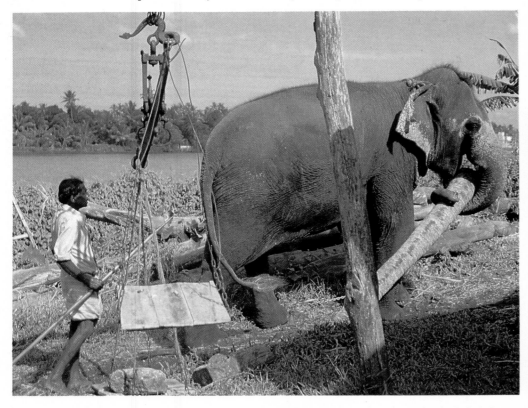

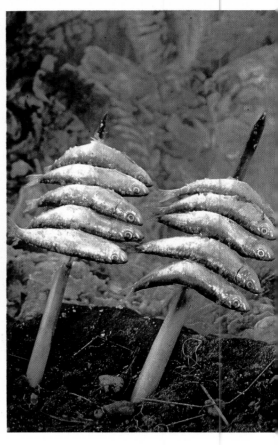

Above Working elephants are very much a part of the way of life in Sri Lanka and this picture has effectively captured part of the atmosphere of the country in which it was taken.

Nikon F3, 50mm lens, 1/250sec. at f8. Ektachrome 64.

Right To many people, the author included, the smell of fresh sardines grilling over an open fire evokes the atmosphere of the Mediterranean more effectively than any view might. This close-up, taken at a Spanish beach bar, almost manages to recreate the smell visually.

Nikon F3, 105mm lens, 1/250sec. at f5.6. Kodachrome 64.

Left *The typically desolate landscape of southern Morocco, with the distant Atlas mountains, has provided an effective backdrop to this colourfully dressed lady. The combination of subject matter has produced a picture with a strong sense of national identity.*

Nikon F3, 150mm lens, 1/250sec. at f8. Ektachrome 64.

Below *Although the costume alone identifies the part of the world in which this picture was taken, the detail of architecture has also created an effective background, as well as adding interest and impact to the composition. A long focus lens was used to isolate a small area of the scene.*

Nikon F, 200mm lens, 1/250sec. at f5.6. Ektachrome 64.

Photography for profit

Photography has become increasingly popular in the last decade or so as a career. Indeed the increasing reliance upon photography and allied media as a source of information, education and leisure has meant that there are more opportunities and a greater variety of ways of applying photographic skills than ever before. Naturally there is also considerably more competition for the jobs that are available and a prime requirement for someone considering the possibility of a career in photography is a fair degree of determination and persistence.

There is now a wide variety of photographic courses available, ranging from secondary school O and A level courses to full and part-time college courses, all of which can lead towards recognised diplomas. Qualifications like these can be a positive advantage in many aspects of a career and in many cases they are essential. However, in many fields such as advertising, fashion and journalism it is quite possible to become established by the means of a good portfolio and experience as an assistant or a freelance photographer.

Even if a full-time career in photography is not your intention, a keen and competent amateur can still find it a rewarding way of earning extra money in a variety of ways on a part-time basis. Social photography, such as portrait and wedding photography, can provide a convenient source of work for those who are only available in the evenings and at weekends. A professional approach is vital both in the standard of the work and in the way it is organised and presented. It is important to base your fees on realistic costings which include not only film, processing and printing costs but also postage, travelling and of course your time. Keep full and accurate records of all earnings and expenses as you will be subject to additional taxation. If your earnings are substantial, enlist the help of an accountant in preparing your tax records.

Submissions to magazines are also a useful means of part-time income, and you have the additional pleasure of seeing your work in print. This can be particularly fruitful if you have specialised knowledge or interests which a particular publication may find useful. It is important before submitting work to a magazine that you study the type of picture which they normally use and find out whether they use pictures from freelance photographers. A phone call to the picture or features editor before sending your work off is a good idea.

As well as selling single pictures, a picture series on a particular theme is also frequently required by magazines. This will be more marketable if you are able to supply a supporting text or article. In any case, all the pictures you submit should carry their own code number in addition to your name, address and telephone number and should be accompanied by all appropriate caption material. Where recognisable individuals are featured, as with glamour shots, you must have a model release form signed by the subject. There are a number of organisations which you can join, such as the Bureau of Freelance Photographers in the UK, who will give advice on potential picture markets in all fields of publishing. Although they take a quite large commission on sales – usually around 50% – a good picture library can help your pictures to find a far larger and wider market than you would be able to reach on your own, and will incidentally relieve you of the time-consuming chore of sending off and recording submissions. However, as a rule they will require that you leave a minimum number of transparencies with them for a specified period of time.

Above Pictures of girls always sell. A shot like this could be presented as a magazine cover, a calendar illustration or, as it is at the moment, to illustrate a book or feature on photography. However, when taking pictures of this type it is important to have a specific market in mind, as the shot's suitability can vary considerably from one publication to another.

Rolleiflex SLX, 150mm lens, 1/125 sec. at f5.6. Ektachrome 64.

Right In addition to general pictures, shots which illustrate a particular place, lifestyle or work process are always in demand. This shot of a rubber tapper taken in Sri Lanka could be filed under a variety of headings in a photolibrary and find a market in a variety of publications.

Nikon F3, 85mm lens, 1/60 sec. at f4. Ektachrome 64.

Left A picture like this, taken in the Maldive Islands, could be used for a number of purposes, as a general illustration in a holiday brochure, for instance, in which its precise location might not be at all important, or in a travel book as a 'portrait' of a particular island. The way it is framed would also make it suitable for cropping in a variety of ways to be combined with type.

Nikon F3, 24mm lens with a polarising filter, 1/250 sec. at f5.6. Ektachrome 64.

The Studio and Darkroom

The studio

For only occasional use, any convenient space can be quite easily and quickly converted into a studio. The actual amount of space will, of course, depend on the type of pictures you want to take. Still-life arrangements and head-and-shoulder portraits, for example, can be taken in quite a small area, but full-length portraits will require considerably more room.

You will need to have a reasonable amount of space between the subject and the background. Two metres is sufficient for most purposes. You will also need enough space to position the camera to include the required area of the subject. A full-length figure photographed with a standard lens will need a 'throw' of about four metres, although you can always place the camera outside an open door to obtain a greater working distance. You will also need enough space each side of the subject to position lights, ideally at least two metres each side of the shooting area. It will also be necessary to exclude or subdue light from the windows when shooting with artificial light.

Simple backgrounds can be provided by painted boards or fabric stretched onto a frame, but if you want to create a seamless join between the wall and floor you will have to use the specially manufactured rolls of background paper, which are three metres wide and available in a range of colours from professional dealers. Although these can be taped or pinned to the wall, it will be far more satisfactory to have a background support unit on spring-loaded poles or tripod stands. In limited space the pole system can be preferable for both backgrounds and lighting as it does not take up so much floor space.

If you are going to make more regular use of a studio facility and have the space to set up a permanent unit, you will be able to build-in a few more conveniences. In addition to adequate floor space, ceiling height is also an important consideration, especially where full-length shots are planned. Less than four metres will create considerable restrictions on both the type of pictures and camera angles. As well as the ordinary background rolls and supports you will also find it useful to construct two or three wall flats – timber frames covered with hardboard. These can be clamped together with G-clamps to form a simple set and painted or papered to create a more elaborate setting for pictures.

For still-life subjects it will also be useful to have a bench. A simple wooden table could be used or an adjustable unit could be built from tubular kits obtainable from professional dealers. Sheets of laminates make an ideal background for use on such benches as they can be curved to make a smooth transition from horizontal to vertical and can simply be wiped clean as opposed to paper or card, which must be discarded.

Two or three large reflectors will also be invaluable. These can be painted wooden or hardboard panels or sheets of rigid white polystyrene, which is extremely light to handle. The reverse side can be painted matt black to act as a screen for reflected light when a more dramatic effect is required. A diffusion screen will also be useful. This can be a timber frame about two metres square covered with tracing paper or frosted plastic sheet. A good firm tripod or wheel-based camera stand is also an essential item of studio equipment.

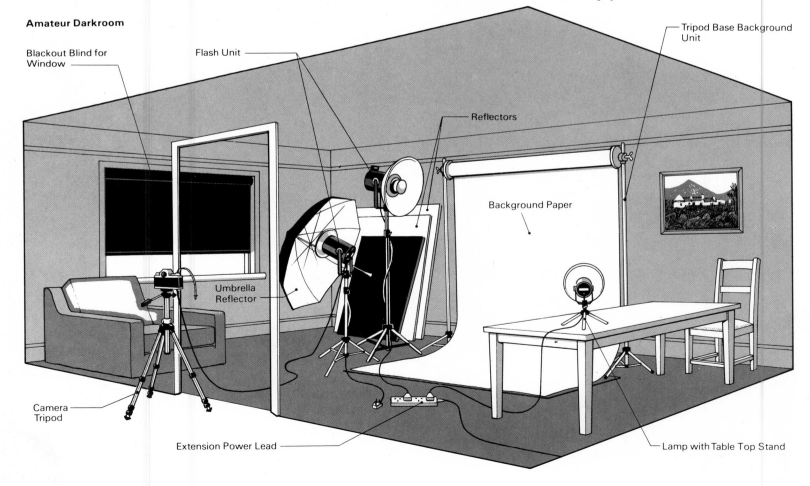

Amateur Darkroom

Tripod Base Background Unit

Blackout Blind for Window

Flash Unit

Reflectors

Background Paper

Umbrella Reflector

Camera Tripod

Extension Power Lead

Lamp with Table Top Stand

Below Where it is possible to set up a more permanent facility you should consider ceiling height as well as the length and breadth of the room. The illustration shows a typical professional studio equipped for handling both still life and fashion. The pole type camera stand allows a camera to be supported at both very high and very low positions, as well as being aimed straight down. The support unit enables background colours and paper to be changed quickly and easily.

Professional Darkroom

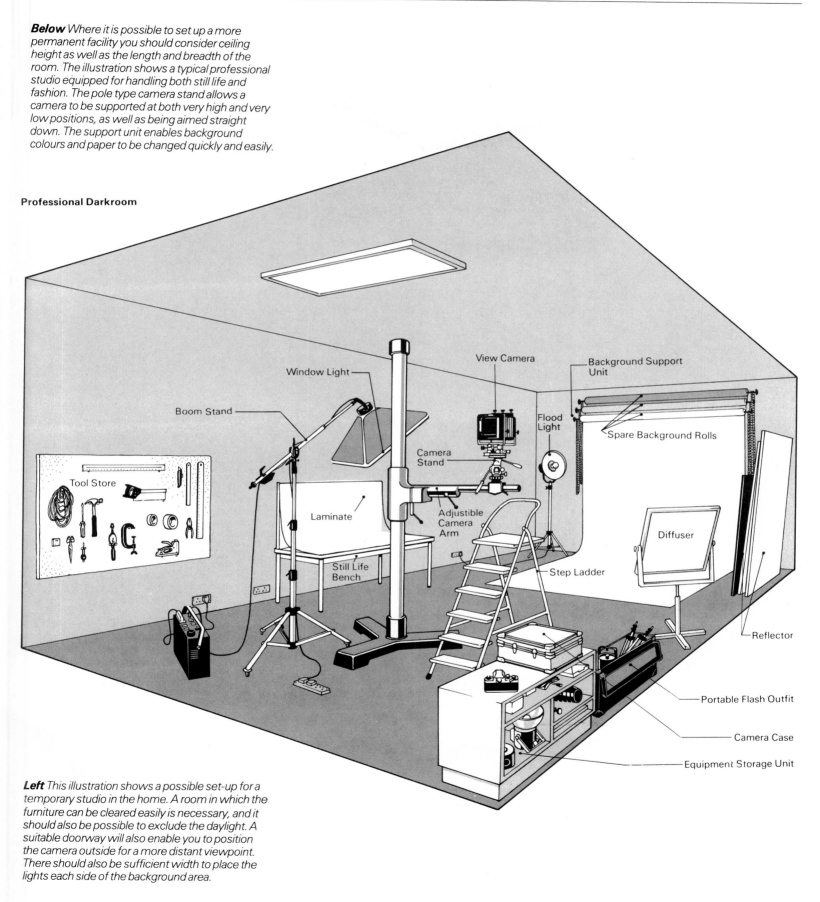

Left This illustration shows a possible set-up for a temporary studio in the home. A room in which the furniture can be cleared easily is necessary, and it should also be possible to exclude the daylight. A suitable doorway will also enable you to position the camera outside for a more distant viewpoint. There should also be sufficient width to place the lights each side of the background area.

The darkroom

Some photographers are deterred from attempting darkroom work because they believe that it requires an elaborate set-up and expensive equipment. In fact many processes can be quite satisfactorily carried out with the very minimum of facilities and a temporary darkroom can easily be made in a bathroom or even a large cupboard.

The first essential is, of course, that the space is made completely lightproof. This can easily be achieved. Use heavy-gauge black plastic sheeting either taped over window areas or fitted to a frame which can fit snugly inside the window recess. To ensure that the space is sufficiently light-tight, it is best to sit in the room in darkness for ten minutes or so. Any significant light leakage will become readily apparent.

Although running water is not essential it would of course be an added convenience, but most mixing and washing procedures can be carried out in another room in white light. You will need a safelight which can be operated separately from the normal room light. This should be one into which you can fit different screens for use with different materials. It is important that the wet and dry processes are well separated and ideally the bench or table for the enlarger should be placed on an opposite wall to the processing bench.

For black and white work you will need a bench or a shallow sink large enough to hold three or four developing trays slightly larger than the largest prints you plan to make. Colour print processes which can be carried out in a drum will require less space. In a bathroom, a convenient wet bench can be provided by making a panel to fit on top of the bath, but it would be advisable to cover the bath with a plastic sheet to prevent the risk of chemical staining. You must ensure that the enlarger is supported on a firm table, as any vibration will cause unsharp prints. It will be convenient to have a timer wired into the enlarger circuit; you will in addition need a minutes and seconds clock for timing processes and a photographic thermometer for temperature control.

If you are able to make a permanent facility in a room then it is a good idea to plan it out carefully so that the various movements and processes can be carried out in a logical and comfortable sequence. Although it is best for a darkroom to be painted white the area around the enlarger should be matt black to prevent stray light being reflected onto the paper during the exposure and causing fog. It will also be useful to have racks and shelves fitted for the storage of chemicals and processing equipment and a cupboard for keeping the dry materials, such as printing paper and film as well as enlarger accessories. Conveniently placed items are vital in a darkroom since you will sometimes have to find them by touch only. It is very helpful to fix a cord to run across the room just above head height to operate the room light. This can then be switched on with wet hands quite safely from both the wet and dry side of the darkroom. Cleanliness is vital in a darkroom and you should ensure that there is always a clean dry towel and that all trays and wet equipment are well rinsed and dried after each session.

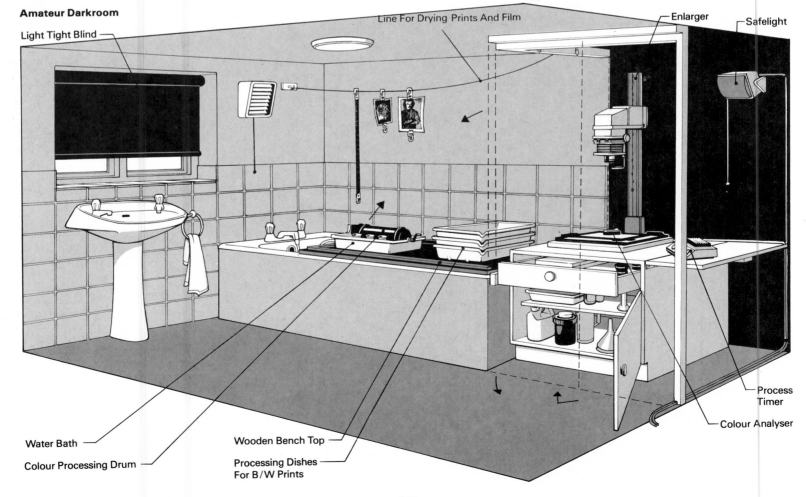

Amateur Darkroom

Line For Drying Prints And Film

Enlarger

Safelight

Light Tight Blind

Water Bath

Colour Processing Drum

Wooden Bench Top

Processing Dishes For B/W Prints

Process Timer

Colour Analyser

Below *A fairly typical layout for a general-purpose darkroom, with the wet and dry areas on separate sides of the room. Instead of a wet bench, most professional darkrooms have a large, shallow sink — usually made of plastic — in which the processing equipment is placed. Safelights are positioned for maximum efficiency and the equipment arranged for the smooth and convenient flow of movement.*

Professional Darkroom

Safelight

Safelight

Fluorescent Tube

Interval Timer

Safelight

Ventilation Fan

Light Box

Spare Trays

Funnel

Ektaflex Printer

Waste Bin

Processing Dishes

Print Washer

Paper Safe

Transfer Tray

Exposure Timer

Processing Chemicals

Enlarger

Focusing Magnifier

Masking Board

Measuring Cylinder

Left *A possible set-up for a temporary darkroom in a bathroom. The bath can be covered with a board and used as a wet bench with washing processes carried out underneath. As electric wall sockets are not allowed in a bathroom, you will have to run an extension cable in from another room for the enlarger and other electrical equipment.*

Developing film

Although processing your own film is largely a matter of routine, offering little opportunity for creative control over the image, it is an important step towards control over the quality of your pictures. It is also a useful and inexpensive introduction to the principles of darkroom work.

Actually, it is not even necessary to have a darkroom for film processing, since once the film is loaded into a light-tight tank the process itself can be carried out in daylight. There are two types of daylight developing tank, metal and plastic. Although the loading procedure is different, the principle is the same. The film must first be fed into a spiral. Metal spirals are loaded from the centre out and plastic spirals operate by feeding the film in from grooves on the outer edge. The latter can be adjusted to accept a range of film sizes, but the metal spirals must be bought for a specific film format.

Care and cleanliness are essential in all aspects of darkroom work and film processing in particular. It is most important that chemicals are carefully measured and mixed and that there is no contamination. Keep jugs and bottles set aside for each solution and mark them clearly. The exact

procedure will, of course, depend on the material you are processing. However, the same principles apply to both black and white and colour, although there will be more stages in most colour processes. In order to ensure correct and constant results you must learn to stick to a set routine, to control the temperatures and times of the processes and, equally important, the degree of agitation given to the film during development. Times and agitation rates will be recommended in the instructions for the process you are using. You will also need an accurate photographic thermometer and a clock for timing both minutes and seconds. One with an alarm for controlled intervals is ideal.

As soon as the developer has been poured into the tank, tap it sharply on the side to disperse any air bubbles that may have formed as the solution was poured in. The timing of the development should include the time that is needed for the solution to be poured out, so this should be started ten seconds or so before the required time. It is also most important to ensure that the required temperature is maintained accurately throughout the process. As most

colour processes are carried out at temperatures considerably higher than the ambient temperature, it is best to use a water bath. An ordinary large washing-up bowl is ideal. Fill this with water at the required temperature and place all the storage bottles and the tank in it for the duration of the process.

If developing solutions are to be kept for re-use it is important that they should be stored with the minimum amount of air in the storage bottle. You can exclude air from the concertina type when the container is not full. It is also important to record each use of the chemical and be sure not to exceed the manufacturer's recommendation, as stale solutions will cause a variety of problems.

Washing stages should also be considered equally important parts of the process and recommendations should be followed. Careful drying too is vital since the film is very vulnerable when wet, and dust, scratches and drying marks can easily ruin otherwise well-processed films. The best method is to add a little wetting agent to the tank after washing. Let it soak for 30 seconds or so and then just hang the film from a line with a weighted clip on the end in a clean, dry atmosphere.

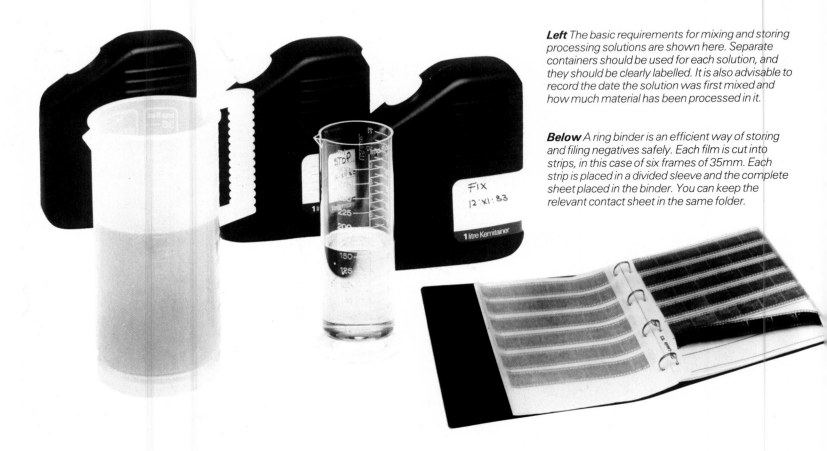

Left The basic requirements for mixing and storing processing solutions are shown here. Separate containers should be used for each solution, and they should be clearly labelled. It is also advisable to record the date the solution was first mixed and how much material has been processed in it.

Below A ring binder is an efficient way of storing and filing negatives safely. Each film is cut into strips, in this case of six frames of 35mm. Each strip is placed in a divided sleeve and the complete sheet placed in the binder. You can keep the relevant contact sheet in the same folder.

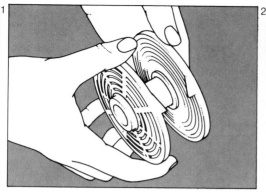

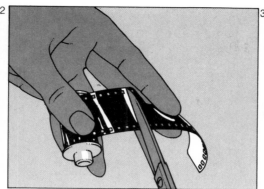

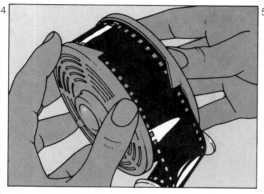

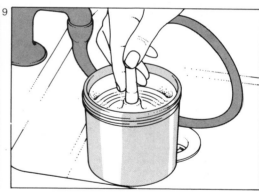

Above These illustrations show the steps involved in processing a roll of film. The film spiral of the appropriate size is show in the first picture. After removing the spool of film from the cassette, the tongue is cut from the end of the film to leave a straight edge in 2. The next stage, 3, is to feed the end of the film into the entry grooves of the spiral. 4 shows the film being fed into the spiral by twisting each side back and forth. 5 shows the spool being

cut from the end of the film and 6 illustrates the loaded spiral being placed into the tank already filled with developer at the right temperature. 7 shows the tank being agitated, after the lid has been put on, by inverting it a few times every minute like a cocktail shaker. At the end of the development period, the developer is poured out. The stop bath and then fixing solution is then poured in, 8. Finally 9 shows the washing stage.

Below These three pictures show the appearance of negatives when different degrees of development is given. The centre picture shows the way a correctly developed negative should look, the picture on the left is the result of under development and on the right shows the effect of overdevelopment.

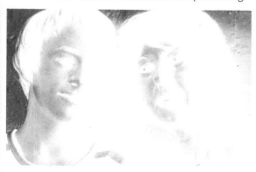

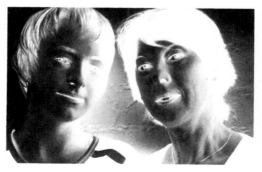

Black and white contact printing

The first stage in printing from a newly developed roll of black and white film should be the production of a good set of contact prints. Apart from being a convenient means of reference they will also make it easier to assess the negatives for enlargements. As soon as the film is dry, cut it carefully into strips and place it into negative sleeves until required. It is best to cut 35mm film into strips of six negatives and roll films into three or four. This will enable a complete roll to fit easily onto a sheet of 10 × 8 inch bromide paper.

For contact printing, you will require an enlarger or a light source such as a domestic bulb which can be suspended over the work bench, a sheet of flawless plate glass about 12 × 10 inches, bromide paper and chemicals and a set of three or four dishes also about 12 × 10 inches. You will also need a safelight recommended for the material in use in addition to the timer and thermometer used for processing the film. With the safelight on and the room light extinguished, remove a sheet of bromide paper from the packet and place it, emulsion side up, under the light source, not yet switched on. If you are uncertain as to which side of the paper is which, a lightly moistened fingertip on one corner of the paper will feel tacky on the emulsion. Next place the negatives, emulsion side down, onto the paper. This is the dull side or the inside of the curl of the negatives. Lay the plate glass carefully on top to hold the paper and negatives firmly together. They can now be given an exposure to the light source.

The length of exposure will depend, of course, on the brightness of the light source. You will have to make initial tests; this is best done in the form of a strip test. Give the whole sheet of paper an exposure of, say, two seconds. Then cover about one-fifth with a piece of black card and give another exposure of the same duration as the first. Repeat this until you have exposed all the paper, progressively covering it up. After processing, you will see a range of densities

Below *The basic requirements for processing black and white prints are shown here. Left to right: a dish for the developer solution, with plastic print tongs to prevent handling the wet print; a dish containing either a stop bath or a plain water rinse; a fixing solution bath with separate print tongs to eliminate the possibility of contamination; and a dish specially designed for washing prints with a hose to maximise water circulation.*

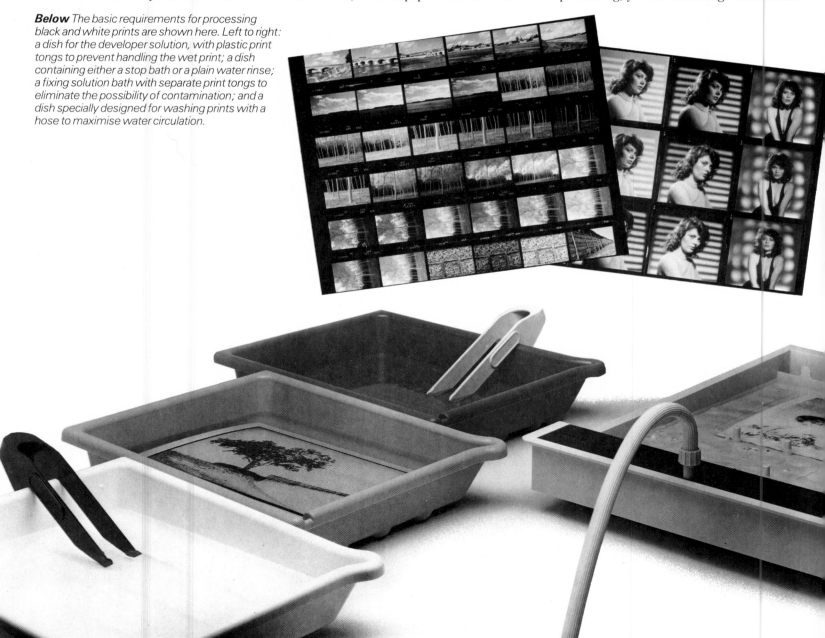

Above *This sequence of illustrations shows the stages involved in making a sheet of contact prints. The bromide paper is placed emulsion side up under the light source, 1, the negatives are placed on it emulsion side down and held in contact by covering with a piece of plate glass, 2. A test strip to determine the best exposures is made next, 3. The paper is then immersed in the developer, 4, for the recommended period of time and agitated, 5. Upon completion of development the print is drained, 6, and transferred to a rinse or stop bath, 7. Then the fixing bath for the recommended time, 8, before finally washing in water.*

from which you should be able to select the correct exposure. If they are all too light or dark you must repeat the procedure, either reducing or increasing the increment, moving the light source nearer or further from the paper or, if you have an enlarger, by opening up or stopping the lens down. Once established, this exposure will vary little for other normal negatives contact printed at future sessions. So don't forget to make a record of it.

Although processing black and white prints is not as critical as negatives, constant results will be more assured by a careful routine. It is best to maintain the developer temperature to within a few degrees of 20°C and to give the full amount of time recommended. The paper should be slid smoothly and quickly under the surface of the

solution, face-up, so that it is covered evenly, and gently rocked in the dish to agitate until development is complete. Although a plain water rinse can be given between development and fixing bath, a stop bath will help to preserve the latter and reduce the risk of staining. The print should be well drained from one corner before transferring from one bath to another. Agitate it for the first 20 seconds or so and then periodically until completion. After the recommended fixing time, the print should be well washed in running and efficiently circulating water for the suggested time before being dried. Resin-coated papers can be dried easily by wiping off surplus water with a squeegee and then pegging them on a line. Fibre-based papers will take much longer and dry less flat by this method, unless you use a print drier.

Black and white enlargements

One of the pleasures of black and white photography lies in the ability to experience the image-forming process. This is particularly exciting and enjoyable when making an enlargement from a good negative. The only additional equipment you will need beyond that for contact printing is an enlarger.

The first step is to carefully assess and select the negatives for enlargement from the contact sheet. This will give you an opportunity to judge the density and contrast of a particular negative and to determine whether it will benefit from cropping or any shading or dodging. You should also check the negative itself with a magnifying glass to ensure that it is critically sharp. Before you place the negative in the enlarger carrier, clean all surfaces carefully with a soft brush or an airspray to remove dust particles, as these will show up as white marks on the print when enlarged. If you hold the negatives and carrier glasses obliquely in the light of the enlarger they will show up quite clearly.

Next, place the negative with the emulsion side towards the lens and the image adjusted for size and focus onto the masking board. You will find it easier to focus accurately with the aid of a focusing magnifier. Now make a test strip in the same way that you did for the contact print. (Exposure increments will need to be greater because of the enlarged image.) It is usually sufficient to use only a third or quarter of a sheet of paper for this test, and you must select the most representative and important part of the image to position it with the safe filter of the enlarger swung over the lens.

When you have produced a test strip, you must judge it for contrast as well as density. A negative of normal contrast will usually print best on a normal or grade 2 paper, but if the negative is of lower or higher contrast it may be better to use a harder or softer grade of paper respectively. If your test does not contain a good rich black and the highlights are grey or veiled, then you should try another test on a harder paper, a grade 3 or even 4. If there are very dense blacks with no detail and the highlights are bleached out,

Above A small disc of black card was mounted on a thin piece of wire and used to hold back the child's face in the picture on the left. The unshaded picture on the right shows how much improvement can be achieved by selectively reducing (or increasing) the exposure when enlarging prints.

then a softer grade such as a 1 or 0 would be preferable. Instead of keeping three or four different grades of paper you can buy variable contrast papers such as Ilford Multigrade, where the same sheet of paper can be made to yield a different contrast according to the use of a filter.

Even when you have made a print from a negative on the most suitable grade of paper, you may still find that some areas are too light or too dark and that detail is being lost. This can often be controlled by shading or dodging, techniques in which your hands or

Below The left picture shows a straight print in which the brightly lit sea in the foreground lacks detail and tonal range. The right image was produced by using the hands to give additional exposure to the lower part of the picture after the main exposure. This technique is sometimes called burning in.

small pieces of card are used either to give additional exposure to areas of the print which are recording too light, or to hold the light back for part of the total exposure time from tones which are printing too dark. Very small areas can be controlled by mounting a small piece of card roughly shaped to the area onto a piece of thin wire and moving it gently during the exposure to avoid a defined edge. This will lighten the tone. To increase tone, give extra exposure through a small hole cut into a piece of black card.

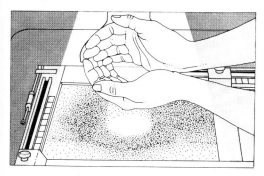

Above right and right *These two pictures show the effect of using the hands to hold back an area that is printing too darkly during the exposure. The lower image is the straight print and the top print shows the additional detail and tonal range achieved by shading.*

Below *These three pictures demonstrate the variation in contrast between the different grades of paper. A normal contrast negative was printed onto a normal grade of paper in the centre picture. A hard grade was used for the print on the right and a soft grade for the image on the left.*

Print manipulation

Although the purpose is often to make a black and white print from a negative in a way that most faithfully reproduces the tones and effect of a particular negative, there are occasions where a better or more interesting result can be created by modifying or manipulating the print.

Perhaps the most basic method is that of cropping. Instead of making a print from the whole of the negative, a specific section is enlarged. This can be done either to improve the composition by excluding unwanted or distracting details or by emphasising or exaggerating certain aspects of the image. It is always worth looking at this possibility if the first print from a negative is a little disappointing and you do not necessarily have to limit yourself to the proportions of the printing paper. Often a picture can be given considerable additional impact by the use of a narrower or squarer format.

Shading and dodging techniques can also be used creatively as well as correctively. Heavy printing-in, for instance, can be used to subdue obtrusive aspects of an image and to improve the composition. Landscape pictures often benefit from the sky area being printed-in quite heavily so that the picture becomes much darker towards the corners and edges of the image to help focus attention on the main part of the subject. Light tones can be shaded constantly during the exposure to remove tone and create a white background, for example.

The grade of paper you choose can also contribute to the final effect. A soft grade can be used with a normal negative, for example, to create a more subtle and delicate image, perhaps to enhance the mood of a picture. A harder grade can be used to emphasise contrast and create images with harsh bright highlights or bold and dramatic shadows. This technique can often be used effectively with images that have a strong textural quality or to emphasise the grain of a negative.

The manipulation of contrast can be taken even further by the use of very hard grades of paper and lith materials. With grade 4 or 5 paper combined with a normal or even a contrasty negative it is possible to create very stark images in which the tonal scale of the print is very restricted. With lith materials, the image will be reduced to just pure black and white. Lith film is made for use with reproduction processes. When exposed and processed in its own special developer, all the mid tones in the image will be eliminated. The exposure for this film is important because it determines the point in the tonal scale of the negative at which the division between black and white will occur. A brief exposure, for example, will produce an image in which only the deepest shadows

Above and left Cropping is perhaps the most basic and certainly one of the most useful ways of manipulating the image when enlarging. The bigger picture shows how unwanted details can be excluded to improve the composition.

Below In this picture, a softer grade of paper has been deliberately used to reduce the contrast of the image in order to emphasise the soft, misty quality of the subject.

will record as black, leaving the rest of the picture as pure white. On the other hand, full exposure will create an image in which only the brightest highlights remain white in an otherwise black image.

This technique is most effective with subjects that have an interesting outline or a dominant shape and images that have a well-defined pattern. After drying lith film you will usually find small, clear dust spots in the black tones. These must be spotted out with an opaque retouching medium before printing. This can also be used to 'tidy up' the image by removing any unwanted details that have recorded.

Above These two pictures show how printing-in techniques can be used to alter the nature and mood of a photograph as well as simply correctively. In the top picture the sky area was given 300% more exposure than in the straight print, reproduced below.

Top right and right A deliberately contrasty print has been made in the picture, right, to emphasise the strong pattern created by the shadows in this detail of a building. A grade 2 paper was used for the straight print, above, and grade 4 for the manipulated print.

Tonal technique

The lith materials already described can also be used to create a more elaborate tonal manipulation called *tone separation* or *posterisation*. The effect is to create an image in which the original continuous tone negative is reproduced in white, black and one or more flat tones of grey.

The method is to first make two or three lith positives on film from the selected negative, giving three different exposures. The first exposure should record only the deepest shadows, leaving the rest of the image as clear film; the second lith should leave approximately half the image clear and half black; and the third leave only the brightest highlights clear. When these lith positives are dry and spotted they are contact printed one at a time onto a single sheet of ordinary negative film in perfect register. You can make a simple register device by gluing two wooden pegs which exactly fit the holes made by a stationary punch onto a wooden board. Register the three lith negs visually on a light box and then punch them together. This makes it simple, once the unexposed negative film is fixed in position on the contact board, to expose them individually but in precise register.

The method of exposure is important. First make a test with the lightest lith, aiming for an exposure which with normal negative development will produce a mid grey. Once you have established this, all three lith

positives should be given the same exposure. The result will be a negative which will print with the shadows as solid black, the highlights as pure white and all the tones between as one or two shades of flat grey, depending upon whether two or three lith positives were used.

Another rather simple technique which can also be used to create an interesting tonal effect is called *bas relief*. This involves making a fairly light positive from the selected negative by contact printing it onto a sheet of ordinary negative film and processing it in the normal way. After drying place it in contact with the original negative, emulsion sides touching, so that it is almost, but not quite, in register. If you place the sandwich on a light box you will be able to see the effect of varying the displacement of the two images and you will find that some positions will produce the effect of a three-dimensional relief. When you have chosen a satisfactory combination, tape the sandwich together in position and make a print in the normal way. This technique is particularly suited to subjects that contain large areas of boldly defined details.

Another method of creating unusual tonal distortions is *pseudo-solarisation* or the *Sabattier effect*. This requires exposing a negative briefly to light about half-way through the development period and then continuing in the normal way. Since the results are somewhat unpredictable it is best not to do this with original negatives. Make yourself a supply of copies. The technique can work equally well with positives made on ordinary film or lith film processed in normal developer. The results, however, are often very dense and lacking in contrast.

Above right This picture shows the effect of a bas relief image. Subjects with boldly defined details, such as the bricks in this church path, are the best choice for this technique.

Right This image, which demonstrates the Sabbatier effect, was produced by exposing a black and white negative onto a sheet of lith film, and re-exposing it, briefly, about half-way through its development time in an ordinary negative developer.

Left The two small pictures on the far left show the lith images made from the black and white negative which will enable the final tone separation to be made. In this instance the image consists of black, white and mid-grey. Additional tones of grey can be obtained by using more lith positives in the production of the separation negative.

Image distortion

Just as soft-focus techniques can be used successfully in the camera so can the use of a diffuser at the enlargement stage produce exciting results. However, when printing from negatives the result is the opposite since the lighter tones of the negative – the shadows – tend to spread into the lighter highlights of the print. There is also a reduction in contrast. The technique can successfully subdue unwanted detail, such as skin texture in a portrait, and also help to create a degree of atmosphere in a picture. The methods are the same as for soft-focus camera work. A thin film of petroleum jelly smeared onto a piece of glass or a piece of stretched nylon fabric or plastic film, held in front of the enlarger lens, can be used. The effect can be varied by using the diffusion material for only a proportion of the total exposure time.

Another technique which can be effective in suppressing the detail of a picture while at the same time introducing an interesting textural quality is the use of a texture screen. This is simply a piece of translucent film or other material that has a visible pattern or texture on its surface. It is placed in contact with the negative in the enlarger carrier and a print made in the normal way. You can buy sets of ready-made texture screens printed on film which create the impression of surfaces such as canvas, silk and so on, but it is just as effective – and more fun – to make or find your own. For instance, the material used for the translucent acetate negative envelopes can produce a rather pleasing crystalline quality. It is a simple matter to photograph well-defined textures of a wide variety of surfaces to produce a fairly light image which can in itself be used as a texture screen. Alternatively, large pieces of textured translucent material such as tissue paper or hammered glass can be placed on top of the bromide paper instead of with the negative. In addition to altering the nature of the recorded detail in the negative, it is also quite simple and often very effective to distort the appearance of the image itself. One way of doing this is to place the bromide paper, with or without a masking board, at an angle instead of parallel to the negative carrier of the enlarger. Indeed, the paper does not even need to be flat. It can be curved or partially crumpled and taped to a support to create quite wildly distorted prints. Since the image will be at different distances from the negative it is necessary to use a small aperture to obtain sufficient sharpness on the print, although of course complete sharpness is not possible with a very distorted print.

Distortion can also be achieved by moving the image during the exposure. If the lens is progressively racked back, for example, it will create a zoom effect in which the central part of the image appears to radiate towards the corners of the print. It is also possible to move the paper at intervals during the exposure, either pulling it sideways or turning it, so creating a series of stepped images. These types of technique work best with subjects that have a quite well-defined and boldly contrasted shape against a relatively plain light background.

Above The rather sinister quality of this portrait was produced by tilting the masking board which held the paper during the exposure, supporting it at one end so that it lay at a steep angle. The top of the subject's head was then further from the negative than the bottom and so has been enlarged substantially more.

Right These two pictures show the effect of introducing a diffuser over the enlarger lens during the exposure. The nearest was a straight print and a piece of polythene was held over the lens for about 75% of the total exposure time for the picture far right.

Below The effect of this landscape picture was created by placing a piece of the translucent paper used for negative envelopes in contact with the negative in the enlarger carrier. This makes a cheap and effective texture screen.

Above The very bold and striking effect in this portrait was produced by taking a close-up shot of a moiré pattern and placing this in contact with the portrait negative before making the enlargement. Since the texture screen in this instance was virtually black and white with no mid tones, it has had an effect similar to that of a printer's screen.

Left The textural effect in this shot was achieved by using a thin, underexposed negative of a piece of hessian as a texture screen. It had been photographed with strong cross lighting to emphasise its texture.

Montage printing

Montage is the combination of images from two or more negatives in one print. The effect can vary from a quite subtle and almost undetectable change to the nature of a picture, such as a more interesting sky montaged onto a landscape, to very contrived and surrealistic images where bizarre juxtapositions of subjects from several negatives can be blended together.

In any case, the method is essentially the same. Your first requirement is a good masking frame with a positive means of locating the bromide paper accurately for each exposure. You will also need a piece of drawing paper the same size as the print you wish to make and a black fibre-tip pen or pencil. Having selected the negatives for the montage and made perhaps a rough sketch of how they are to be juxtaposed, place the most dominant negative into the enlarger carrier, and size it up and focus the image onto the drawing paper, which should be positioned in the masking frame. When the focusing is satisfactory, trace the main outlines of the image onto the paper. Then you can make a test strip in the normal way, making a note of the best exposure. Next, replace the first negative with the secondary image. Using the traced outline of the first, size and position this onto your guide paper. When this appears to be satisfactory make a tracing and a test and note the exposure. Once you have completed this procedure with all the negatives you need for the montage you are ready to make a first print.

After having checked the position and focus of the last negative against the traced outline on the guide paper, expose this onto a full sheet of bromide paper. This must then be replaced in a light-tight box while the next negative is similarly resized and positioned onto the tracing before exposure. It is vital that the bromide paper is replaced in the masking frame the same way round for each exposure. Make a mark in one corner and ensure that this always goes into the same corner of the masking frame. When the sequence is completed you can process the sheet of paper in the normal way. You must appreciate that where two or more images overlap, the exposure will be cumulative, resulting in overexposure. With most

Right *The surrealistic quality of the picture above was achieved by montaging the eyes and nose of the cat onto the face of the girl. To do this successfully, the angle and proportion of the two faces had to be very similar and the transition of tone where the two images combined had to be quite smooth and even. This meant that a 'hole' had to be shaded out in the girl's face and the eyes and nose of the cat had to be vignetted accurately into this space.*

subjects it will be necessary to hold back or shade these areas of overlap as each image is printed. This will also help them to blend more effectively. When doing this keep your hand or the card used for shading gently moving so that a hard edge is not created.

It is most unlikely that first results will be completely satisfactory, especially where several negatives are involved. You will probably have to modify both the basic exposures of the individual negatives and also the shading method. It is important to make a careful note of each series of exposures and of the areas and degrees of shading. By altering the balance of the exposures and the proportion of shading you will be able to control the way the images blend. By giving more exposure to one, for example, and less to another, the former will be more dominant and the latter more reticent. Where the exposure and the shading are carefully matched, two images can be made to merge imperceptibly.

Below and left *The much more natural effect in this landscape shot was simpler to achieve, although the basic principle was the same. Because the picture of the tree had a white sky, it was only necessary to shade the lower half of the sky negative to create a smooth vignette around the outline of the tree and horizon. The technique was made easier by the selection of a sky negative with a cloud formation which almost fitted the outline of the landscape picture, so the necessary shading did not create a completely unnatural line.*

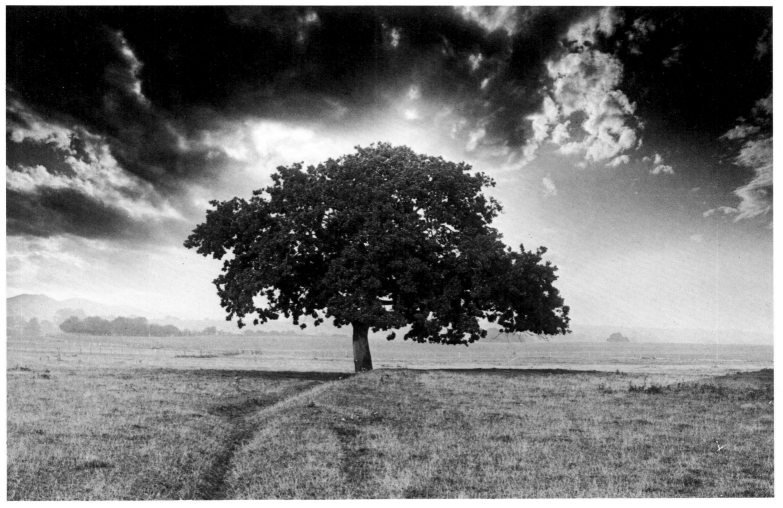

Printing colour negatives

Although the processing chemicals and the printing paper are different, making a print from a colour negative is very similar in principle to making a black and white print, with one important difference: it is necessary to make tests and evaluate for colour balance as well as density.

In addition to the equipment used for black and white printing you will also need a set of colour printing filters, or an enlarger with a colour head, to make adjustments to the colour balance according to your tests. Although it is quite possible to process colour paper in open dishes, it is preferable to use a print drum, since this will enable you to control and maintain temperatures more accurately. You will also need much smaller quantities of chemicals, which can be discarded after use, helping to ensure more

consistent results. To help temperature control, use a water bath for both the drum and the storage bottles as the process is usually at a much higher temperature than that of the darkroom itself.

For your first printing session, choose a negative that has a subject of average tones and colours and also has an area of neutral grey. Once you have established a filtration and exposure for this negative – and made a careful note of them – you will have a useful reference for future sessions and which you will be able to use as a control when you change a batch of paper or experience problems.

Once you have processed a test strip at the filtration for the batch of paper you are using, you will be able to select the best exposure in the same way as a black and white test. The colour balance may be more of a problem initially. It is very important to appreciate that a colour cast can only be removed by a filter of the same hue. You will need a cyan filter, for example, to remove a cyan cast. To get some idea of the degree of filtration required, view the test through a filter of the opposite hue to the correction filter you think is necessary, ideally in daylight or under

colour-matched fluorescent tubes. If you think that a print needs, say, a 30 cyan filter then you would be able to judge the effect to a degree by viewing the test through a 30 magenta. Avoid using all three filters, cyan, magenta, and yellow, since this will include a degree of neutrality which can be removed from the pack. For instance, if you found that you had, say, 20 cyan and 30 magenta and the result was too yellow, instead of adding a yellow filter remove some of the cyan and magenta. This will have the same effect. When adding filters in this way it is important to allow for the increase in exposure that will be required.

In order to help judge the colour balance of your prints and estimate the necessary filtration, it will help to make a set of prints from your control print by adding, say, a 20 filter of each colour to the correct filter pack. If you mount the results together on a board with the correct print and use it when judging future tests, it will help to distinguish and isolate a particular cast. It will also help to assess negatives if you make a sheet of contact prints from a roll of film before making enlargements, as for black and white prints.

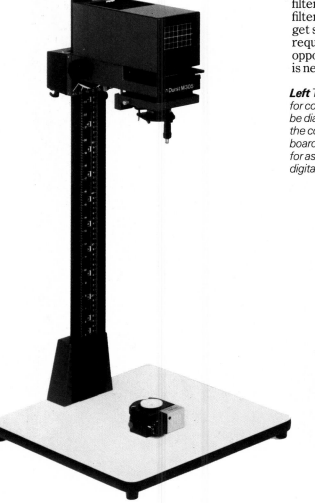

Left *This illustration shows an enlarger designed for colour printing in which the filtration values can be dialled into the illumination head by means of the control unit placed on the centre of the base board. On its left is a colour analyser with a probe for assessing colour negatives, and on the right a digital timer.*

Below *This picture shows an amateur version of the larger professional continuous processer for colour and black and white papers. This model handles up to 10 × 8 colour negative paper.*

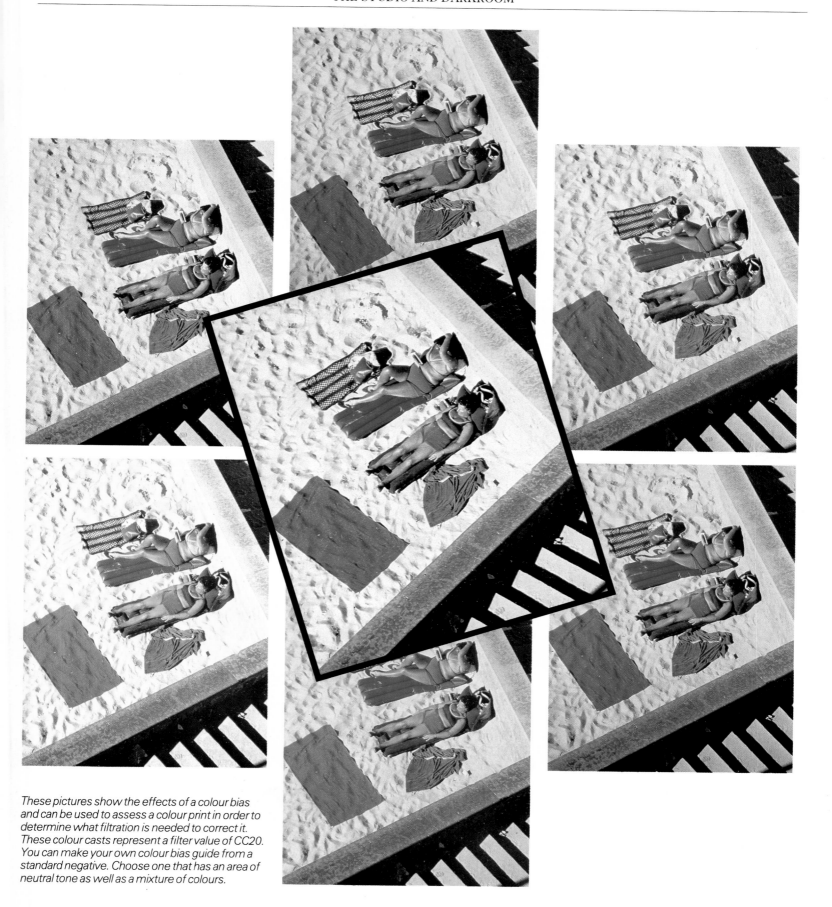

These pictures show the effects of a colour bias and can be used to assess a colour print in order to determine what filtration is needed to correct it. These colour casts represent a filter value of CC20. You can make your own colour bias guide from a standard negative. Choose one that has an area of neutral tone as well as a mixture of colours.

Printing colour transparencies

In many ways it is easier to make colour prints from transparencies than from negatives, particularly for a beginner. Although timing and temperature control are still as critical for many processes, colour reversal prints tend to be more tolerant of both exposure and colour casts. In addition, unlike a colour negative, you have a direct comparison to help in the assessment of your tests.

The important thing to appreciate is that the effect of exposure is the opposite of that when printing from negatives. Less exposure is needed to make the image darker and more to make it lighter. The filtration too is the opposite. You need a filter of the opposite hue to remove a colour cast – a magenta filter, for instance, to remove a cyan cast. Because of the greater tolerance of this material you can make larger adjustments to the exposure and filtration of tests than you would for colour negative materials. Since varying exposure times can affect the reciprocity and colour balance of the paper it is best to vary exposure by opening and closing the aperture of the enlarging lens rather than by giving

substantially longer or shorter exposures. Drum processing is preferable for materials like Cibachrome, although of course with Ektaflex and Agfachrome speed paper a different method is required for the single solution process.

Choose transparencies for printing with some care since there is an inherent contrast gain in the reversal process which makes results from weak, dense or contrasty slides unsatisfactory. Even with a fairly normal and correctly exposed transparency there will often be an undesirable gain in contrast on the print and it may be necessary to control this. In some cases this can be achieved by modified processing, either be reducing the first development or by diluting solutions. The maker's instructions will indicate this.

It is also possible to reduce contrast by *flashing* the paper. This involves giving the paper a very brief exposure to white light before development. It has the effect of reducing the density of the shadows without affecting the highlights. The length of the flashing exposure can be controlled by making an additional exposure with the slide

removed from the negative carrier. Give the same exposure as that required for the mid tones of the subject, but through an ND2 neutral density filter.

A more satisfactory way of reducing contrast is *contrast masking*. This is used by professional laboratories. It involves making a very weak contact negative from the transparency onto ordinary black and white film. It should be exposed and developed so the image only records the highlight tones. After processing this must be accurately registered with the transparency. Then they are taped together and the print made from this sandwich. This effectively holds back the highlights, allowing more exposure to be given to the shadows without the light tones bleaching out.

In many cases, however, especially when there are large and well-defined areas of highlight or shadow, it is possible to control contrast by shading and printing-in. With your hands, or a piece of card cut to shape, you can give additional exposure to the shadows or hold back the lighter tones during the basic print exposure.

Left *A print processing drum for colour work. The exposed paper is loaded into the drum in darkness. After that, the process can be carried out in daylight. The drum storage bottles and measures are placed in a container filled with water at the correct processing temperature and the drum rotated by the handle.*

Above This picture shows the effect of a test strip made from a colour transparency onto reversal Ektaflex paper. In this case a standard exposure was given and the aperture adjusted by one stop for each exposure. The strip on the left has therefore had one stop less exposure than the central strip and the strip on the right one stop more exposure. A much smaller increment would be needed when printing from colour negatives to achieve the same effect. More exposure would result in a darker image.

This illustration shows a motorised processing unit for the Kodak Ektaflex. It uses only a single processing solution which is not temperature critical and will handle both negative/positive prints and reversal prints. A simpler, less exensive hand-cranked version is also available which will process prints up to 10 × 8 inches.

Applied Photography

Print finishing

No matter how carefully made and processed, a print will never look its best when displayed without any finishing work at all. Even the most careful worker will find that there are small dust spots and blemishes on his or her prints. These must be removed to make a professionally immaculate presentation. The most common blemishes are those caused by dust particles settling on the film or the glass covers of the carrier when the print is exposed. On a negative these will record as a clear white spot and with reversal materials as a black mark.

White spots on a black and white print are most easily removed with the use of a very fine sable brush and a neutral grey dye or watercolour. The technique is to keep the brush almost dry with just the tip picking up the pigment. This is then applied with a very light stippling motion to the white mark so that the tone is gradually built up to match the surrounds. You may find it easier to start with the marks in the darkest areas and as the pigment becomes weaker on the brush instead of recharging it fill in some of the spots in a lighter tone. Most retouching methods are easier on a matt or lustre finish paper rather than glossy and the results are less noticeable on the surface of the print.

Black spots on the print can be removed either by bleaching or applying a white pigment. The method which many people prefer is to very gently scrape at the surface of the print with a sharp scalpel held at an oblique angle, gradually shaving away the emulsion until the black is reduced to match the surrounding tone. Spotting a colour print involves basically the same technique, but of course with the use of coloured retouching dies to match the surrounding area.

Mounting is also an important stage in the effective presentation of a print. It will also give a degree of protection. The most effective method is the dry mounting process. This involves placing a layer of adhesive in the form of a sheet of tissue between the print and the mounting board and applying heat and pressure to melt the tissue and bond the layers together. This is most easily done in a dry mounting press, but a domestic iron on a low setting can be used just as well with a little care. First fix the tissue to the back of the print by touching the centre of the tissue with a heated tacking iron. The print and tissue can now be trimmed flush together with a scalpel and a straight edge. Now position the print on the mounting board and tack the corners of the tissue to it in the same way. Then with a piece of card to protect the print surface, either place it in the mounting press or apply an iron, working from the centre of the print out towards the edges.

Apart from dry mounting, you can also use rubber-based adhesives and aerosol spray mountants, but first make sure that they are recommended for photographic use. Some adhesives contain chemicals which can cause staining. It is also possible to obtain double-sided adhesive sheets. However, none of these methods is likely to create the very smooth and flat effect of dry mounting.

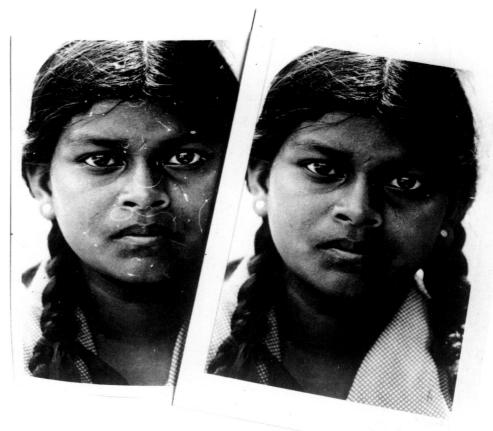

Above These pictures show how even simply spotting and mounting a print can quite dramatically improve its final effect. The photograph on the right has been spotted to remove the white marks caused by blemishes on the negative.

Above The two techniques used for retouching the photograph at the top of the page. 1. Shows watercolour, or dye, being applied with a fine brush to 'fill in' white marks to match the surrounding tone. 2. Shows a scalpel being used to scrape away the surface of the print to reduce a black mark until it matches the adjacent details.

Left *The four illustrations show the main stages in dry mounting a print. 1. A heated 'tacking iron' is used to fix the dry mounting tissue to the back of an untrimmed print. 2. A scalpel and straightedge are used to trim the print and the tissue flush to the required size. After positioning the print and tissue on to the mounting board they are fixed into place by applying the tacking iron to all four corners of the tissue. 3. The final picture. 4. Shows the combined print, tissue and mounting board being placed into a dry mounting press with a protective board over the surface of the print.*

Below *The required equipment for dry mounting photographs. On the left is a print trimmer which can be more convenient than a scalpel and straight-edge when there is a substantial amount of trimming to be done. Below this is the electronically heated tacking iron, and on the right a thermostatically controlled dry mounting press.*

Combining prints

In most instances, a photograph is taken and presented as an individual image. However, it can be extremely effective to combine a number of separate prints to create a composite picture and there is a variety of ways of doing this.

A panorama is a quite simple but very effective way of presenting a rather less familiar type of picture, provided the individual photographs are taken with care. It is important that the camera is perfectly level so that as it is panned across the scene you wish to photograph, the horizon remains in the same position in the viewfinder. It is best to allow a quite generous overlap between frames – about a quarter is ideal – and to use a standard or even slightly long focus lens. This will avoid creating perspective effects where the pictures are to be joined. The exposure should be calculated for the average of the scene and left at this setting for all the pictures. The same exposure must also be given to the prints when they are made. When joining the prints, try to find some natural vertical line within the images to make the cuts. The overlap of the negatives will help you to select the best place. After the prints are butted together and mounted onto a board you will be able to retouch any imperfections and then re-photograph the combined print if you wish, to enable copies to be made. If this is intended, it is an advantage to make the initial prints rather softer than normal with plenty of detail in both highlights and shadows, as copying will increase the contrast.

A similar method of joining prints can also be used to create a more abstract effect. It is possible to create a quite intriguing pattern or kaleidoscope effect with a single picture by making, say, four prints, two of which are reversed left to right. You can do this by turning the negative the other way up in the enlarger. Then they can be joined together alternately, as with a panorama, or, if the subject is appropriate, they can be formed into a square. Since the effect of this technique depends largely upon the repetition of a shape, it is most effective with subjects that have a quite bold shape or dominant lines. Pictures with strong diagonals can be particularly striking. Sometimes you can create a very exciting effect simply by shooting the picture at an angle so that either the horizon or a vertical line, or both, runs across the diagonal of the picture.

It is also possible to create very unusual or abstract pictures by the means of *collage,* whereby individual images are cut out and recomposed onto a background picture. This can be done either to create a realistic effect or to produce more bizarre juxtapositions. Although it can be most effective to plan your final image and shoot the individual pictures especially for the collage, it is often possible to select suitable images from your existing contact sheets. It is a good idea to make a working layout of the final effect so that you can judge the relative sizes of the individual prints. These should be made on a single-weight paper, which can be more easily and accurately cut with a craft knife or sharp scissors. Mount the background print onto a board and after cutting out the separate images, chamfer the back of the edges with a fine sandpaper before sticking them into position with a suitable adhesive. This will make the joins less noticeable, but any imperfections can be retouched and the final result can be copied to give a master negative.

Right *A photographic pattern made by combining four prints in the method described in the text. The effect of this picture is dependent upon the strong diagonal lines in the original image.*

Below right *This rather ambiguous picture is a quite simple collage made from four photographs cut out and mounted down together.*

Below *This subject lends itself well to the panoramic treatment described in the text. It is vital to ensure that the camera is perfectly level before making the exposures.*

Hand colouring

In the early days of photography hand-colouring was the only means of producing a colour photograph. The intention was invariably to create as realistic an effect as possible. Today the only reason to hand-colour a black and white print is to create an image with a more unusual or subtle quality than could be obtained by shooting on colour film in the first place. Used in this way the technique can produce images of a more personal and interpretive nature than a straightforward colour photograph. Both water-based retouching colours and oil paints can be used. The former tends to give a more subtle effect and may be easier for anybody less skilled with a brush. As water-based colours are transparent a strong black and white image will desaturate the colours. For this reason it is best to make rather lighter and softer prints for colouring.

Water-based colours require the print to be damp. The first step is to blot the surplus water from the wet print and tape it by the edges to a board. Start with the larger areas of colour. These will need to be built up gradually with repeated applications of fairly weak colour. Use a palette or saucer to dilute the concentrated dyes to the desired density and to blend colours together to produce exact shades. It is a good idea to have a spare print so that the effect of a mixture can be tested on it first. The colour for broad areas can be applied with a large sable brush or even a cotton bud or cotton wool swab, but you will need a selection of finer brushes for smaller areas and details. After each application of colour you should blot the excess moisture and colour from the surface and work progressively from the larger to smaller areas of tone. Finish with the smallest details, using a very fine brush and more concentrated colours.

It is not by any means necessary to colour the entire print. Often the most effective pictures of this type are essentially monochromatic with specific details picked out in colour. It can also be effective to combine hand-colouring with selective toning so that you have an image that is, for example, partially black and white, partially sepia and selectively hand-coloured.

Below and right *These four pictures show the stages in hand-colouring a black and white photograph; the first step in the picture directly below is to make a light and soft black and white print. This print is then sepia toned in the next picture. The third stage shows the effect on the image after the paler background colours have been added, and the final effect is shown in the picture below right after the smaller details have also been coloured.*

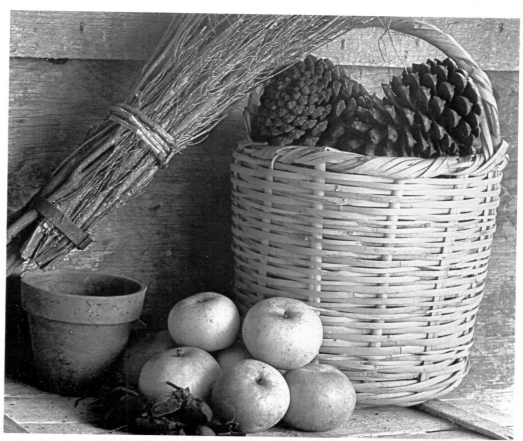

Left *This picture relies upon only a limited area of colour for its effect. A fairly light black and white print was made on resin-coated paper, and a reasonably concentrated dye was applied to the flower with a fine brush. The very restricted use of colour emphasised the simple and direct quality of the photograph.*

Black and white to colour

There are a number of ways in which you can change a black and white print into a coloured image. Chemical toning converts the black metallic silver image of a bromide print into a chemical dye. This can be done with any conventional black and white print that has been properly processed and well washed, and the procedure can be carried out in normal room lighting. The process varies according to the toning kit in use. Some processes, such as sepia toning, require the print to be bleached first and then redeveloped in the toning solution. Others use only a single solution.

Apart from toning the image, which leaves the highlights unaffected by the colour, it is also possible to use dyes to tint the lighter tones but leave the darker tones as a neutral or black image. Ordinary fabric dyes can be used for this purpose. Use them fairly dilute and control the depth of colour in the print by the amount of time it is left immersed. Kits such as ColorVir contain a variety of bleaches, toners, colour couplers and dyes which can be combined in a number of ways to produce a wide range of colour effects, including a mixture of different colours on the same print and an effect similar to solarisation.

The ability to create a variety of colours on the same print can be increased by selective bleaching and toning. This can be done either by applying the bleach to selected areas of the print with a brush or by using a protective rubber solution painted over an area of the print to prevent it being affected by the solution when immersed. It can simply be peeled off afterwards.

Most chemical toners and dyes can also be used on film. You can therefore produce colour transparencies in this way by printing a black and white negative onto ordinary panchromatic film to produce a positive image, and then treating this in the toning or dye baths.

In addition to dyes and toners it is also possible to obtain a bromide emulsion on a tinted paper base. Prints can be made directly onto it from a black and white negative and the paper processed in the normal way. This gives an image in which the light tones display the colour tint and the darker tones are less affected. This material is available in a wide range of colours, including metallic and fluorescent hues.

Conventional colour printing materials can also be used effectively to create coloured images from a black and white negative or transparency. The tone separation technique is particularly suitable because the black and white lith positives can be printed in register onto a sheet of colour film, using different coloured filters for each exposure to produce a multicoloured result.

Below *This seascape was first printed onto a conventional black and white resin-coated bromide paper and then treated in the ColorVir blue toner. Much of the success of toning lies in suiting the subject to the treatment, and the steely blue image colour enhances the wintery quality of this shot.*

Above *This image demonstrates how a variety of colour effects can be combined with the ColorVir kit. In this instance, yellow toning has been combined with a solarised effect and then treated in the red dye bath. The final quality can vary according to the density and contrast of the original print, and a wide variety of interesting effects can be achieved.*

Left *These two pictures show how different treatments can be applied to the same image to create a quite different effect. The picture on the far left has been treated in the blue-green toner of the ColorVir kit. The picture on the near left has been toned in the more traditional sepia bath, which involves first bleaching the image and then redeveloping. All these processes can be carried out in normal light.*

Presentation

Part of the pleasure for most photographers is showing their work to other people, whether it be family and friends or more ambitiously as an exhibition or competition entry. Many photographers do not appreciate that no matter how good the picture is and how well printed, its full impact will not be achieved unless it is also well presented. The nature of the presentation will depend on a number of factors – whether it is a transparency or print, for example, and to whom and in what circumstances it is being shown. There is little doubt that the most effective way of presenting colour transparencies is by projection. When shown in a darkened room on a proper screen, the rich tones and colours of a good transparency cannot be matched by any other means. However, the full impact of a slide show will depend on careful planning. You must edit the slides well, rejecting any substandard or repetitive images, and planning the sequence in which they are shown. In addition to the natural or chronological order of the pictures – which may be dictated by a story line – you must also consider the effect that each image has on the previous and subsequent ones.

A succession of slides with a soft and subtle colour quality may be effectively ended with a bold, bright image. The danger of repetition, which is often prevalent in a show on a specific topic, can be avoided by interspersing long shots with close-ups, and people with landscapes and so on. Don't overlook the possibility of using taped background music as an accompaniment to a

Above Carousel slide projectors suitable for viewing your own slides. The drum will usually accept about forty slides which will enable you to title a roll of thirty six exposures.

Below A card presentation mount for colour transparencies, wrapped in a protective acetate sleeve. The frosted back allows the slides to be viewed against any convenient light source, as well as a light box.

commentary if required or just on its own. This can help to create the right atmosphere if the music is chosen well.

Where colour slides are simply to be shown as they are, as part of a portfolio for instance, then they can be displayed very effectively in large card mounts which hold a dozen or more slides together. These can be fitted into a plastic sleeve with a frosted back which enables the slides to be held against a convenient light source for effective viewing.

The best way of presenting prints is to mount them. This will also protect them. Small prints for personal use, such as holiday enprints, can be mounted directly into an album with self-adhesive leaves, but for the best effect you should apply the same criteria as for projection – ruthless editing of second-rate pictures and a careful and well-planned sequence, paying attention to the way the pictures are layed out on the page. Don't cram too many together but juxtapose them within the space to create a pleasing design. Larger prints should be mounted individually onto boards. Dry mounting is best. Once this has been done they can either be placed into a portfolio album with protective acetate sleeves or kept in a portfolio box for normal presentation purposes. The effect of mounted prints can be greatly enhanced by the use of cut-out overlays or mats.

For your really best work you may also consider displaying prints on the walls of your home or office. There is a variety of do-it-yourself framing kits, ranging from simple clips which hold a print between a sheet of glass and hardboard to the more elaborate metal frame kits which can create a highly finished effect when combined with a mat overlay. Avoid hanging colour prints in direct sunlight as this can cause them to fade.

Above These are two ways of presenting a photograph for wall display: top right shows a picture flush mounted onto a simple, self-adhesive block mount; top left is a more elaborate presentation, using a mat overlay and wooden frame.

Below The effect of a print with a mat overlay makes the unmounted photograph appear unfinished in comparison. With colour pictures the colour of the overlay can be chosen to tone with the picture.

Above This is a portfolio album in which large prints have been dry mounted onto thin card and then displayed in acetate sleeves for added protection. This system also makes it a simple matter to change content of the portfolio.

197

Travelling with the camera

Travel and photography are ideal partners. The stimulation of visiting new places and seeing different scenery and people is invariably reflected in a fresh wave of enthusiasm for shooting pictures. An interest in photography can add to the pleasure and excitement of travel as well as providing a life-long *aide-mémoire* of the experience. However, to embark on a trip of, say, two or three weeks with a camera does require a rather more careful and considered approach than a casual afternoon's photography if the best use is to be made of the opportunities. The importance of a good and well-organised camera bag cannot be overstressed when you are going to be carrying it and using it every day for a long period. If you plan to take a large amount of equipment, it can be an advantage to carry the entire outfit in a rigid suitcase-style bag for maximum protection during travel and to transfer your needs for a particular excursion to a soft bag for easier carrying and access.

As a general rule it is advisable to take all the film you will need with you. This will guarantee that it is fresh and will also give you a chance to test a roll before you go. If you are travelling by air, avoid X-ray security scans whenever possible. Even the film-safe machines have been known to fog film, particularly if the same film is subjected to a number of checks. Carry the film in a separate bag as part of your hand luggage and simply ask, politely, for it to be checked by hand. You are seldom refused. Also make sure that you have a supply of fresh, spare batteries, especially if you are travelling away from the tourist routes. A camera cleaning kit is also important. A dust-off spray or blower brush, some lens tissues and a selvyt cloth will enable you to keep your equipment free of the dust and smears which invariably accumulate under travelling conditions. It is a good idea to write a check

list of the equipment you will need to ensure that nothing important is overlooked, but don't be tempted into taking more than you need, since a heavily loaded camera bag can easily become a burden. A basic outfit consisting of, say, a wide angle lens, a mid range zoom and a long focus lens, with perhaps an extension tube, a filter kit and a tripod will enable you to cover a wide range of subjects. Any additions to this should be made to justify themselves. A small flash gun can be useful and a second camera body is advisable, partly as a back-up and to save time, since it will enable you to load up simultaneously with both black and white and colour film.

Don't forget to check that your camera insurance will cover your trip. If it does not include foreign travel, it is usually possible to extend the cover for a small additional premium. It is a good idea to carry a duplicated list of all your equipment and the serial numbers so that if you experience any difficulties at customs, the list can be stamped to prove that it is for personal use and will be re-exported when you leave.

Right *Pictures like this are partly good luck. Yet being in the right place at the right time and being well prepared to shoot quickly and to have everything immediately to hand is a vital element of travel photography. Good organisation is as important as good photographic technique.*

Nikon F3, 150mm lens with a graduated filter, 1/30 sec. at f8. Ektachrome 64.

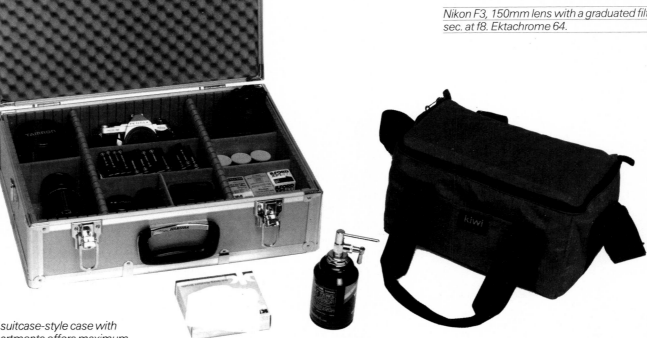

Above *The rigid suitcase-style case with adjustable compartments offers maximum protection and safe transportation. In front is a pad of lens-cleaning tissues, and a dust-off airspray and a blower brush.*

Above *The soft compartment case is less protective than the rigid version, but more comfortable and convenient in use.*

Collecting photographica

There is little doubt that a great many photographers take considerable pleasure in their equipment for its own sake as well as its usefulness and efficiency in taking pictures. This is hardly surprising, since a good camera shares many of the qualities that are valued in any personal possession, such as a pleasing design and fine engineering. One way in which this enjoyment and appreciation of the craftsmanship in photographic impedimenta can be very satisfyingly indulged is to collect old and redundant cameras and accessories.

Although a fine old brass and mahogany field camera is now a desirable and collectable item which can command a high price, there are many other opportunities for buying interesting and attractive items for a very modest cost. Junk shops and markets are excellent hunting grounds and often a nice old box camera or a veteran folding camera perhaps 70 or 80 years old can be found for less than the price of a roll of film. Although in

the early stages of collecting any piece of equipment at a reasonable price will be attractive, you will probably find that a particular interest will emerge to encourage you to specialise in box cameras, for instance, or 35mm cameras or even models from one particular manufacturer. Photography has developed so rapidly that some equipment from only a decade or two ago now has an 'antique' quality.

Although it is by no means necessary to know much about the history or background of early cameras to enjoy collecting them, such an interest will often follow and there are now many good books on the subject. An excellent example is *Cameras* by Brian Coe (Marshall Cavendish Editions). For the really serious collector there is *Von Daguerre bis Heute* by M.D. Abring, which is a virtual catalogue of all cameras from the very beginning to the present day.

In addition to cameras there is also a

wealth of interesting opportunities in other equipment and accessories – old brass-mounted lenses, for instance, or exposure meters. If space is not a problem you may consider old magic lanterns or even enlargers. Many old pieces of equipment are still in good working order or need only a little attention and it can be quite rewarding to actually put them to work again. Apart from the sheer novelty, the soft luminous quality of some of the old lenses can produce some very pleasing results.

There are various societies for collectors in many countries, such as the Photographic Collectors Club of Great Britain, which issues a magazine and organises swap meets, lectures and postal auctions as well as helping to make contact with people who share similar interests and obsessions. If you have a specific interest and want to track down particular items, such an organisation can be invaluable.

This picture illustrates a variety of 'miniature' cameras designed to use both 35mm film and roll film. Left to right, a Robot, a 35mm camera with a clockwork motor drive circa 1934. A Baby Box Brownie by Kodak, manufactured in Bakelite, in 1935, taking 127 roll film. A 531 Super Ikonta by Zeiss, a precision folding camera with a coupled rangefinder also made in 1934. An Ilford Advocate finished in white enamel taking 35mm film and made in 1950. Houghton's Ensign Cupid, a novelty design for a box-type camera and an Ensignette a miniature folding camera also by Houghton, made in 1907.

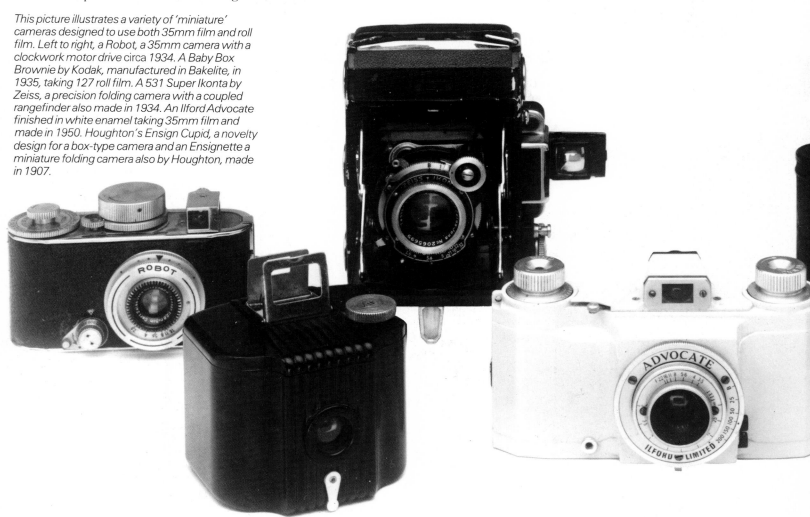

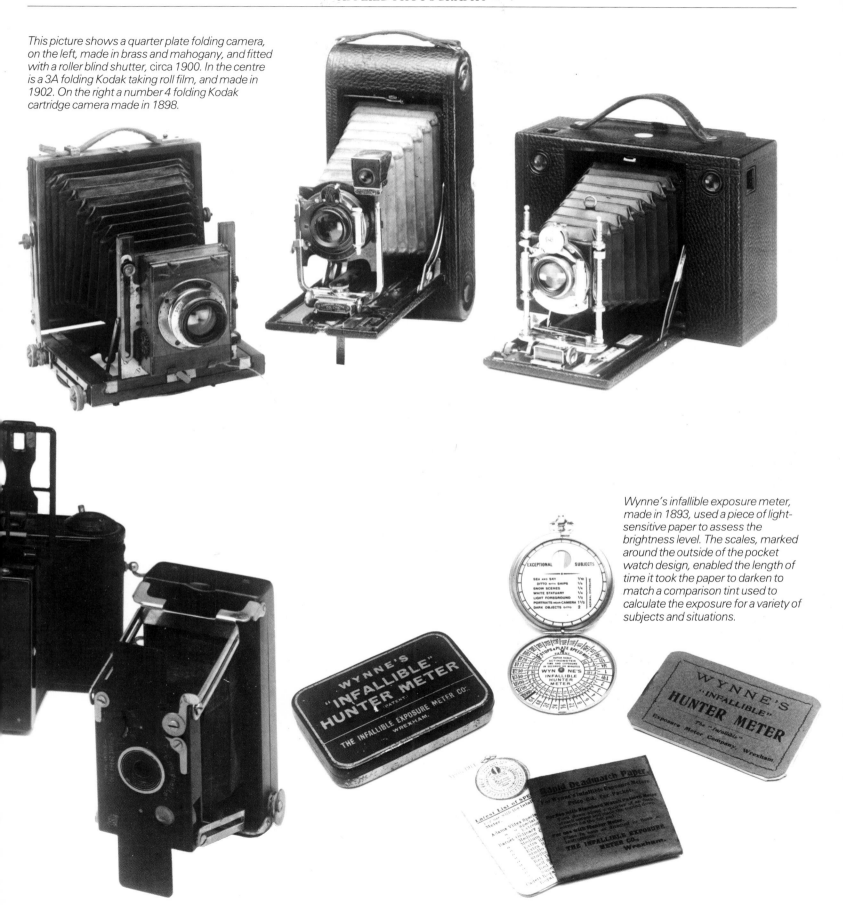

This picture shows a quarter plate folding camera, on the left, made in brass and mahogany, and fitted with a roller blind shutter, circa 1900. In the centre is a 3A folding Kodak taking roll film, and made in 1902. On the right a number 4 folding Kodak cartridge camera made in 1898.

Wynne's infallible exposure meter, made in 1893, used a piece of light-sensitive paper to assess the brightness level. The scales, marked around the outside of the pocket watch design, enabled the length of time it took the paper to darken to match a comparison tint used to calculate the exposure for a variety of subjects and situations.

Solving problems

One of the most effective ways of learning anything is by one's mistakes. Photography is no exception. Even the most professional photographers make occasional errors. However humiliating, such an experience can be used and modified to create a controlled effect for a particular shot. The difficulty, however, particularly for the beginner is to know how the fault has arisen. An important step in learning how to take good photographs is the ability to look at your results critically and analyse what went wrong.

Camera Faults

Faults that occur in the camera fall broadly into two categories: technical faults, which affect the quality of the image on the film; and what might be called visual faults, where the camera has been badly aimed, resulting in a picture which although technically good is aesthetically poor. This is the first distinction that should be made. The two main considerations in terms of image quality are density and sharpness, if the image is too light or too dark or not sharp, then the result will be a poor picture no matter how well composed.

If a picture is too dark it is because the film has had insufficient exposure. This can be caused by a number of things, which should be checked in succession. The most basic error is to set the wrong ISO number on the exposure meter or film speed dial of the camera. If an ISO 100/21 film is mistakenly set to ISO 200/24, the result will be one stop underexposed. If this is not the cause the next most likely error is that the subject was abnormal in terms of its tonal values or brightness range and the reading was not adjusted accordingly. The usual causes are bright light sources in the picture, such as street scenes at night, or a large area of sky, or shooting into the light, or a subject which is primarily light in tone, such as a snow scene. If this does not appear to be the case, then see how frequently the problem arises on the roll of film. If it is just an occasional frame, it could simply be that you inadvertently set the shutter speed to a faster setting than you intended or the aperture to a smaller f number (when using a non-automatic camera), or you did not allow for a filter when using a non-SLR camera. If you are using an automatic camera, you may have set the exposure override to a minus value. If the entire roll of film is consistently too dark, then the problem could be a camera malfunction and you should have it checked by a repairer. A less likely cause is stale film. When using flash the reason may simply be that you were too far from the subject for the power of the flash gun.

If a picture is too light, it is likely that the film has had too much exposure. The prime causes of this are setting the exposure meter or film speed dial to a lower ISO number than the film in use, using a slower shutter speed than that intended when using a manually set camera, or a wider aperture or by setting the exposure override of an automatic camera to a plus value. If the subject contains excessively large areas of dark tones and no adjustment of the exposure reading is made, the result will also be overexposure. With flash, overexposure can be caused by using the flash gun too close to the subject. If films are consistently too light, then it is possible that there is a camera or exposure meter fault and this should be checked. With automatic flashguns, the sensor that measures the light reflected back from the subject can be obscured, therefore, causing the unit to fire at full power. When synchronising flash to a camera with a focal plane shutter only part of the film will be exposed if a shutter speed higher than 1/60 sec. is used. On cameras with X and M synchronising no exposure will be recorded if electronic flash is used on the M setting, or socket.

Vignetting on negatives or transparencies can occur when a lenshood designed for a telephoto lens is used with any lens of a wider angle. Vignetting may also occur when using more than one filter of the screw-on variety on a lens with a focal length less than 28mm.

In addition to overexposure, both fog and flare can cause the image to be too light. Fog is a result of light or X-rays reaching the film before development. Loading and unloading in bright light, loosely-wound films or leaky cassettes or camera backs can cause this, as can some airport security X-ray machines. Flare is caused by bright light shining on to the front of the lens and being scattered indiscriminately within the camera. Unlike overexposure, all of these causes are likely to produce streaky or uneven light areas on the image.

If the image contains areas that are both too light and too dark on the same frame, this is probably because the brightness range of the subject is too great for the film to accommodate, resulting in parts of the image being both overexposed and underexposed. If the image is the correct density but the wrong colour, this is most likely to be because the light source is not of the correct colour temperature for the film in use – daylight film in tungsten light for instance.

The most common cause of an unsharp image is camera shake. This can usually be identified by the fact that the whole image is unsharp with a suggestion of a double image. If part of the image is sharp but other areas blurred the most likely cause is either incorrect focusing or inadequate depth of field. If the unsharp part of the image is a moving subject, then the cause is likely to be an insufficiently fast shutter speed. If you are getting consistently unsharp pictures then it may be because of a lens problem. The lens may be dirty or smeary or out of alignment, or the focusing mechanism may be faulty, in which case it must be checked by a repairer. An unsharp picture may also result when using a zoom lens on the camera, and inadvertently changing the focal length when depressing the shutter. Although this can be used to dramatic effect. Another cause of unsharp pictures could be condensation on the lens or film. This can happen when you take your equipment from a cold atmosphere into a warm one, or when you take film from, say, a refrigerator and do not allow sufficient time for it to warm to the ambient temperature.

If a picture has a colour cast then this is most likely to be caused by the film being exposed in a light source which has a different colour temperature to that for which the film is balanced. This will be most apparent when using transparency film since corrections to the colour balance can be made at the printing stage. When colour negative film is used this is usually adjusted for automatically in a trade laboratory. With colour transparencies, however, a strong colour cast is likely to be the result of either daylight type film being exposed in artificial light, producing a pronounced orange cast, or by exposing artificial light film in daylight producing a strong blue cast. Another common fault is a green cast. This occurs when either types of film are exposed to fluorescent light. Although this lighting appears to be similar to daylight it is in fact very different and quite strong filtration, in order of 30 Magenta, is needed to correct this cast. It is also possible to buy special conversion filters for use with daylight film in fluorescent lighting, as well as in normal tungsten lighting. There is a conversion filter available for using tungsten light film in daylight. Where a colour cast is only slight this may be caused by a less dramatic variation in the colour temperature of the light source. A blue cast, for example, will be created when the sky is overcast or when photographing in open shade. When there is a blue sky, a blue cast will also result as there will be an excess of ultra violet light. This most frequently occurs at high altitudes, and near the sea. A warm, or orange, cast will occur when the colour temperature of the light source is lower than that for which the film is balanced. This often occurs when shooting in early morning, or late evening sunlight when the sun is low in the sky. It is also possible to get an orange cast when

photographing in ordinary indoor light when using artificial light film. This is because domestic bulbs give an illumination of a lower colour temperature than the photographic bulbs for which the film is balanced.

Non Technical Faults

Even if a picture is correctly exposed, sharp and with a natural colour quality the results can still be disappointing. If this is the case the fault is likely to be in aiming the camera rather than in adjusting the settings. Perhaps the most common fault, particularly with inexperienced photographers, is that of not being close enough to the subject and including too many irrelevant details in the picture. This is sometimes caused by not observing the image carefully within the viewfinder, and seeing how the subject is positioned relative to the edges of the frame. With viewfinder cameras in particular, this problem can be compounded by the fact that the viewfinder often shows less of the scene than is actually recorded on the film. When this is combined with too distant a viewpoint, the result can be a much smaller image of the subject than was intended. Another frequent error with beginner's pictures is to simply centre the subject in the viewfinder, using it as if it were a gunsight.

A centrally placed subject is rarely the most pleasing arrangement and the solution, again, is to observe carefully the position of the subject relative to the edges of the viewfinder, and to adjust this until a more balanced and interesting arrangement is achieved.

Distracting, or unattractive, backgrounds are another very frequent fault. This too is the result of insufficient observation. As well as learning to see the subject in terms of its position within the borders of the frame, it is also vital to see it relative to the background. The common cliché of a tree growing from someone's head is a direct result of failing to do this. When photographing people, or other quite close subjects, such as animals. Another common fault which will cause disappointing results is that of not being sufficiently aware of the quality and direction of the light, so taking pictures in which harsh lighting, or dense shadows, obscure the subject and create an unpleasing or unflattering quality. With views, or pictures of distant subjects a frequent cause of bad photographs is the failure to identify a well defined centre of interest, to which the eye is most strongly attracted, and around which the other details of the picture can be included. With this type of picture a lack of foreground definition can also be a factor in producing a flat and uninteresting quality in the work.

It is vital when assessing your results to be quite analytical in your appraisal so that you can identify the reasons why a picture is poor or disappointing. Only in this way will you be able to increase your awareness of what is required to create appealing photographs.

The most common fault in processing black and white film is incorrect development. Too much development will result in dense and contrasty negatives and too little development will produce thin, weak negatives with no shadow detail.

Correct development is determined by the processing time and the temperature of the solution. If overdevelopment has occurred, then the most likely cause is either that the temperature of the solution was too high or that the film was developed for too long. Excessive agitation can also cause the image to be overdeveloped. If you are using a concentrated stock solution, insufficient dilution will also produce overdevelopment.

Underdevelopment is caused by erring to the other extreme – too low a temperature, insufficient time in the developer or inadequate agitation. Excessive dilution or stale chemicals will also produce thin negatives. Streaky or stained negatives are usually caused by contaminated solutions or a stale fixing bath.

Inadequate fixation or washing of films and papers will result in fading or discolouration. As these faults will not manifest themselves until sometime after this stage of processing it is extremely important that great care is taken. Particles in the water supply may adhere to the emulsion at the washing stage of film processing. These will appear as spots on the finished print. A filter on the tap will eradicate this problem. With 35mm films fine lines may appear along the length of the emulsion if the film is wound into the cassette too tightly. A similar fault will occur if tiny particles of grit or dirt are caught within the opening of the cassette.

Small circular light areas on the negative are not uncommon and are usually the result of air bells forming on the film when the developer is poured in. This can be prevented by immediate agitation and a sharp tap on the side of the tank to dislodge them. If the problem persists, you can try pre-soaking the film for about a minute in water with a little wetting agent added. (Discard before pouring in the developer.) Small, crescent-shaped marks of greater density are usually caused by the film kinking during the loading operation. Bands of uneven density along the edges of the film can be caused by excessive or too vigorous agitation and are more often experienced when processing 35mm film, particularly if several rolls are processed together. The problem seems more prevalent with steel spirals. An extremely coarse regular grainy effect is the result of reticulation caused by using solutions at too high a temperature or subjecting the film to too violent changes of temperature. Shadows and/or rebates veiled by density can be caused by fogging during loading, or by chemical fog caused by stale developer or contamination.

The same pitfalls apply to processing colour films, except that variations in time and temperature and contamination of one solution to another will tend to have a more marked and dramatic effect as the colour quality of the image will also be affected. In addition to the faults described in black and white negatives, the most likely – and difficult to attribute – is that of contamination, which can cause a wide range of effects. For this reason it is particularly necessary that great care is taken to avoid solutions being in contact with each other and to use separate measures and containers for each. If problems do arise, it is best to discard all your solutions and start again with a fresh batch.

Where faults are experienced with prints it is important to first establish that the fault is in fact at the printing stage and does not exist in the negative or transparency. If, for example, you have produced a very flat and muddy black and white print but the negative is of normal appearance then the problem is either in the choice of paper grade or an error in processing. The same criteria exist with printing procedures as with film processing. Once you have established a set routine, any substandard results that do not exist at the negative or transparency stage will almost certainly be because of inaccurate time or temperature control, contamination, or fog, and you must eliminate each in turn until you can identify the source of the problem.

When printing either black and white or colour, Newton Rings can form in a glass type carrier of the enlarger. This can be avoided by using the glassless variety of carrier, although the film may not be held perfectly flat, or with a carrier fitted with anti Newton Ring glass. Mounted transparencies can also suffer from the same problem. Again, mounts employing anti Newton Ring glass, or glassless mounts, will correct the fault.

If, when, shooting in poor lighting conditions your pictures are under-exposed, even though you followed an exposure meter reading, the cause will probably be reciprocity failure. This is because, at speeds longer than about ½ second the film no longer relates to twice the exposure equalling one stop lighter. A meter reading of several seconds may need to be increased as much as 50 or even 100 per cent to obtain correct exposure. An unpredictable effect on colour balance may also result when using very long exposures.

Galleries

This list of galleries is intended only as a guide. National photographic magazines usually carry listings of current shows as will your local press. Very often, in most major cities there is a museum or internationally known art gallery that will also exhibit photography. The Victoria and Albert museum in London, for instance, have an archive of photographs that is continually being enlarged. They also exhibit photography, as does the Museum of Modern Art in New York and the Georges Pompidou Centre in Paris. Because these centres have a great deal more space at their disposal than a local gallery they tend to specialise in large, retrospective exhibitions of, say, an individual photographer or a group who developed an individual style.

If you feel that your photographs would make a worthwhile exhibition it would be best to contact your local photographic gallery.

United Kingdom Galleries

Aberbach Fine Art Gallery,
17 Saville Row,
London.

Albert Street Workshop,
8 Albert Street,
Hebden Bridge,
Yorkshire.

Arnolfini Gallery,
Narrow Quay,
Bristol.

Art Faculty Concourse,
Kedlestone Road,
Derby.

Battersea Arts Centre,
Lavender Hill,
London.

Camerawork,
121 Roman Road,
London, E2.

Cockpit Gallery,
Princeton Street,
London, WC1.

The ffotogallery,
41 Charles Street,
Cardiff.
Sells original contemporary prints

Fox Talbot Museum,
Lacock,
Wiltshire.
Sells quality reproductions

Grassroots Photographic Gallery,
1 Newton Street,
Manchester.

ICA Gallery,
Nash House,
12 Carlton House Terrace,
London.

Impressions Gallery of Photography,
17 Colliergate,
York.
Sells original contemporary prints
Sells quality reproductions

Kodak Gallery of Photography,
190 High Holborn,
London, WC1.

Midland Group Gallery,
24-32 Carlton Street,
Nottingham.
Sells original contemporary prints
Sells quality reproductions

National Museum of Photography
Film and Television,
Market Street,
Bradford,
Yorkshire.

Olympus Gallery,
24 Princes Street,
London, W1.
Sells original contemporary prints
Sells quality reproductions

Open Eye Gallery,
90-92 Whitechapel,
Liverpool, 1.
Sells original contemporary prints
Sells quality reproductions

Photogallery,
The Foresters Arms,
2 Shepherd Street,
St Leonards-on-Sea,
East Sussex.

The Photographers Gallery,
5 and 8 Great Newport Street,
London, WC2.
Sells original contemporary prints
Sells quality reproductions

The Photographic Gallery,
Brewery Arts Centre,
122a Highgate,
Kendal,
Cumbria.

The Photographic Gallery,
The University of Southampton,
Southampton.

The RPS National Centre of Photography,
The Octagon,
Milsom Street,
Bath.
Sells original contemporary prints
Sells quality reproductions

Side Gallery,
9 Side,
Newcastle upon Tyne.

Spectro Photography,
Bells Court,
Pilgrim Street,
Newcastle upon Tyne.

Stills,
The Scottish Photography Group Gallery,
58 High Street,
Edinburgh.
Sells original contemporary prints
Sells quality reproductions

Sutcliffe Gallery,
1 Flowergate,
Whitby,
North Yorkshire.
Sells original contemporary prints
Sells quality reproductions

Uppermill Photographic Gallery,
Uppermill Library,
Saddleworth,
Oldham,
Lancashire.
Sells original contemporary prints

The Webster of Oban Gallery
of Photography,
15 Stafford Street,
Oban,
Scotland.

European Galleries

Aspects Photography Gallery,
rue du President 72,
B-1050 Bruxelles,
Belgium.

L'Atelier,
20 Galerie Vivienne,
F-75002,
Paris,
France.
Sells original contemporary prints

Camera Obscura,
Kakbrinken 5,
11127 Stockholm,
Sweden.

Cannon Photo Gallery,
Leidsestraat 79,
1017 NX Amsterdam,
The Netherlands.

Creatis,
44 rue Quincampoix,
75004 Paris,
France.

L'Espace Cannon, 117 rue Saint Martin,
75004 Pris,
France.

European House of Photography,
Rubenscenter,
Groenplaats,
Antwerpen,
Belgium.

La Galeria,
Plaza Replica Argentina 2,
Madrid,
Spain.

Galerie Fiolet BV,
Herengracht 86,
Amsterdam,
The Netherlands.
Sells original contemporary prints

Galerie Perspectives,
53 avenue de Saxe,
75007 Paris,
France.

Galerie Perspektief,
Stationssinggel 19b,
Rotterdam,
The Netherlands.

Galerie Photo du Forum,
avenue du 8 Mai 1945,
F 95200 Saracelles,
France.

Galerie Spectrum/Cannon,
Balmes 86,
Barcelona 8,
Spain.

Galerie Tau,
Carrer Prim 6,
Sant Celoni,
Barcelona,
Spain.

Galerie Ton Peek,
Oude Gracht 259,
Utrecht,
The Netherlands.

The Gallery of Photography,
37-39 Wellington Quay,
Dublin 2,
Eire.
Sells original contemporary prints
Sells quality reproductions

Image Center for Fotografie,
Mejlgade 16,
DK-80000 Aarhus C,
Denmark.

Marlborough Galerie AG,
Glarnischstrasse 10,
CH-8002 Zurich,
Switzerland.
Sells original contemporary prints

Photofactory,
Chateau Neuf,
Slemdalsvn 7,
N-Oslo 3,
Norway.

Rudi Renner Fotogalerie,
Mannhardstrasse 4,
8000 Munich 22,
Federal German Republic.

Studio 666,
6 rue Maitre Albert,
75005 Paris,
France.
Sells original contemporary prints

Werkstatt für Fotografie,
Friedrichstrasse 210,
1000 Berlin 36,
Federal German Republic.

North American Galleries

Baldwin Street Gallery of Photography,
23 Baldwin Street,
Toronto 130,
Ontario,
Canada.
Sells original contemporary prints

Carl Siembab Gallery of Photography,
162 Newbury Street,
Boston,
Massachusetts,
02116,
USA.
Sells original contemporary prints

Colorado Photographic Arts Centre,
1301 Bannock Street,
Denver,
Colorado,
80204,
USA.

Corcoran Gallery of Art,
27 & New York Avenue NW,
Washington DC,
20006,
USA.
Sells original contemporary prints

Focus Gallery,
2146 Union Street,
San Francisco
California,
94123,
USA.
Sells original contemporary prints

Fotografia Gallery,
6226 Wilshire Boulevard,
Los Angeles,
California,
90048,
USA.

Gallery of Photography,
453 St Francis-Xavier,
Montreal,
Quebec,
Canada.

The Gallery of Photography,
3619 West Broadway,
Vancouver,
Canada.

International Center of Photography,
1130 Fifth Avenue,
New York,
NY 10028,
USA.
Sells quality reproductions

International Museum of Photography,
George Eastman House,
900 East Avenue,
Rochester,
NY 14607,
USA.
Sells original contemporary prints

Light Gallery,
724 Fifth Avenue,
New York,
NY 10019,
USA.
Sells original contemporary prints

The Lunn Gallery,
3243 P Street NW,
Washington DC,
20007.

Minds Eye Photographic Gallery,
52 Water Street,
Vancouver 4,
British Columbia,
Canada.

The National Film Board of Canada
Photography Gallery,
150 Kent Street,
Ottawa,
Canada.

Pace Gallery,
32-34 East 57th Street,
New York,
10022.

Photopia,
1728 Spruce Street,
Philadelphia.
Pa 19103,
USA.
Sells original contemporary prints

Photowork,
239 Gerrard Street East,
Toronto,
Canada.

The Silver Image Gallery,
92 South Washington Street,
Seattle,
Washington,
98104,
USA.

Soho Cameraworks Gallery,
8221 Santa Monica Boulevard,
Los Angeles,
90046,
California.
USA.

Vision Gallery of Photography,
216 Newbury Street,
Boston,
Massachusetts,
02116,
USA.

Weston Gallery,
PO Box 655,
Carmel,
California,
93921,
USA.

Sir George Williams University,
1455 De Maisonneuve,
Montreal,
Quebec,
Canada.

Witkin Gallery Inc,
41 East 57th Street,
New York,
10022.
USA.

Australian Galleries

Australian Centre for Photography,
76a Paddington Street,
NSW,
Australia.

Kodak Gallery,
252 Collins Street,
Melbourne,
Australia.

The Developed Image,
391 King William Street,
Adelaide,
South Australia 5000.

Photoforum Gallery,
26 Harris Street,
Wellington 1,
New Zealand.

Snaps Gallery,
30 Airedale Street,
Auckland 1,
New Zealand.

Index

NOTE: References to pages on which illustrations occur shown in italics, thus *9*

R

Recording. 146
reflections, use of, 144, *144*, *145*
reflectors, 46-7, 164
reflex system, 12
reportage, 120
retouching, 188
rim lighting, 113
Rolleiflex SL 2000F camera, 32

S

Sabattier effect, 177
selection, picture, 70, *71*, 98
selling pictures, 160
shadows, use of, 62, 64
shape importance, 66
sharpness, 52, 137
shift lens, 34
shooting into the light, 110, *111*
shutter speed, 52, 86
 faults, 202
 for movement, 54, *55*
silhouette shapes, 66
single lens reflex system (SLR), 12
 camera, 30, 32, *34*, 90
skin quality, 82, *83*
sky effects, 92-3
slave cell, 46
slide sandwich, 132
slow film effects, *37, 39*
Smith, W. Eugene, 23
snoot attachment, 47
soft focus effects, 130-31
 attachment, 80, 130
special effects, 130, 131, 132, 133, 134, 135
sport, 104
 movement, 106
spot light, 47
spring-loaded poles, 164
standard lens, 34
starburst filter effect, *44*
still-life, 122-3
studio facilities, 164
studio portraits, 112-13
subject lighting, 62
sunlight shots, 60, 110
supplementary lens, 44, *44, 129*
Sutcliffe, Frank, 15
Sutton, Thomas, 12

T

Telephoto lens, 34, 152
 effects, *152, 153*
texture effects, 68, 154
texture screen, 178
thematic studies, 142
tonal range, 94
tonal values, 64
tone separation, 176-7, 194
toning processes, 194
transparencies, *see under* colour
 transparencies
travel preparations, 198
trees, 126
tri-colour, 136
tripod, 44, *44*, 29
tungsten halogen bulbs, 46
tungsten light film, 37
twin lens reflex camera, 30

U

Ultra-violet light, 42, 60
 filter, 42
umbrella reflector, 46, 112
under-exposure, 57, 58, 202

V

Vanishing point, 100
view camera, 30
viewfinder camera, 30
viewpoint, choice of, *34, 71,* 74, *74*
Vivitar 285 flash gun, *85*

W

Water effects, 93
Weston, Edward, 16
wet plate process, 10-11
wide angle lens, 34, 98, 148, 150
 effects, *94, 150, 151*
window lights, 46
Wratten 12 filter, 134

Z

Zoom lens, 34

Acknowledgements
The publishers and author would like to thank the following individuals and organisations for their kind permission to reproduce the other photographs in this book:

Ansel Adams 19; David Bailey 27; Alastair Black 104; Julien Busselle 94 below; Bill Brandt (courtesy Marlborough Fine Art (London) Ltd) 20; From the Collection of The Royal Photographic Society 14; © Henri Cartier Bresson (courtesy Magnum Photos) 21; Colorific 13 right; Stephen Dalton (courtesy Oxford Scientific Films) 25; © Ernst Haas (courtesy Magnum Photos) 24; André Kertesz 17; © J H Lartigue (John Hillelson Agency Ltd) 18; Leo Mason 106 above, 107 above; Eamonn McCabe 105; © Don McCullin (courtesy Magnum Distribution) 24; John Miller 6, 30/31, 32/33, 35 below, 44 left, 45 below, 56 below, 85 below, 168, 170, 182, 184, 185 below, 196 above and below, 200/201; Arnold Newman 22; Martin Russell 11 above left; The Science Museum 10 left, 10 right, 11 above right and below right, 12 left, 13 above right, left and below left; © 1972 W Eugene Smith 23; Nigel Snowdon 107 below; Frank Meadow Sutcliffe (courtesy The Sutcliffe Gallery, Whitby, N Yorks.) 8/9, 15; Topham 12 right; Patrick Ward 106 below; Edward Weston © Center for Creative Photography, University of Arizona) 16.

The publishers also wish to thank the following for their kind help:

Agfa-Gevaert Limited, UK., Mr. C. B. Elworthy at Cannon (UK) Limited, Keith Johnson Photographic Ltd., Mr. P.M. Sutherst and Simon Archer at Kodak Limited, Minolta (UK) Limited, Charlotte Beer at Nikon (UK) Limited, J. Osawa and Co. (U.K.) Ltd., Chris Childs at Pentax U.K. Limited, Polaroid (UK) Limited.

Our thanks are also due to the following: Bowens Sales & Services, Braun Electric, Johnsons of Hendon, Leeds Camera Centre, Paterson Products, Philips Electronic Industries, Photopia, Sinar, Wallace Heaton, Vivitar (UK).

The following artists supplied illustrations: Andrew Popkiewicz, 30, 31; Terri Lawlor, 34, 35, 37, 50 (top), 51, 56, 84, 112, 113, 172, 173, 188, 189; Andrew Farmer, 45, 46, 47, 50 (bottom), 52, 128, 164, 165, 166, 167; James Robbins, 169, 171.